Leadership Craft, Leadership Art

Leadership Craft, Leadership Art

Steven S. Taylor

First published in 2012 by
PALGRAVE MACMILLAN®
in the United States—a division of St. Martin's Press LLC,
175 Fifth Avenue, New York, NY 10010.

Where this book is distributed in the UK, Europe and the rest of the world,
this is by Palgrave Macmillan, a division of Macmillan Publishers Limited,
registered in England, company number 785998, of Houndmills,
Basingstoke, Hampshire RG21 6XS.

Palgrave Macmillan is the global academic imprint of the above companies
and has companies and representatives throughout the world.

Palgrave® and Macmillan® are registered trademarks in the United States,
the United Kingdom, Europe and other countries.

ISBN: 978–0–230–33893–7

Library of Congress Cataloging-in-Publication Data

Taylor, Steven S., 1960–
 Leadership craft, leadership art / by Steven S. Taylor.
 p. cm.
 Includes bibliographical references.
 ISBN 978–0–230–33893–7 (hardcover)
 1. Leadership. I. Title.

BF637.L4T394 2012
303.3′4—dc23 2011024352

A catalogue record of the book is available from the British Library.

Design by Newgen Imaging Systems (P) Ltd., Chennai, India.

First edition: January 2012

10 9 8 7 6 5 4 3 2 1

Transferred to Digital Printing in 2012

For the first leaders in my life: my parents, Pat and Mike Taylor

CONTENTS

Contents

ILLUSTRATIONS

TABLES

ACKNOWLEDGMENTS

In this book, I contend that creativity always involves collaboration—sometimes implicitly, sometimes explicitly. This book's creation was no exception, and I want to acknowledge some of the people who played an important role in making it happen. I'd like to start by thanking the folks at Palgrave Macmillan, in particular Laurie Harting and Tiffany Hufford. Throughout the process, I've also been supported by my university, Worcester Polytechnic Institute.

The early creative sparks for this book were nurtured at the Banff Centre, and Nick Nissley's and Colin Funk's support of my work was critical. Countless friends have helped me in developing this work—I'd like to give special thanks to Ralph Bathurst, Donna Ladkin, Brad Jackson, Nancy Adler, Kevin Stephens, Daved Barry, Mary Jo Hatch, Ted Buswick, Mark Rice, Mike Elmes, Piers Ibbotson, Bill Torbert, Brent French, Hans Hansen, and Fulton 214 (Rich Dejordy, Danna Greenberg, Erica Foldy, Pacey Foster, Tammy MacLean, and Jenny Rudolph).

I also owe a great deal to all of my students over the past decade who have taught me so much about the practice of leadership. But, of course, the biggest debt of all is owed to my wife Rosemary, who gave me so much more than just the cover art for this book and whose love made it all possible.

CHAPTER ONE

Craft, Art, Creativity, and Leadership

Human beings have always been masters of craft. We make things, and some of those things we decorate to make them special. Our ancestors spent a lot of their time making things such as knives and adding complex decorations to the handles to make the knife have some meaning that was different from that of other knives. When I was a teenager, it was commonplace to add patches or embroidery or otherwise decorate your blue jeans to make them special. This creating and making special are the origins of craft and art.[1] The Industrial Revolution consisted largely of taking traditional crafts and turning them into modern production processes by taking the variance out of the process, by breaking the process down into its component parts and making assembly lines, and by introducing machinery and automating as much of the process as possible. Our material standard of living has increased greatly as a result.

Relentless economic forces push the costs of these production processes ever downward through automation, rationalization, and outsourcing. As nearly everything that can be turned into a modern production process has been turned into one, more and more of us find ourselves working in processes that cannot be turned into such production processes—processes that require variance in the process; that require creativity, craft, and art; and that involve working with other people, reaching agreement on what to do and how to do it, and dealing with exceptions to the production processes.

One of those processes is leadership. Despite all the efforts of countless scholars, practitioners, and leadership developers to get at the essence of leadership in order to make it more effective, in order

to mass-produce it, leadership remains a craft, at times an art, and always a creative effort. In the words of the leadership scholar James MacGregor Burns:

> The key distinctive role of leadership at the outset is that leaders take the initiative. They address their creative insights to potential followers, seize their attention, spark further interaction. The first act is decisive because it breaks up a static situation and establishes a relationship. It is, in every sense, a *creative* act.[2]

Leadership is a creative act, in part because of the challenges that leaders face. We live in a complex and interdependent world where even agreeing on the nature of an issue is difficult. Consider the big issues of our time—energy, climate change, population pressures, distribution of wealth, species extinction, addiction to growth[3]—that may really all be one big, interconnected challenge.[4] Some talk about climate change, and others respond by saying: well it's really all about carbon-based energy and we need to move to renewable energy sources. Others say that it's really about how we produce food, that much of our carbon use comes from food production and distribution, and that we need to create (or perhaps re-create) a local and organic food system. Others argue that at the root of all of these issues is the ever-growing human population and that we have long since passed the ability of the planet to support so many people. Others say that it's not population, it's consumption, because even if population levels off as they are predicted to do sometime in the twenty-first century, we still expect our economy to grow every year, and so growth in consumption is the core issue. Still others follow this argument further and suggest that investor capitalism has growth at its core and that we need a new system of organizing our political economy that does not require constant growth. Deep down, we recognize that there's more than a grain of truth in *all* of these positions and that a leader who could solve these problems would be a master of the art of leadership.

The terms *craft* and *art* are often used interchangeably to refer to a variety of creative processes, including leadership. But since both are central topics here, let me draw a distinction[5] between them. Craft applies a systematic set of skills in an established process to achieve a desired end result. For example, a woodworker carefully planes her pieces of wood, cuts out the dovetails for the joints, assembles, and then sands and finishes a chair. It has been created by hand and if you look closely you can see minor imperfections that come with handwork. It

is not exactly like any other chair, but it is pretty much the chair the woodworker had in mind when she started making it. Daved Barry and Stefan Meisiek summarize this idea by saying that craft is fundamentally about destinations. And it is easy to see how crafts such as woodworking have been turned into a modern production process that spits out perfect, identical chairs with no variation.

Most of what has been written about "the art of leadership" is really talking about the craft of leadership. The art of leadership books discuss the skills and steps in a process much in the same way that books on woodworking talk about the skills and steps to make a chair or a table. In contrast, art is about reaching the audience's imagination by engaging their senses and taking them someplace they haven't been before. Barry and Meisiek say that art is fundamentally about departures. For example, when I see Roy Lichtenstein's painting, *Cow Going Abstract*, which has three panels that show a cow on the left, an abstract painting on the right, and a mix of the cow and the abstract painting in the middle, I start to think about the process of abstraction. I imagine how I might abstract other images and I wonder about what is the essence of the cow picture that has been abstracted. When I see a good play I am transported into the world of that play and I imagine all sorts of things about what that world is like and what it means for me to be in that world, if only as an observer. Of course, we cannot imagine art-making or art-audiencing being turned into a modern production process because the variation is an essential aspect of art.

Having made this distinction between craft and art, it is also important to recognize how intertwined they are. Great art has often been made with exquisite craft, and craft in its highest form may be seen as art. Both are creative processes. For example, consider the harp chair designed by Jorgen Hovelskov (see figure 1.1). Is it art, does it offer a departure, does it engage your imagination and take you someplace? This chair was factory-produced, but there is also clearly a high level of craft skill in the design: the delicate sturdiness of the three-legged structure, the curves, and the airiness of the strings. In short, there is a strong aesthetic presence that grabs our senses and engages our imagination that is largely based in the craft skills of chair design. I might add that it is remarkably comfortable to sit in.

Turning to leadership, consider the example of Martin Luther King Jr.'s famous *I Have a Dream* speech. King had incredible craft skills in terms of his ability to craft and perform the speech. And the speech is art in the sense that it created a departure, it activated the imagination, and allowed many listeners to go someplace new. It shows us what may

Figure 1.1 Harp Chair by Hovelskov

be the crux of leadership as art, which is that when the craft of leadership is done at a very high level, it can become an art of leadership. The destination that is the focus of the craft is a departure for its followers. Not all, or even most, leadership craft reaches the level of art, but just because it doesn't reach or even aspire to art doesn't mean that it isn't important and worth mastering. Leadership craft is still a creative process, just as leadership art is a creative process. To understand and practice both leadership craft and leadership art, to understand leadership as a creative process—what, for lack of a better term, I shall refer to as creative leadership—we need to first understand creativity in a more general way.

The Creative Process

There has been a lot of research into, and writing about, creativity and the creative process. The work in this field ranges from first-person accounts to laboratory work to field studies, and covers a wide range of

academic disciplines and popular approaches. Some of the most recent, integrative, and interesting work on the topic has been done by Keith Sawyer.[6] My brief description of the creative process draws heavily upon his work. But before I describe what we know about the creative process, I will start with what the creative process is commonly thought to be but in fact is not.

There is a romantic conception of creativity as a bolt of inspiration that comes to the select few. From out of the blue, the creative person suddenly has a stroke of genius, which the person then executes—the poet writes the poem, the scientist conducts the experiment that will confirm the theory, the painter paints what has already been seen in the mind's eye, the inventor manufactures a working prototype, and so on. Perhaps the best example of this myth of the creative process is the story of how the poet Samuel Taylor Coleridge wrote his classic poem *Kubla Khan*. When the poem was first published, Coleridge included the following account of the poem's origin:

> In the summer of the year 1797, the Author, then in ill health, had retired to a lonely farm-house between Porlock and Linton, on the Exmoor confines of Somerset and Devonshire. In consequence of a slight indisposition, an anodyne had been prescribed, from the effects of which he fell asleep in his chair at the moment that he was reading the following sentence, or words of the same substance, in Purchas's *Pilgrimage*: "Here the Khan Kubla commanded a palace to be built, and a stately garden thereunto. And thus ten miles of fertile ground were inclosed with a wall." The Author continued for about three hours in a profound sleep, at least of the external senses, during which time he has the most vivid confidence that he could not have composed less than from two to three hundred lines; if that indeed can be called composition, in which all the images rose up before him as things, with a parallel production of the correspondent expressions, without any sensation or consciousness of effort. On awakening he appeared to himself to have a distinct recollection of the whole, and taking his pen, ink, and paper, instantly and eagerly wrote down the lines that are here preserved. At this moment he was unfortunately called out by a person on business from Porlock, and detained by him above an hour, and on his return to his room, found, to his no small surprise and mortification, that though he still retained some vague and dim recollection of the general purport of the vision, yet, with the exception of some eight or ten scattered lines

and images, all the rest had passed away like the images on the surface of a stream into which a stone has been cast, but, alas! without the after restoration of the latter![7]

Kubla Khan remains an unfinished fragment, and Coleridge's story of waking up from an opium-induced slumber with the entire poem in his head stands as an apocryphal and oft-repeated example of the romantic conception of the creative process. However, Coleridge's story simply isn't true.[8] We know that the poem went through several drafts over a period of many months. Scholars point to a variety of other works that are clearly influences on the poem. None of this makes it any less a great poem. It does, however, become clear that Coleridge was telling the world a story that he believed the world wanted to hear. The idea of the poet dozing after taking opium and waking up filled with divine inspiration fitted well with the romantic conception of creativity and almost certainly bolstered Coleridge's reputation as a poet and creative genius.

Coleridge's story was a fabrication to fit a myth of creativity that still exists today, but careful research has revealed quite a bit about the creative process and how it actually happens. There are five characteristics of the creative process that I will use to think about leadership. They are: (1) it's a process, (2) there is a creative mind-set, (3) it works best where there is passion, (4) it is collaborative, and (5) it exists within a domain. I will explain briefly what I mean by each of these.

To say that the creative process is a process may seem somewhat redundant, but it is worth stressing that it is not just a flash of inspiration[9] but rather a process that includes a lot of hard work. Thomas Edison had it right when he described genius as "one percent inspiration, and ninety-nine percent perspiration." At the core of the creative process is a discipline that brings together craft skills, intellectual and embodied knowledge, and conscious and unconscious processing in a sustained practice. Within that sustained practice there are many insights and discoveries that are explored, elaborated, and used or discarded. Or, in the words of Piers Ibbotson, "All ideas start off half-baked. In a creative process you look for a hundred of them before you begin to cook any."[10] In short, a writer writes, a scientist theorizes and experiments (does science?), and a painter paints.

Although the particular craft skills and disciplines that are an essential part of the creative process are different in different domains—that is to say, the skills of painting are different from the skills of writing, which are different from the skills of biology,—there are some aspects

of the creative process that are common across disciplines. I call these common aspects the creative mind-set, the essence of which is how the creator pays attention to her own direct sensory experience of the world. Mary Jo Hatch, a painter and organizational scholar, told me once, "The more I paint, the more colors I see." It is this practiced ability to really pay attention to what our own five senses are telling us about the world and make fine, detailed discriminations that is at the core of the creative mind-set.

This process works best when the creators work on something about which they are passionate. The work must matter to the creator for its own sake rather than for the sake of rewards that may come to the creator as a result of creating. That is to say, writers write best when they are writing about stuff that matters deeply to them without any concern about whether such writing will bring them wealth, fame, or a true love's heart. Process is more important than product, the journey more rewarding than the destination. Passion means that I don't write plays simply because I enjoy writing plays or care deeply about the things I write about (although both are true), but rather because I have to write plays—I have no choice.

Perhaps the most counterintuitive characteristic of the creative process is the way in which it is fundamentally collaborative. A part of the romantic myth of creativity is the image of the creator as a lone genius, perhaps locked away in an isolated garret. A more accurate archetype would be as a participant in an improvisational theater game cocreating a scene. Sometimes this collaboration is implicit and can be mediated through books or works of art, but it is always present. In many ways it is as simple as saying that none of us live in isolation from our fellow humans and that creators are influenced by their interactions with others.

The final characteristic is that the creative process occurs within a domain. That is to say, one can be creative in physics, in painting, or in a variety of other domains. However, just because you are creative in one domain doesn't mean that you will be creative in others. What is considered creative within a domain is determined by the experts of that domain; and although the creative mind-set may cross domains, craft skills, knowledge, and discipline tend to be specific to a domain. Domains are defined both by their specific content and by an often-implicit set of rules for that domain.

I will delve into each of these characteristics and how they relate to leadership in more detail in the chapters that follow. But first, with these characteristics in mind, let me offer a model of the creative process. It's

a rather circular model, full of loops rather than straight lines, and there's no clear start or finish, because in my experience of creativity a creative process doesn't really ever start or stop. Nonetheless, we have to start someplace (see figure 1.2).

Let's start with our most basic interaction with the world and the sensory information that our world floods us with. We all see, touch, taste, hear, and smell a constant stream of information. We then select some of that sensory information and tell ourselves little stories about what it all means—we make sense of it.[11] Based on how we are making sense of the information, we pay attention or attend to the stream of new sensory information in a particular way. This process, of selecting data, making sense of it, attending to particular data, and so on, is driven by our passions. In the simplest case, it is based on what we are interested in, but the creative process works better with passion when we care deeply about what we are paying attention to in the world and what we are creating (see figure 1.3).

At some point, we take action based upon how we have made sense of things, and this is where the collaborative part of the creative process kicks in. Our actions affect other people and the environment. The responses of those others and the environment then become new information that becomes part of the stream of sensory information, which we then need to make sense of. Similarly, the interaction with others is at its best when it is most fully explicitly collaborative. This process occurs within a specific domain. All this sounds horribly abstract, so let's look at a simple example of how this creative process plays out in real life.

To keep things relatively simple, I will describe my own process of creating an edge for a flower bed in my yard. The flower bed is between the front of my house and the lawn. When we bought the house there was no sharp edge to the bed, it just sort of ended and the grass began in what was more or less a straight line. My wife, Rosemary, and I agreed that we wanted a more defined edge and that the edge should follow a more organic curve. Just reaching that sort of an agreement was itself

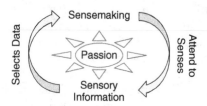

Figure 1.2 The conversation between sensory information and sensemaking

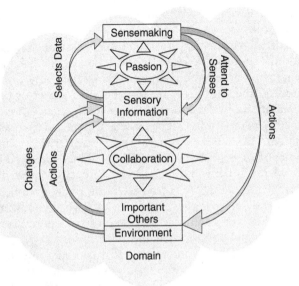

Figure 1.3 The creative process

a complicated and creative process (spread out over a couple of years) on its own, but I'll start from having decided that much.

With our requirement in mind, we made a visit to our local stone yard and looked at what sort of materials they had that might make nice edging material. We walked around the yard paying attention to our senses and observing what various materials looked like, what they felt like, and how they were being used in various displays. At this point, the data I selected were based on the sensemaking I already had about the desired edge. I don't recall what the weather was like or what we were wearing, but I do recall looking at various types of brick, rough-tumbled cobble stones in various sizes, and some manufactured paver products that were being used as edging in some sample patios. I looked at the colors, the weights, the sizes, the texture of the surface, the regularity or lack thereof, and how they fit together. In short, I paid attention to what was important based on my thinking about the edging and I didn't pay attention to countless other things that were happening in the world around me.

As we looked at the materials, we talked about them. That is to say, I took action and commented upon what I was seeing and how I made sense of it. I said things like, "oh, this color is very nice" and "these

granite chunks have a nice smooth edge." Rosemary also made comments like, "these would go well with the edging in the back yard" and "I'm a little creeped out by having someone's name on the edging." (The smooth granite pieces were from headstones that had broken during the engraving process and many of them did include parts of names of the dead on them.) This is the collaborative aspect of the creative process, and my comments were actions that Rosemary attended to and her comments were actions that become sensory data I then selected and made sense of. As we talked, it became clear that brick was not appealing to either of us, so, based on that sensemaking, I stopped looking at different types of brick and stopped selecting data about brick from the world I was in. As we talked, I paid attention to the granite stones and how big they were, how they would fit in with the existing edging, how regular they were, and how they might fit together. Eventually we made a decision and bought a truckload of edging stone.

We took the stone home and the next day laid out some rough curves demarcating where the edge of the bed should be. This was a process of setting the stones out in a curved line and then looking at the edge and talking about it: "maybe out a little more here," "I think it's too straight there," and so on. Then, making adjustments again, moving the stones around, talking some more, and making more adjustments until we were happy with the edge. During this process, we were selecting data about how the curve looked in relation to the house, the yard, and the existing plants in the bed, and making sense of the whole of it in an intuitive and *felt* way. We would act by talking and adjusting and then consciously making sense of it again, and based on that sensemaking (it's too straight here), make further adjustments. After several iterations of the process we were ready to move on to the next step, setting the stones into the dirt.

The process of setting the stones into the dirt is very much the same as the previous activities of selecting the stone and determining where the edge should be in terms of selecting data, making sense of it, acting and attending to particular data based on that sensemaking. However, the craft skills involved and what data I attend to in this process is different. What was fundamentally a problem in two dimensions has become a problem in three dimensions as I now have to work with the many ways in which my yard is not level. Where before I was looking at the big picture of the curving edge, I am now more focused on how each stone fits with the one before it, how deep the hole needs to be, and making sure the stone rests securely in the hole without wobbling. Every few stones, I step back and look at the curves of the edge I am making, and sometimes I pull a stone out and reset it in a slightly different position.

I also think about pragmatic issues such as how high the edge should be and how that will affect drainage in a rain storm. There are also periodic conversations with Rosemary as we step back and talk about how the edge is going. The final edge is similar to the one we laid out in the previous stage, but it doesn't follow the same path exactly.

Luckily there weren't any external environmental changes during the course of the process—no earthquakes that might have changed the physical characteristics of the yard, and no changes in job status that might have changed how we felt about the house and what we wanted to do with it. This may be typical of craft processes, but it is unusual for leadership processes, which often take place within the context of a changing environment.

Creating an edge for the flower bed took place within the domain of home gardening. That domain has a strong local influence, as part of our thinking about what the edge should look like is influenced by other yards on our street and in our neighborhood. We live in New England and there are stone walls everywhere, including a couple in our backyard, which certainly was a significant influence on our choice of stone as a material. Our knowledge of the domain is not purely local, because it is also influenced by the plethora of home gardening design shows on cable television and our tendency to watch them from time to time, as well as the subscription to the magazine *Garden Design* that my mother gave me and our visits to various famous gardens while we lived in the United Kingdom—which probably also says something about our level of passion for garden design.

In the next several chapters I draw upon this conception of the creative process to talk about the nature of craft and art and apply insights from these areas to leadership. My contention is that leadership is a creative process that requires craft skills in much the same way that creating the edge for my flower bed is a creative process and required specific craft skills. When done with sufficient skill and aesthetic quality, it can be considered an art.

In Part I, I develop this conceptual position—this theory of leadership if you will—according to the characteristics of the creative process: that it is a process that starts with a creative mind-set, is driven by passion, is fundamentally collaborative, and occurs within a domain. I discuss each characteristic in more detail and offer illustrations from my own practice as an artist and then suggest the implications for both a craft of leadership and an art of leadership. In Part II I turn to the practice of creative leadership, as a craft and as an art.

PART I

Theory

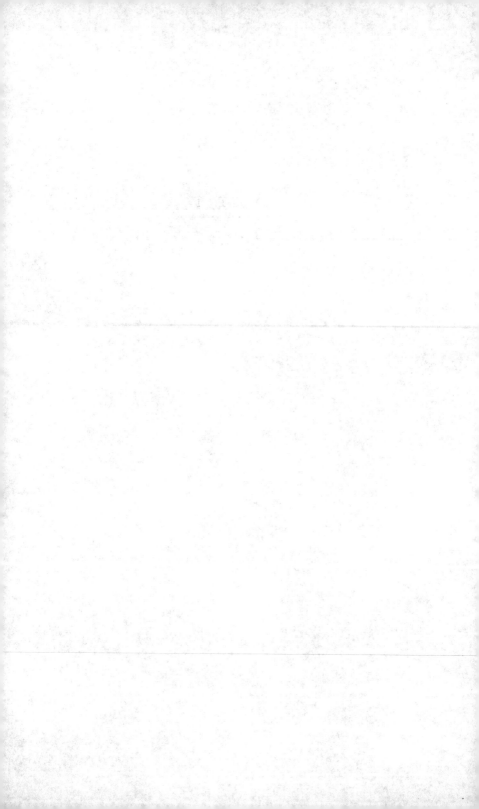

CHAPTER TWO

Focus on the Process

Imagine that you have just been promoted to be the director of consulting services at the small software company where you have been working as a client manager for the past couple of years. It is a newly created position, and the four client managers, your former peers, will report to you. What sort of leader should you be? Should you be participative as you recognize that things aren't very different from last week when you were one of five client managers and you suspect that most of your time will be spent continuing to mange the client relationships you are personally responsible for? Or should you be authoritarian to establish yourself as being in charge? Or should you try to be charismatic or authentic or transformative? Should you focus on crafting a strong vision for the newly formed consulting services group? In short, what will it mean on a moment-by-moment basis for you to be the leader? What will you do as a leader, or in other words, what should the (creative) process of leading look like for you?

Let's start by delving into what the creative process looks and feels like. The creative process has been described in various ways, but there is general agreement that it generically follows five stages:[1] (1) preparation, (2) time-off (or incubation), (3) the spark, (4) selection, and (5) elaboration.[2] Although that sounds like a nice linear progression, it is generally acknowledged to be more of a repeating pattern in an ongoing spiral, with elaboration feeding into the next round of preparation. Although this set of stages is useful for thinking analytically about the creative process, it doesn't really capture the essence of creativity as a practice and in some ways misleads us into thinking that the creative process can be understood and perhaps learned as a series of distinct stages that

consist of different tasks. Nonetheless, with those caveats in mind, I will explore the stages in more detail in an effort to offer some insight into the different happenings within the creative process.

The preparation stage can be thought of in a couple of different ways. In one sense, it includes everything you've ever done in your life that might somehow come into play in the creative process—all of the years spent learning about the domain in which the creative process is happening and all of those seemingly unrelated experiences that may somehow provide some insight or inspiration during the process. It has a huge impact on how we make sense of things, which I shall discuss in more detail in the next chapter. In a more focused sense, the preparation is a period of working on the issue, trying to understand it, and talking to others about it until you "grok" it (or at least feel like you get what you are trying to do). I'm going to resist saying that preparation has a rough correspondence to problem formulation, because problems are often formulated without having achieved much understanding and because the very process of problem formulation can be a complete creative process in itself. That is to say, the preparation stage of a creative problem-formulation process can mean working hard and talking to others about how to formulate the problem (which could be described as formulating the problem of problem formulation—which just goes to show the problems with trying to pretend that this language is in any way precise). This fractal nature of the creative process, in which each stage, when looked at closely, looks like a multistaged creative process unto itself, is one of the reasons that approaching the creative process in terms of stages is difficult to translate into action.

Following the preparation stage is time-off, which is sometimes referred to as incubation. In its simplest form, this means changing the context, ceasing to focus on the problem or issue at hand, and doing something else for a while. It's that part of the process where you "sleep on it," even if you don't actually sleep on it (although you can actually sleep on it). This part is often explained as kicking the problem back into the back of your brain and letting your subconscious work on it. We don't really know if your subconscious works on it or whether not focusing on the problem allows you to think of and otherwise come into contact with other ideas about the issue, or whether both are true or neither are true. We do know that some time off is consistently part of the creative process. And we have all had the experience of suddenly getting a creative spark after some time off, whether that is while taking a shower first thing in the morning after a good night's sleep, during a dream, or having the answer suddenly coming to us

just after we stop working on the problem. You might think of time off as a brief vacation from working on the issue, which allows you to come back refreshed and inspired. Although we might intuitively think that leaders generally don't have the time to have time off in their process, Howard Gardner's research[3] shows that leaders tend to have cycles of intense activity alternating with periods of relative isolation and reflection.

At some point during the time off, there is a spark or flash of insight that offers a way forward with the issue. The spark may come from something someone else said—we've all heard someone say something and then said to ourselves, "hey, that gives me an idea," or said something that sparked another's creativity. Sometimes we are aware of what incited the spark and sometimes we are not. Sometimes we can articulate how the inciting event relates to the issue we're working on and sometimes we cannot. The spark may be a huge flash of insight that unlocks everything, but more often it is a small flash of insight that builds on the hard work of preparation and allows the process to proceed ahead into selection and elaboration that then starts a new cycle of preparation, time-off, and spark. The spark may even be so small as to not be noticed. There may also be more than one spark. And although it may sound as if the spark comes out of the blue, it is always connected to the work and relationships in the preparation and time-off stages. The myth of the romantic genius essentially consists of putting all of our focus on the spark, as does much of the industry around making business people more creative. There seems to be a belief that business is not creative because there aren't enough creative ideas and enough good sparks. But the spark is only one stage of the creative process, and often a relatively small part of the overall creative process at that.

The next stage consists of selecting a spark. This may sound like a trivial stage, but there may be several sparks to choose from, and in order to select a spark you first have to recognize it as being a spark worth pursuing. We've all had that "aha" feeling when we get a creative idea, but that doesn't mean it's a spark worth selecting, nor does it mean that it isn't. The only way of really knowing is to try it, keep it if it works, and discard it if it doesn't. An overly critical judgment of potential sparks can stifle and shut down your creative process. A completely open and noncritical judgment can result in huge amounts of time and effort wasted. We know that with experience the ability to pick good sparks and the quality of judgment seem to increase. This is guided by intuition and gut feeling. I can't tell you why I pick one idea rather than another when I write plays,[4] other than the rather

unhelpful, "it felt right." To go a little deeper than that, I choose sparks that have life, that I don't know where they lead, and that perhaps scare me a little bit and certainly intrigue me more than a little bit. This is a far cry from how business schools teach people to make choices. It is not about data-driven, rational analysis or minimizing risk. Perhaps most importantly, I know that no single spark is that critical—it feels to me that there is a constant stream of sparks, and if one doesn't work there will be another (and another and another) coming along after that one. This sense of a constant stream of sparks is something that most artists I talk to have, and it is in many ways one of the key differences between those artists and people who feel they aren't creative. For the artists, it is a question of not being able to act on all of the ideas or impulses they have, while the "noncreative" folks seem to be looking for sparks. I have come to believe that the difference has to do with what artists call "being open to the work" and recognizing the sparks, but more on that in chapter 3.

Having selected a spark, the next stage is elaboration—the crafting and doing part of the process. In modern times we seem to value the elaboration less than the spark. Andy Warhol was known for having the idea for a work of art and then having one of his assistants carry out the actual making of the piece. The same was true for Michelangelo. But for the application of the creative process to leadership, this stage is the most important. As in many artistic processes, the devil is in the details, and the moment-by-moment micro-choices that are characteristic of the elaboration stage make all the difference. It is in this elaboration stage that we see the craft skills of the artist. The elaboration of the spark allows us to judge the spark—did it work, does it address the issue? The elaboration stage also often raises new issues and sets off another iteration of the creative process.

Looking at the creative process in terms of these five stages helps us move away from the romantic notion of creativity as an act of divine inspiration and focus on the hard work of creativity as a process. Of course, each creative process will differ in the relative duration and significance of each stage. We could also think of the creative process as having a fractal-like quality where each stage can be zoomed in upon and seen to have all five stages within that process—what we see as each stage depends upon the level of detail with which we are concerned. That is to say, when we look at an actual creative process, we don't see five separate stages, instead we see a practice. We may be able to force the five stages onto that practice and gain some analytic insight into the practice by doing so, but it will feel like an awkward fit. To

illustrate this, I now turn to an example of my own creative process, namely, drawing a self-portrait.

Drawing Myself

In January of 2009, I took a class to learn how to draw.[5] I didn't have an active practice of drawing regularly before attending the class, nor did I expect to suddenly start drawing regularly after taking the class. I was interested in the idea that the course could enhance my creativity in a general sense. On the first morning of the class, we were given drawing supplies that included a mirror. Our teacher set up the mirrors so each student could sit and see his or her own reflection. We were then asked to draw a self-portrait. This nicely served the purpose of providing a "before instruction" example of our talents. It also provided an opportunity to go through our own creative process.

It took me about ten minutes to draw my self-portrait (see figure 2.1). I started by looking into the mirror and thinking about how I wanted

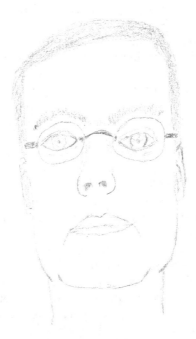

Figure 2.1 Initial self-portrait

to look (smiling, serious, laughing) and how the picture would be composed. I then drew a rough outline of my head and drew my eyes, mouth, and so on. I saved the nose for last because I felt very unsure as to how to capture it. At each stage I would look carefully in the mirror and then try to draw what I saw. I went back and added detail to the hair. I don't think I did any erasing. I made a choice to not include the multiple chins that I could see in the mirror, because I didn't want to think of myself as having them; besides, I convinced myself that it was surely an artifact of how I was holding my head to look into the mirror. When we all had finished, I thought that it might not be the worst self-portrait in the group, but it would probably be on the short list for the worst.[6]

This drawing is analogous to much of the leadership we see in the business world today. The drawing is done by an amateur with little or no training, but perhaps a little bit of natural ability. It isn't a completely horrible drawing, and if you held it up next to a photograph of me you would probably be willing to admit that it does sort of look like me. But it is not a great drawing and shows a lack of craft skills. Many leaders manage to lead in the same way that I managed to draw this picture—the leadership works in its own way, but it clearly is somewhat amateurish and lacks mastery of the craft of leadership, let alone anything approaching artistry.

We spent the next four and a half days learning how to draw. We learned some theory on left brain versus right brain and looked at some drawings by masters of the art, but mostly we spent the time doing drawing exercises designed to teach us the perception of (1) contours and edges, (2) negative space, (3) perspective and proportion, (4) light and shadow, and (5) the gestalt.[7] The concept guiding the class was that our lack of drawing skills was not a lack of physical skills, but rather a problem with how we perceived, or, more to the point, failed to perceive, the world. All of the drawing exercises were designed to give us ways that allowed (or perhaps even forced) us to look at and perceive what we were actually seeing, rather than seeing some shorthand idea that we had of what we were seeing. (This is a critical aspect of the creative process and is addressed in a more general sense in chapter 3 on the creative mind-set.) I particularly liked using a "ground" in the drawing (which means starting from a shaded area so that you can go darker by drawing or lighter by erasing) and the technical skills of measuring the proportion you see with your pencil (held at arms length) and then transferring that proportion to the drawing.

In terms of my aesthetic sensibilities, I became fascinated with light and shadow over the course of the week, which you can see in the

self-portrait that I did at the end of the week (see figure 2.2). This fascination with light is a defining aspect of my drawing style (to the degree that I have a drawing style). To go back to the questions at the start of the chapter, participative or autocratic leadership is a question of style. In order to express a style, in either drawing or leadership, you need a level of craft skill—a basic practice of drawing or leading.

The second self-portrait took me about three hours to draw. I suggest that the primary difference between the creative process that produced the first self-portrait and the one that produced the second was a vastly increased level of craft skill on my part. The difference was in my practice of drawing.

Rather than just looking in the mirror and then trying to draw an eye where I think I see an eye, with the shape that I think I see (which turns out to be based more in my mental symbol for an eye), I would carefully measure the distance from the top of the eye to the bottom of the eye in terms of other elements of the drawing. I started with one lens of my glasses and then based other elements on that—the bottom of the nose was one lens-width below the bottom of the glasses, and so

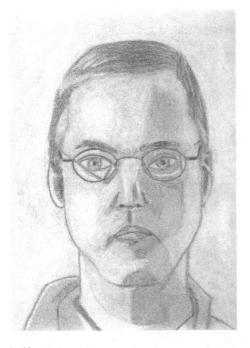

Figure 2.2 Second self-portrait

on. I carefully drew the dark shapes I saw in my ear rather than trying to draw an ear. The result of this careful measurement of proportions is that in the second self-portrait the face is in a much more correct proportion to the head than in the first self-portrait. In the first self-portrait the eyes are almost two-thirds of the way up the head, and in the second the eyes are about halfway up the head, which is much closer to the actual proportion. In the first self-portrait the temple pieces of my glasses seem to be perfectly horizontal (which is how I imagined they ought to be), in the second self-portrait the temple pieces seem to be tilted higher above my ears, which is in fact how I actually wear my glasses. While drawing the first self-portrait I did no erasing. In the second self-portrait there is hardly a line that was not drawn, checked and found to be off in some fashion, erased, and then drawn again.

One of the more interesting differences in the process is that in the first self-portrait I worked from the gestalt to the detail, drawing the outline of my head first, then adding the details in gross form, and then adding more and more finer details. In the second self-portrait I worked from the detail to the gestalt. I worked on the details of the edges of what I saw while I anxiously waited for the gestalt to appear— and at some point (I can't tell you when) it did. In the first instance I was focused on the final product and wanted to produce it and then refine it to improve it. In the second process I was focused on the process. I drew what I saw, checked to make sure that it really was what I saw, and waited to see what came out of the process. The second process was by no means perfect (for example, the mouth is not wide enough), but I think you'll agree that it produced a much better self-portrait than the first process. I also find it interesting that in terms of composition the two drawings are very similar. That is to say, in terms of leading, the vision I had was pretty much the same, the difference is in the practice. The second self-portrait has a much higher level of craft skill and captures more nuance and subtlety. It has enough technique to be able to have a style. As a leader, you need this sort of basic level of craft skill to be able to make a choice about your leadership style.

Within the visual vernacular of the self-portrait there were several compositional and other choices that I could have made. To give you an idea of some of those choices, look at a third self-portrait (see figure 2.3) that I drew a couple of weeks later. In this third self-portrait, I chose to draw myself laughing. I also chose to push even farther into exploring the light and shadow, choosing a much harsher lighting that gave stronger shadows, which I also emphasized in the drawing. As I emphasized the light and shadows, I used less detail

Figure 2.3 Third self-portrait

in the other aspects of the drawing. I moved past the vanity of not wanting to draw multiple chins that I had in the first self-portrait. I still chose to draw myself head-on rather than three-quarters or in profile. These different choices were by and large not well-thought-out conscious choices that I made before starting the portrait, but rather the cumulative expression of many small micro-choices made throughout the process as I looked, drew, looked again, erased, drew again, and so on.

The primary point that I want to show with this description of my drawing is how the creative process is a practice and that hard work and craft skills play a large role in that practice. It is not fundamentally about a brilliant creative insight. When I talk to artists about creativity and raise the question that is often asked by business people about how to be more creative, I usually get a blank stare. The artists don't know what I mean by being more creative. The Swedish artist Mikael Scherdin told me that being more creative wasn't the problem, his problem was about being less creative. He had too many ideas, too many things he would like to do, and not enough time to do it. He

went on to say that for him it was all about the process, and that any "artworks" that were produced were simply a by-product of the process and not really important. It's nice when the world likes what you've done and rewards you for it, but that's not why you do it and that's certainly not the point of doing art. Other artists I have spoken with have also expressed bewilderment about the idea of being more creative or teaching business people to be creative. They often just don't get what it means, saying that they just do their art and they don't really understand what I mean by being creative. When I draw I don't have any sense of creativity as being about new ideas and/or inspirational sparks of genius—I just draw. When I write, I don't have any sense of being creative in any way that is special or different from other things I do, I just have a sense of the hard work of writing, word after word. I do have a sense of drawing upon my whole self and of using every craft skill and aspect of the discipline that I have. It is this sense that I want to explore as it relates to leadership.

Lessons for Leadership

There are two aspects of this understanding of the creative process that I want to explore further with respect to leadership. The first is the idea of discipline and technique. The primary difference between my process for drawing the first self-portrait and the other two was the application of a discipline for drawing—the use of the craft skills and technique that I had spent the week learning. The second aspect of the creative process was the focus on the process (as opposed to the end result). Both of these aspects tell us something about the creative process of leadership.

I can describe the craft skills of drawing and can work to get better at them. For example, I can work on cross-hatching to create different degrees of darknesses for shading. I can practice transferring scales between what I see and what I'm drawing. I can learn how to hold my pencil to use it to measure relative angles. This begs the questions: What are the craft skills of leadership? What are the techniques of leadership? We have a wealth of answers to these questions in the vast writings on the subject; and there are a variety of particular answers in the leadership competency models that have dominated so much of the leadership development world in recent times.

There are many different competency models, but as an example let's look at the one that is used by Leadership Development at the Banff

Centre.[8] This model includes twenty-four different competencies, which are grouped into six dimensions:

- Self-mastery (self-consciousness, self-development, self-discipline, self-authorization),
- Futuring (foresight, strategic action, out/in communication, intention),
- Sense Making (integrative thinking, disciplined inquiry, in/out communication, pattern recognition),
- Design of Intelligent Action (perspective, sensibility, stabilizing and destabilizing strategies, commitment),
- Aligning People to Action (creating capacity, engaging others, understanding others, attracting resources),
- Adaptive Learning (reflexive learning, creating generative space, recognizing challenges, leveraging forward knowledge).

The competency model comes from the Banff staff's reading of the literature and their work with leaders, and in my opinion it is an excellent attempt to describe the craft skills of leadership. Other competency models would be organized differently, name competencies differently, include some things that this model does not, and exclude things that this one has included. But, overall, there would be considerable overlap.

There are two points that I'd like to make about this competency model. The first is that it shows us something of just how complex leadership is and reminds us that there has been a lot of work done around how we understand and enact leadership. In thinking about the craft and art of leadership, it would be a mistake to throw out all of this previous work. It is important to recognize that we know a lot about leadership and the craft skills that are used to enact leadership. Books have been written about each and every one of the competencies in the model. A lifetime of practice could be devoted to developing and perfecting each and every skill. Leadership is a complex and difficult craft. Luckily for us, humans are adept at enacting complex and difficult crafts.

As we think about skills, it is important to think about skill levels. Piers Ibbotson[9] makes the following point about the difference between amateur and professional artists and their relative mastery of skills:

> There is a large difference between the amateur who does it sometimes for love, and the professional who has to do it continuously

for money. And the difference may not be a difference of original-
ity or insight but a difference of mastery. The professional, by dint
of sheer extra hours of practice, can do things with the medium
that the amateur can't, and so they are able to express things more
strikingly, more subtly, more beautifully and more truthfully than
the amateur.

This is certainly as true for leadership as it is for any other art. The
professional leader develops his or her skills through constant use.
I suspect that many (if not most) managers in organizations are ama-
teur leaders, sometimes leading because they have to (not for the love
of it, as in the case of the amateur artist), but generally engaged in the
other aspects of their job as managers. I am an amateur artist, and the
small level of skill I gained in the weeklong class greatly improved my
drawings. But the drawings are by no means masterworks or profes-
sional in any sense.

The second point that I want to make about the competency model
is that it is framed within an individualistic approach to leadership. The
skills are all skills of an individual leader in the same way that creativ-
ity is thought of as belonging to an individual (and often in some way
heroic) genius. There are a variety of conceptions of leadership that try
and move away from this individualistic approach,[10] but because the
multibillion-dollar business of leadership development is really about
leader development, person-centered approaches to leadership drive the
work. If we start to think about creative leadership and really embrace
the collaborative aspects (chapter 5), there is a need to focus on the
skills of the group and the way people work together—that is to say
that the spaces and relationships between people become as important
as, or even more important than, the skills of the individuals. Creative
leadership includes group skills as well as individual skills. One of the
meta-skills for both the group and individuals is the second aspect of
a process approach to creativity that I want to explore, which is a focus
on the process, a focus on the skills for their own sake rather than with
an eye toward the end result.

Focusing on the process rather than the outcome is a profound and
difficult shift in approach. When I direct a play for the stage, I take
the cast through a rehearsal process that explores the play in a variety
of ways. I may have ideas about what I think the final performance
will look like, but I am usually wrong. Over the years, I have come to
trust in the process and believe that if we have a good process the end
result will be good. This is seemingly in stark contrast to the popular

conception of the leader as having a strong vision of the future—the outcome. The creative leader has a strong vision of the process and ideally no attachment to the outcome. The modern, sensegiving[11] leader says, "this is where we're headed." The creative leader says, "why bother taking the journey if you know where you'll end up?" Most of us like the confidence and certainty of knowing where we're going. It requires a completely different sort of faith and a very radical shift of mind to have faith in the process and enjoy the excitement of the journey to the undiscovered country. As people talk about a need for transformation and ideas of transformational leadership, I say that it's not transformation if you know where you're going to end up—it's just another change.

A focus on the process pulls you into the present—the eternal now. The creative leader's attention is on what is happening in the moment rather than thinking about the past or future. The skills are exercised not with a sense of what sort of results they will bring, but rather with an eye toward doing them for their own sake. For example, communication is not about letting others know what is going on so they can contribute to some collective vision, or even to give them a sense of confidence that everything will turn out all right because you really know what you're doing (even though it may serve both of those purposes), but rather because communication is an important part of the process and I want to do it as best I can. Creative leaders want to pay attention to skills because they believe that the process is enacted through the skills: the better the skills, better the process; and the better the process, better the outcomes—it all flows from the skills. That's not to say that the outcome isn't important, or that the big picture doesn't matter. Being able to perceive the gestalt is one of the five skills of *Drawing on the Right Side of the Brain*. As I draw a line that defines a space, I'm trying to draw that line as truthfully as I can, but I am also aware of how that line relates to the gestalt of the drawing.

This focus on the skills in the present moment is the essence of a discipline. It is the essence of craft, and of practice. There is a repetition of skills that require attention and are never quite exactly the same. This involves the hours spent weaving a rug or throwing a pot. It doesn't have much to do with the romantic conception of creative genius and divine inspiration, but it captures a critical aspect of the creative process. Creative leadership is also a craft, a discipline, a practice with repetitive skills that require being in the moment. Artists often speak of being lost in the moment. When I draw, I'm not aware of the time passing—although the soreness in my body when I stop is a reminder

of how many hours I have spent in one position. There is no cutting corners, no shortcuts, there is only the discipline, the craft, the skills.

By bringing these two aspects of the creative process together—discipline and focus on the process—we get an idea of creative leadership as a craft, as a discipline of using craft skills in the moment. It is a craft in the way that woodworking, pottery, and acting are all crafts. Like all crafts, there are many schools of practice for each craft, and although we can see differences in the schools, we don't claim that one is inherently better than another. As an example, consider the craft of acting. There are some actors who have had no training and are in some way natural actors, who have developed their skills in their own idiosyncratic way. Most American actors are trained in a way that is descended in some fashion from Method acting,[12] which is often described as working from the inside out. This means that the actor works on developing the proper psychological state and inner feelings and lets them manifest in their outward appearance and behaviors. In contrast to this, most European actors work from the outside in,[13] focusing on the outward appearances and behaviors and letting the inner state come from that. All three approaches work, but the craft skills are different in each case.

As an example of what it would mean to approach leadership as a craft discipline, consider Action Inquiry.[14] There is a well-developed theoretical basis for Action Inquiry as there is for many approaches to leadership, but there is also a set of craft skills to be practiced in the moment. One of the core craft skills of Action Inquiry is balancing advocacy, inquiry, framing, and illustration as you communicate with others. It is a typical craft skill in that it is always slightly different in every situation, yet the basic idea is the same. You can always do it better, but with practice you can usually do it well enough. At its best, the practice of balancing advocacy, inquiry, framing, and illustration produces moments of pure beauty—academy award winning moments of leadership. At its worst, it produces clunky, artless conversations—B movies, flops, razzie award winners—that may nonetheless produce the desired results. Here is an account of an attempt at balancing advocacy, inquiry, framing, and illustration:[15]

> Each coordinator directs a given consulting specialty. I had to constantly be aware of how to frame questions, which areas to hone in on, which to tactfully sidestep. For instance, on several occasions, I drew a chart with "market growth" and "market penetration" on the two axes (the old star/dog/cash cow diagram). While talking with the coordinator of a health care team, I marked his team in

the star category, and a defined benefit team in the dog category. Should the leaders of these two teams have the same set of responsibilities? Perhaps the health care coordinator should let expenses rise to permit getting more revenue, while the defined benefit coordinator should work on cutting costs to increase profit.

In any event, the chart proved to be a perfect arena for using my framing/advocating/illustrating/inquiring skills. You can't just tell a senior manager and expert who's been in the business 25 years that he should change his behavior. But the components of action inquiry verbal behavior came right out of me. "Let's talk about revenues and expenses for the next few minutes (framing). I don't think that two separate team coordinators should necessarily share the same focus regarding profit generation (advocating). Look here on this chart. See how the pension team is at the opposite end of the spectrum; from the health care team (illustrating)? Would you have them focus on the same issues (inquiring)?" It was an opportunity to increase the team coordinator's awareness.

Going back to the scenario at the start of this chapter where you are promoted to be the director of consulting services, we can see that the question of what kind of leader to be is the wrong question. The question should be: how should I practice leadership, and on what sort of craft skills should I be focused on a moment-by-moment basis? If I choose to practice the Action Inquiry school of leadership, one of those craft skills will be balancing framing, advocating, inquiring, and illustrating. In the example above, we see that the author is focused on the skill, not on trying to be participative or authentic or on some other style of leadership. The author has definite overall intentions, but the focus is on the process, on the discipline of practicing Action Inquiry. Action Inquiry is certainly not the only leadership discipline that could have been successfully employed here; but it does show us something of what it means to practice leadership as a discipline that focuses on the process of enacting the craft skills of that discipline.

It is important to note that the practice of Action Inquiry and the craft skill of balancing framing, advocating, illustrating, and inquiring is based in a specific idea of what leadership is. It is based in an idea that leadership is based in mutually working together, which means that the leader must be open to influence and actively want to engage with others, hearing what they think and allowing what others think and feel to influence their own understanding. If it were based in an idea of leadership that was about defining a vision and then imposing that

vision on others, the craft skills would be more about persuasive communication than about mutual understanding. I chose Action Inquiry as an example because it does have well-defined craft skills and because those craft skills echo the creative mind-set in the way they encourage leaders to engage in an ongoing interplay between what they are thinking and what is happening around them. In the next chapter I turn to the creative mind-set in more depth.

Exercises

To develop your ability to focus on process, try the following exercises:

- Track your own creative process. Pick an activity that you enjoy and is creative. For example, you may have an artistic process, such as writing poetry or songs, sculpting, painting, or dance. You may have a creative endeavor in your home life, such as cooking, gardening, or home decorating. You may have a creative endeavor in your professional life, such as writing computer code, crafting strategy, or designing processes. Whatever the process is, take notes on what you did, when you did it, what was going on around you, how you felt while doing it, and what the results were each time you engaged in the process. From the notes, answer these questions: What does my process look like (what is the process of my process)? What helps/nurtures/encourages my creative process? What inhibits my creative process?
- Learn a new skill. Take a lesson in how to do something new, such as woodworking, sewing, painting, welding, or playing a musical instrument. Pay attention to the embodied, craft skill that is required and what it feels like to learn the new skill. Practice the new skill focusing on improving the skill rather than the outcomes.
- Teach someone a skill at which you are good. This can be any skill, whether it is something simple, such as tying your shoe, or something more complex, such as making a dovetailed wooden box or baking a croissant from scratch. Notice how you go about teaching the skill, and what works and what doesn't work. Pay attention to all of the subconscious aspects of the skill that you normally take for granted and that your pupil doesn't.

CHAPTER THREE

Creative Mind-Set

The focus on the craft skills of the discipline rather than a focus on any particular outcome from it is one way that the creative process is different from the approaches we teach in business schools. In this chapter I lay out the critical difference between the creative mind-set and how we teach people to think in business schools. At its heart is the question: "As a leader how will you approach the world, how will you understand what is happening and make choices of how to act?" For example, let's suppose you are the president and founder of a small software consulting services company. You have been successfully providing programming services based on interfacing with the Windows operating system in a way that your customers find useful but technically difficult. However, Microsoft has recognized the customer need that you are filling, and in the next release of Windows the interface will become part of the operating system. Your niche will thus be eliminated. You have twenty-five programmers on staff and need a new strategic direction as you anticipate all of your current business drying up within six months. What do you do? How do you decide what strategic direction to pursue?[1]

How you decide what to do will depend largely upon your mind-set. Mind-set is probably not the right word because that implies a way of thinking that is somehow separate from the body, and at its heart the creative mind-set is very embodied, very connected to the whole person through the senses. But rather than use a more nebulous word like "approach," I use mind-set because it captures the idea that somehow creative people are different from other people in how they see and interact with the world. Although there may be some truth to that, it

is not something that the rest of us can't do; in fact, I suggest that the creative mind-set is our birthright as humans (and is our single biggest evolutionary advantage).

We humans live in a very complex world, and regardless of what popular culture tells us, we always have lived thus. By world, I mean the physical, the natural, and the social worlds that we inhabit. It is complex in the sense that there are a huge number of different things that behave differently and interact with other things in a variety of ways. Some of those things are other people, some are trees, some are insects, and so on. In order to live in this world, we need to make sense of it in some way. As humans we tend to understand our world through story—that is, we create a story that allows us to understand our world.[2] Our ancestor's saw footprints in the dirt and told themselves a story about the prey they were hunting, which was helpful in following that prey and securing food (see figure 1.2 The conversation between sensory information and sensemaking).

This tendency to make sense of our world runs deep and is generally expressed in one of two ways. The first, and by far the more common, is captured in the phrase, "everything happens for a reason." This expresses a deep belief in causality and intent, or, in narrative terms, that there is a plot and an overarching theme—that is to say that our life is not a series of random events, but rather it makes sense and has some larger meaning. The second approach is to reverse the order of the causality and say that we make up a reason for everything that happens.[3] Regardless of whether you believe the reason comes before the events or after the events, the key point is the very strong tendency to associate a reason with events, which is a core aspect of how we deal with the complex world we inhabit.

In terms of the model of the creative process I presented in chapter 1, we are talking about the conversation between sensory information and sensemaking. To explore this further, I start with a discussion of our tendency to make sense of the world based on our personal experience. I then move on to the business school solution of the difficulties with that approach, which is to make sense of the world based upon rational analysis. Finally, I discuss the approach to the conversation between sensory information and sensemaking that is characteristic of the creative process. Of course, in most situations we use some combination of the three ways and they really aren't completely separate, but nonetheless it is useful to look at them as three distinct ways of dealing with our complex world in order to understand the creative mind-set, or how it is that creative people think differently than most people.

Personal Experience–Based Understanding

When we make sense of complexity based on our experience, we take in a situation and quickly look for a situation from our personal history that is similar, and then we assume that the current situation is like the historical situation. In short, we do a quick bit of pattern matching, which is the essence of expertise.[4] This is an excellent strategy for making sense of the world if we can reasonably expect situations we encounter to be like past situations we have encountered and if the patterns we have in our heads of those past situations are good. But those are two rather large "ifs." As an example of how this works in practice, take the example of a young teenager who falls in love with the boy of her dreams. The boy cheats on her with another girl and breaks our teenager's heart. She learns from this situation that boys are not trustworthy, and in her next relationship she does her pattern matching and looks for evidence that her new boyfriend is untrustworthy and is cheating on her. She sees him talking to another girl and flies into a jealous rage, taking out all of her anger from the first betrayal on the new boyfriend. In short, when we make sense of the world based on our experience, we tend to project our own past unresolved issues onto the world, like the angry teenage girl does in my example.

As president of the software consulting services company, history has taught you that if you learn how to do one thing really well and then do that one thing well for a customer, other customers will start contacting you, and you'll have to hire more and more programmers as your business grows. Thus you have never needed to have a sales and/ or marketing staff—except maybe one guy who answers the phone, handles the legal stuff, and schmooze's potential clients, and you call him a salesman—and you've thereby come to believe that sales and marketing are for the weak and technically less savvy. Experience has taught you that if you build a better mousetrap, the world will beat a path to your door. Based on that experience, you decide to focus your resources on finding a better mousetrap to build, so, as your contracts end and no new ones appear, you have your programmers look for cool technology that they can master. When the new version of Windows comes out, your revenue completely dries up, so you fire your "salesman." A few months later you go out of business.

Add to this tendency to project our own "stuff" on the world the twin facts that the social world is inherently ambiguous, with the reasons behind events never being simple or clear and the human tendency to look for and pay attention to information and interpretations that

confirm our own sensemaking, and we have a recipe for disaster, or at the very least an infinite number of bad situation-comedy plots. In our example of the teenager above, her new boyfriend may be innocently talking to the girl next door—a lifelong friend—with the hopes of getting some advice on what sort of gift he might get for the teenager to impress her, because he likes her so much. But the teenager only pays attention to the fact that they are talking, and based on her personal experience she has decided that the new boyfriend must be cheating on her—it is the only reason she considers, and she very quickly is convinced it is true because it confirms her theory that all boys are untrustworthy. I am quite convinced that at least some teenage boys are trustworthy and that our teenager's theory is wrong (as general theories based on a single event often are). But she is not convinced, and for her the theory is not open to testing and probably not even part of her conscious awareness—this entire process happens instantly and outside of her conscious awareness. The result is that making sense of complexity based on our personal history is often error-filled, self-sealing, and problematic.

In the example of our teenager, the present situation differed from the past in an important way (the boy was not a cheating bastard), so the sensemaking pattern or story that the teenager applied wasn't appropriate. Even when the present is like the past, there can be problems with the sensemaking stories we tell ourselves. Our tendency is to quickly apply the story (our own mental map) of the situation and then stop paying attention to the evidence of our own senses. We figure out what is happening and then stop listening and seeing—we stop the conversation between sensory data and sensemaking. For example, look back at the first self-portrait in chapter 2. The face takes up the majority of the head and the eyes are about a third of the way from the top of the head rather than halfway down the head (which is where they turn out to be when I measure my head). I put the eyes there because in my experience the face is much more important than the forehead and I unconsciously equate importance with size. I have learned to pay attention to the face because that is where most of the important information I get from other humans comes from. I can see how they are feeling from their eyes and their mouth, I can tell if they are angry or amused by looking at their face—I learn almost nothing from looking at their forehead. In my mental image of a person, the face takes up the majority of the head. So when I drew the first self-portrait, I drew largely from my own mental image of a person rather than what I was actually seeing.

There are great benefits to making sense of things based on our experience. Being able to quickly fit our situation into an existing story or pattern allows us to know how to act in this complex world. It is the same basic process that allows us to encounter a fire and know not to stick a hand in it (once you have learned that) because you don't want to get burned. The story that I have learned about fires and getting burned is applicable to a really wide range of fires (and other hot things). But many of the stories we learn from our own history are not so widely applicable, or are perhaps not the right story to take away from our experience ("right" in the sense that they are generally useful and helpful). We know the dark side of this process with names like stereotyping, bigotry, racism, and sexism—where we apply a story or mental pattern about other people that the culture believes to be inappropriate. Many great thinkers[5] have suggested that we need to see others for who they are as individuals and not fall into our habit of quickly labeling them and then acting toward them based upon our story about that label. But that is easier said than done.

Rational Analytic Understanding

An alternative choice for how to make sense of the world is rational analytics—or, in short, science. With rational analytics, we make sense of the world by applying established theories to the particular situation in which we find ourselves.[6] The established theories have been supported by research and are generally agreed to be valid. This has been an extremely useful approach in the physical sciences where theories such as Newton's laws of motion have been developed. Application of Newton's laws allows us to predict and control the movement of physical objects with a high degree of precision in the vast majority of situations we encounter. If we encounter the scene of a car crash, we can draw upon Newton's laws to accurately create a story of what the cars were doing before they collided, how fast and what directions they were traveling. Although the rational analytic approach is very helpful for figuring out what happened and how it happened, Newton's laws are not very helpful in figuring out *why* the drivers crashed into each other: Was one talking on a mobile phone while the other was texting a friend so their attention was elsewhere? Was there an impenetrable fog? Was someone drunk or depressed, because of a recent breakup, or trying to show off to friends? This rational analytic approach is a relatively recent phenomenon in human history, having really taken off

only in the Enlightenment period roughly 400 years ago—before then the question of *why* was far more central to human inquiry.[7]

It is hard to understate how much rational analytics have created the world we live in, how much our modern lives are based in the industrial, technological, and agricultural revolutions made possible by science. Because it has been so successful, the rational analytic approach has been applied to more and more aspects of our lives. However, as we move from relatively simple situations such as physical bodies governed by Newtonian mechanics to more complex situations, we also move from finding theories that accurately predict within the precision of measurement to theories that explain some of the variance and work with cumulative results for a population rather than individual situations. For example, Newtonian mechanics may not be a perfect match with all we know of the physical world, but it does accurately predict how two billiard balls will behave on a pool table when one strikes another. Of course, if those billiard balls were travelling near the speed of light, Newtonian mechanics wouldn't predict their movement so well. Which is to say that theory applies in a particular context, a fact we generally ignore because that happens to be the context almost all of us find ourselves in all of the time. Staying with the sciences, in more complex situations we still create simple theories. There is a theory that is popular in the medical world that high cholesterol causes heart disease. If this theory functioned like Newton's laws, then all people with high cholesterol would get heart disease and all people with low cholesterol would not.[8] Of course, the medical world doesn't claim that the relationship between cholesterol and heart disease functions like Newton's laws. Rather, cholesterol is one of many variables that have an affect on rates of heart disease. Heredity makes a bigger difference, but there's nothing you can do about the genes your parents passed on to you, while there is something that can be done about your cholesterol level—you can take a pill.

And we do take pills—Lipitor is the best-selling prescription medicine in the world. There are also drugs such as Zetia, which has been shown to reduce cholesterol but has never been shown to reduce coronary heart disease. It does make you question the relationship between cholesterol and heart disease if a drug can affect one without affecting the other. In the philosophy of science, this would be known as a black swan—the one piece of disconfirming data that proves a theory is wrong (in the eponymous example, the theory that all swans are white). But the theory of cholesterol and heart disease is not a theory of individual relationships, that is, it does not say that if I reduce my cholesterol I will

not get coronary heart disease and die. Rather, it says that if a hundred of us with high cholesterol take a statin drug (like Lipitor or Pravachol), three or four of us who would have otherwise had a coronary incident, won't. Ten of us in that hundred will still have a coronary incident, and most of us will not have a coronary incident with or without the statin. But for those three people, the statin made a difference. Of course, we have no way of knowing which three people out of the hundred will be helped. This is how scientific rationality deals with complex systems that don't have straightforward, linear relationships like moving billiard balls on a pool table.

The problem for our sensemaking using analytic rationality then is that we want to make sense of a particular situation—usually the one we're in—but the theories we have are about populations and aren't meant to be applied to particular individual situations. I want to know if I should take Lipitor because my cholesterol is high, and science can only tell me that if I do there's some small chance I will be one of those three out of a hundred that won't have a coronary incident because they take it. When I think from the medical community's perspective it seems worthwhile, but as an individual, the chance of personal gain seems very small. And for most of us, the reality is that our primary care physician tells us that our cholesterol is high and prescribes us Lipitor, and so we take it—without ever knowing the rational analytic reasoning behind that prescription. And there simply isn't time to develop the expertise and explore the analytic reasoning behind all of the sensemaking about our complex world that we need to do. So we don't.

This idea of scientific rationality is at the core of what is taught in mainstream business schools. For our president of the software consulting services company, business school teaches that he should engage in a strategic planning process, which probably includes things like a SWOT (strengths, weaknesses, opportunities, threats) analysis, or a Porter Five Forces analysis of the market. Based upon a rational and systematic analysis of the external environment, potential markets, and internal firm capabilities, the president can logically choose a new strategy for his company.

As we apply this sort of analytic rationality to the social world, it becomes even more problematic than the complex world of medicine and our physical well-being. In the world of medicine there is a fairly agreed upon way of looking at the things in terms of diseases, treatments, and so on.[9] In the social world the first question is always, how do we frame the problem? For example, in the contentious debate

around abortion in the United States of America, one side claims that it is an issue of protecting the life of the unborn child while the other side claims that it is an issue of protecting a woman's right to free choice about her own body. How we frame the issue completely determines what the "correct" solution is. Within organizations, Bolman and Deal[10] suggest four different frames for looking at issues: structural, human resources, political, and symbolic—each one has different things that are important and lead us to make sense of a situation differently. This highlights an important aspect of the rational analytic approach to social situations, which is that the analytic frameworks (i.e., theories) offer a way to make sense of a situation that generally implies a course of action. It is not the only way to make sense of the situation, even though it is often presented as the only way, or at the least as the best way, to do so. When leaders and scholars write about leadership and they say leadership is blah, blah, blah, what they are really saying is, here is how I make sense of leadership and so should you. After all, I was a great leader, or I have done lots of research.[11]

All of this is not to say that rational analytic frameworks such as those taught in business schools aren't valuable. They are often very useful tools and can be very helpful in making sense of situations and choosing a course of action. But we need to be aware that they are always not the only framework, and that particularly the frameworks that use quantitative analysis have focused on things that can be quantified even though those things may not capture the essential or important aspects of the situation. In many ways, we are like the drunk looking for lost car keys under the street lamp. When asked where the keys were lost, the drunk motions to a dark spot around the corner. "Then why are you looking here," the drunk is asked. "This is where the light is," came the answer. Our lust for the numbers and our desire for the same sense of certainty and ability to predict, similar to what Newton's laws brought to the physical world, takes us to the light regardless of where the keys are.

Artistic Understanding

There is a third way of making sense of the complex situations we find ourselves in, which is the essence of the creative mind-set, the artistic approach. This way consists of paying close attention to our senses and drawing upon our intuition. The difference between making sense of the situation based upon our experience and making sense creatively

is that instead of trying to quickly match the situation to an existing pattern and then acting based upon that pattern, you continue to pay attention to the sensory data and look for new patterns—that is to say, you keep the conversation between the sensory information and the sensemaking going. In many ways, it is as simple as those two things: (1) continue to pay attention to what your senses are telling you about the world; and (2) look for new patterns or ways of understanding the situation. As we continue to pay attention to our senses, there is a dance between that information and our sensemaking. How we make sense of the situation helps us to look, listen, taste, smell, and feel for particular things. What we see, hear, taste, smell, and feel changes how we are making sense of the situation. Artists often call this "being open," or "being open to the work." Being open refers both to attending to our senses and to allowing our sensemaking to be questioned, changed, and made anew. Making sense based on experience is about being closed. It is about finding the quickest way to make sense of things so that you don't have to pay attention to your senses, so that you can close off the large volume of sensory information that constantly floods us. It's about finding the quickest way to make sense of things so that you can know for sure and can be closed off to doubt and that horrible state of not knowing (particularly in a culture that rewards knowing).

Making sense of the world with analytic rationality also pays attention to information from our senses and engages the dialogue between the sensory information and the sensemaking when it is done well. However, the artistic approach has the advantage of drawing upon your whole body, your whole self, to make sense, rather than limiting the process to the cognitive, analytic part of yourself. Humans have developed intuition over millions of years, and it is a very powerful tool.[12] Intuition is the first step in artistic sensemaking. We might call it trusting your gut or listening to how things feel, but, regardless, it is the first sensemaking when we encounter a situation. In contrast, analytic rationality has a relatively short history of only a few thousands of years and by and large had not been adopted by the general population until— well, okay, it's never been adopted by the general population as the standard for making sense of our world. Artistic understanding starts with intuition and then continues to engage in an ongoing dialogue between the senses and the sensemaking, using a sort of second-level intuition to decide when it is done. As one painter explained it to me, "I paint until it feels right. At first I often only knew when a painting was done because I had gone on painting past when it was done and

with watercolors that ruins the painting. So eventually I learned what it felt like and learned to stop when it was done."

Learning to trust your intuition, learning to know when it feels right and when it doesn't, implies a high level of self-awareness. This highly developed level of self-awareness is also critically important when it comes to making sure the artistic process does not simply become making sense based upon experience. Self-awareness allows us to recognize when we are projecting our stuff onto the situation rather than listening to what our senses tell us about the situation. Of course, our history contributes to our intuition, and in reality the three ways of making sense are not as distinct as one might assume from this sort of discussion (a general problem with making analytic distinctions about the continuums of our experience). Modern artists are often required to provide analytic statements about their art in order to get grants and mount exhibitions. Scientists rely upon their intuition as they experiment and try to make sense of the world. And I suspect that all of us engage in a dialogic process of engagement with our senses and sensemaking in some aspects of our lives. We may not recognize it as a creative process as we look carefully at how the leaves on the flowers have changed each day and ponder when to fertilize and when to deadhead the blooms; or when we tune the carburetor on our classic car listening to the sound and feel of the engine; or when we smell and taste the sauce deciding what additional spices are needed and how much longer it needs to cook over what level of heat; or when we feel the wind on our finger, look at the distance to the green, and select a club; but these are all ways of interacting with the world that we all have experienced and most likely continue to experience in some aspects of our lives.

For the president of our software consulting services company, taking an artistic approach to deciding what to do next would mean actively paying attention to the available sensory information: What are his customers saying and what are they not saying? What does he see and what does he not see in the new version of the Windows operating system? What does his intuition tell him? And what does all of that add up to? How can he now understand his business environment in a new way? Continuing on from the answers to those questions, he goes back to the evidence of his senses: What does this new understanding of his business environment allow him to see and to hear? How does what he now sees and hears change his new understanding?

At the heart of the creative mind-set is an ongoing desire to make sense of our world in new and interesting ways. When we make sense

of our world based on our experience and when we make sense of the world based upon analytic reasoning, we are striving to make sense of the world in an already existing way. There is also a strong tendency to seek closure—that is to say, to make sense of the world and then move on and freeze that sensemaking. Once I have made sense of Jack as being a jerk, I can stop paying attention to what Jack actually does.

Let me close with a rather mundane example of the conversation between senses and sensemaking. On my first trip to Paris I went out to dinner alone one night. On the menu, I saw "ris de veau avec sauce aux champignons." I understood enough French to recognize that "veau" was veal and "champignons" were mushrooms, so I made sense of the dish as being some sort of veal with mushrooms—it sounded great. And it tasted great. After dinner, I looked up "ris" and discovered that it meant sweetbreads. Based upon all of my cultural training, I would never have ordered sweetbreads as I believed that eating the organs of young cows was utterly disgusting. I had a huge conflict between my sensemaking, which was based on some of the deep truths about the world that I had learned growing up, and the evidence of my senses. I could ignore the evidence of my senses and continue to believe that organ meat was disgusting, or I could try and change my deeply held beliefs. Luckily for me, the artist in me won, which has allowed me to discover the joy of haggis and many other wonders of the culinary world and create a life in which food plays a central role.

Three Job Interviews

This process of working back-and-forth between the senses and sensemaking is fairly clear in examples such as the drawings in chapter 2. I look at my reflection in the mirror, I draw, based on what I have drawn, I look some more, then I draw some more. The drawing reflects what I see and what I see is affected by what I have drawn. But in a great deal of artistic work, the art product (drawings, paintings, novels) is not such a straightforward representation of physical reality. Instead, it seems to be a work of the imagination and a far cry from any evidence of the senses. For example, in my play *Soft Targets*, I write about my experience of being laid off and trying to figure out what I would do next. After Joe, the protagonist gets laid off, he looks for work and there are three job interviews. I wanted to capture the feeling of how strange, weird, and unsettling job interviews can be. Here

is the first job interview scene from the play (note: where there are two columns, the action and dialogue are going on at the same time).

Obviously, in my own experience of interviewing for a job, I have never had a group of sprites enter the room and start singing the Pennsylvania Polka (see table 3.1). But I have experienced the sort of mismatch between me and the interviewer that happens between Joe and Walker. Adding the sprites helped capture how that sort of interview felt to me. So the sensory evidence that I am paying close attention to is my own sense of various job interviews that didn't go

Table 3.1 First job interview scene

WALKER Give me an example of what you did at B.A. Labs.	
JOE I would try and figure out ways to defeat the weapons systems that were being designed. For example if the weapon was using an infrared sensor, I would look for ways I could change the infrared signature on a tank. Or I would look for things that have a similar heat signature and I could use to fool the sensor.	
WALKER Joe. We make lawn mowers.	(Three sprites enter. They quietly sing, doing polka-like backup, behind Walker.)
JOE I know that. I guess it's sort of like, uh, when you make lawn mowers. You must have someone who thinks about what could go wrong. Someone who thinks about what would happen if there's a big stick or something and it gets run over by the lawnmower.	SPRITES Strike up the music, the band has begun, the Pennsylvania Polka. Pick out your partner and join in the fun, the Pennsylvania Polka. It started in Scranton, it's now number one. It's bound to entertain ya! Everybody has a mania, to do the polka from Pennsylvania!
WALKER No.	
JOE I guess the point is that you have to be a pretty good engineer to be able to assess the weaknesses of a design. You have to really understand the implications of design choices.	(The sprites move next to Joe. They continue to sing the chorus, getting louder.)
WALKER How many people did you have working for you?	

Continued

Table 3.1 Continued

JOE
Well, the team I was in charge of had five engineers, two systems analysts, and one administrative support person assigned to it. They didn't actually report to me, because we were a fully matrixed organization. I had input into their reviews, of course.

SPRITES
(Getting louder.)
Everybody has a mania, to do the polka from Pennsylvania! Everybody has a mania, to do the polka from Pennsylvania! Everybody has a mania, to do the polka from Pennsylvania! Everybody has a mania, to do the polka from Pennsylvania!

WALKER
But they didn't actually report to you?

(They continue.)

JOE
No.

WALKER
What sort of role do you see yourself in here?

(The Sprites circle Joe)

JOE
I think there's a variety of things that I could do that I think would add a lot of value. I have a lot of experience with engineering methods, project management; so I think could function as a sort of internal consultant in a staff position. Of course, I would rather work in a line position, and whether that's in design, manufacturing or even quality, I'm sure that I could provide a new perspective and really bring a lot to the table.

SPRITES
(Gradually changing from singing to chanting.)
Everybody has a mania! Everybody has a mania! Everybody has a mania! Everybody has a mania! Everybody has a mania! Everybody has a mania! Everybody has a mania! Everybody has a mania! Everybody has a mania! Everybody has a mania!

WALKER
I started off as a quality engineer.

(The Sprites stop circling Joe.)

JOE
I think my experience would make quality a good fit for me. In today's market, quality is becoming more and more important. Maybe we've learned something from the Japanese.

SPRITES
(Getting closer and closer to Joe.)
Mania! Mania! Mania! Mania! Mania! Mania! Mania! Mania! Mania! Mania! Mania! Mania! Mania! Mania! Mania! Mania! Mania! Mania!

WALKER
I hated quality.

SPRITES
(Like a dirge.)

JOE
It's not for everyone.

Pick out your partner and join in the fun, the Pennsylvania Polka.

WALKER
Well, I've enjoyed talking with you.
We'll be in touch shortly.
(Joe stands, shakes hands with Walker.)

JOE
Thank you.
(Walker exits. Joe exits.)

SPRITES
(Joyfully, after Joe exits.)
Everybody has a mania, to do the polka from Pennsylvania!

well. It doesn't feel like I am imagining something new, but rather that I am trying to make sense of and express my own felt sense of the horrible job interview.

Once I had made sense of the job interview experience in a way that included a set of singing sprites, I used that lens to look again at my felt sense of job interviews. I realized that the mismatch was only one aspect of that felt sense. I pushed deeper and explored the absurd interview question. The absurd interview question is meant to give the interviewer insight into how you think on your feet and how you handle a pressure-filled situation. But often, it just feels absurd, which I tried to capture with the text of the second job interview between Joe and Billings. The sprites help Joe with the answer, which captures my sense of dealing successfully with the absurd question, and then they don't help with the follow-up question, which is based in my experience of being caught by my own arrogance when I think I have done well.

Clearly, here my own experience does play a role in this as I have long had a great love of Feynman's work, and I can also feel echoes of schoolboy experiences of very nerdly[13] discussions as we tried to one-up each other about who knew more arcane facts about our passions of the moment (see table 3.2). If the writing process is working well I lose control of the characters, and they do what they want to do and won't say things that I would like them to say. Which is really just another way of saying that the dialogue between the senses and sensemaking is controlled by a deeply felt sense that knows when it is right and when it isn't, when it is done and when it needs more. Thus I claim that by the time I wrote the third job interview I wasn't consciously choosing anything, but rather that Joe and Davis and the sprites just did what they wanted to do. I can recall being surprised and somewhat annoyed when Davis started speaking Latin. Surprised because I don't speak Latin, and annoyed because that meant I would have to find a way to translate what he said into Latin even though I didn't speak it.

Although this may sound somewhat far-fetched to you, it is how I experience the writing process when it is going well. It also captures an important aspect of the creative mind-set, which is the way in which you give up control. It is an odd experience of being completely *in* the process and surrendering to that process without knowing where the process will take you. This may seem antithetical to the idea of leadership as being about having a strong vision and knowing where you are going, and in many ways it is. What I have instead of a strong vision of

Table 3.2 Second job interview scene

BILLINGS
Your resume is very impressive. I just have
a couple of questions.

(Three sprites huddle behind Joe.)

JOE
Sure.

BILLINGS
Who won the 1965 Nobel prize for physics?

JOE
65? Was that Feynman?

SPRITES
Feynman. Richard P. Feynman.

BILLINGS
And?

JOE
And? (Joe looks to the Sprites for help.)

(The sprites dance away from Joe.)

BILLINGS
Three physicists were awarded the prize that
year for their simultaneous discoveries in
quantum electrodynamics.

JOE
Look, I'm an engineer. I think I have a lot to
offer as an engineer, and my experience is
pretty diverse and gives me some very useful
perspective on the whole engineering process.

SPRITES
(Singing.)
Everybody has a mania! Everybody
has a mania! Everybody has a
mania! Everybody has a mania!
Everybody has a mania!

BILLINGS
Julian Schwinger and Shin'ichiro Tomonaga.

JOE
Of course.

BILLINGS
The award was presented by Ivar Walleron on
December tenth, 1965. Unfortunately, there's
absolutely no way I could hire someone who
didn't know that. Thank you for your time.
(Joe stands and Billings shakes his hand.
Billings exits. Joe turns to the Sprites.)

FIRST SPRITE
We've got a lovely parting gift for our contestant
that didn't get a job today. This high quality
tape of all your favorite polkas! So tell me,
Joe, is there anything that you'd like to share
with our home audience after yet another
crushing defeat in the great employment search?

SPRITES
Strike up the music, the band has
begun, the Pennsylvania Polka.
Pick out your partner and join
in the fun, the Pennsylvania
Polka. It started in Scranton,
it's now number one. It's bound
to entertain ya! Everybody has
a mania, to do the polka from
Pennsylvania!

what the final play will look like is a strong commitment to the process and allowing the truth of the experience to come out—whatever that truth is. I do not know where the conversation between senses and sensemaking will take me, but I trust that if I engage in it well, it will take me where I need to go.

Based on the audience responses I received when *Soft Targets* was performed, many people have had an interview like that, where it felt as if the interviewer was speaking a foreign language (see table 3.3). And the guy believed Elvis Presley was still alive. That's the power of metaphor, when we make sense of our situation as being like another situation. *It was like the interviewer was asking me questions in Latin. And he was nuts, I mean he started by saying that he believed Elvis Presley is still alive.* The metaphor provides a first frame for the sensemaking, and as I write the scene, the metaphor frames my felt experience and that felt experience changes the metaphor.

Lessons for Leadership

Bringing the creative mind-set to leadership means being curious, being comfortable with ambiguity, and having faith in that deeply felt sense that monitors the process. Curiosity and its cousin, a sense of wonder with all things, drive the dialogue between the senses and the sensemaking. If my sense of curiosity is weak, I will quickly adopt a particular sensemaking (whether that is based on experience or rational analysis) and stop the conversation. If I don't quickly adopt a particular sensemaking, then the situation is ambiguous. Most of us are not very comfortable with ambiguity. Western culture values knowing and the surety of action that comes from knowing. What are your eight desert island disks? Who's the best football player of all time? What's going on and what should we do about it? So, leaders are decisive. Or are they?

If decisive means instantly making sense of a situation and acting upon that sensemaking, then creative leaders aren't decisive. The creative leader doesn't rush to make sense of the situation but rather engages with the situation and the process—that is to say, they practice their practice of leadership, which includes a conversation between the situation and how they understand it. They learn to pay attention to their gut feel of when they have it right, but they never stop listening to their senses. How they understand a situation will change as the situation changes.

Table 3.3 Third job interview scene

DAVIS
Credo Elvis ipsum etiam vivere.
(Three sprites enter. and line up behind Davis.)

JOE
What?

DAVIS
Elvis ipsum etiam vivere.

JOE
I think I lost lock.

SPRITES
Elvis is still alive.

DAVIS
Latin.
(The Sprites quietly start to sing the Pennsylvania Polka moving and sounding like Elvis.)

JOE
Yes.

DAVIS
I like to conduct interviews in Latin sometimes.

JOE
I don't speak Latin.

DAVIS
You can answer in English.

JOE
I don't know what you asked.

DAVIS
Does that really make a difference?

JOE
I'd like to think so.

FIRST SPRITE
The king, you idiot!

SECOND SPRITE
Is he alive?

THIRD SPRITE
What do you think?

DAVIS
Just answer. I can't help you any more than that.

JOE
I think Elvis is dead.

DAVIS
Nullo modo.

SPRITES
(Chant until Joe exits.)
Loser, loser, loser, loser, loser, loser, loser, loser, loser, loser.

Claus Springborg[14] says it this way:

> ... at the core of good art and at the core of good leadership is the ability to perceive some element of one's own immediate experience without letting concepts and ideas about this element take one's attention away from the senses. Furthermore, both, I argue, are characterised by the ability to arrange conditions in a way that inspires others to also stay with their senses.

So although it is essential that creative leaders engage in a practice of paying attention to their own senses and making sense of the situation in new ways, it is not enough to do that just for themselves. The leader helps others engage in this same practice and creates conditions that facilitate this practice. It is not enough for creative leaders to be artists in their own practice, they need to foster an audience for that practice. Rather than saying here is how I see things and playing a strong sensegiving[15] role with the expectation that others will see things the same way and act upon that sensegiving, the creative leader encourages others to engage with their own senses and the leader's sensegiving in the way that an audience engages with a work of art. Just as we learn how to look at art and understand it differently over time[16] (and in all likelihood differently from how the artist understands it), creative leaders help us learn how to engage their sensemaking of situations and make our own sense of it. This stands in stark contrast to contemporary ideas of making sure that everyone is "on the same page" and "stays on message."

In addition to being curious and comfortable with ambiguity, the creative leader must have a great deal of self-awareness. This is by no means a new insight into leadership practice. The most consistent empirical finding about what predicts effective leadership is self-awareness or accurate self-knowledge. Every major spiritual tradition has sought knowledge of the self in one form or another as part of its teachings. Emerson and the transcendentalists echoed the ancient Greeks with their call to "know thyself." Here the call for self-awareness serves two purposes. First, by knowing yourself you can know when you are projecting your stuff onto the world and when you are really paying attention to what is out there. Second, you must know yourself well to be able to listen to that part of you that knows when a painting is done, that knows when your sensemaking is right and complete and when it isn't.

Paying attention to your senses and engaging in the dialogue between senses and sensemaking is not an easy thing to do. We are hardwired to

act, and act quickly, based upon our experience. It offered a significant evolutionary advantage, particularly in stable times when our past was a good predictor of the future. Daniel Quinn, puts it this way:

> When your eye encounters photons bouncing off an apple, they're turned into a pattern that's sent to the primary visual cortex. There, the general shape of the apple is recognized and sent on to a higher region of brain function where its color is identified. Then this pattern moves along to a still-higher region where it's put together with other knowledge that enables you to recognize that this is an apple, not a strawberry. This bottom-to-top flow of data is what we think of as perception. But there is also a top-to-bottom flow of information that is equally powerful, and it's a curious fact that the neural paths carrying information down to the bottom outnumber paths carrying information up to the top, ten to one.[17]

They are rare individuals who manage to pay attention to their senses when their sensemaking is telling them a different story. I have been suggesting that this is the essence of the artistic mind-set, but most artists don't manage to do this outside of their art. I was talking about these ideas with a friend who's a theater professor, and he said, "you want me to bring the same openness I bring to my art to faculty meetings? You have got to be kidding." He was capable of being fully open to his senses when doing an improv exercise with other actors, but the thought of being open in that way with his colleagues when talking about the business of the department was ludicrous. Nonetheless, that is exactly what I am suggesting is needed for leadership to really be a creative process.

Of course, there are reasons for my friend's reluctance to be open in that way at faculty meetings. There is a tremendous vulnerability in being open to an ongoing conversation between your senses and your sensemaking. You don't have a firm position to fall back upon. Others may sense weakness as your stance shifts. We expect leaders to be strong and know what they want, where they stand, and what we should do. In situations like faculty meetings there is a strong political dimension, and it is a game of coalitions, bargaining, compromise, and power. Jonathan Haidt says, "Our minds were not designed by evolution to discover the truth; they were designed to play social games,"[18] by which he means that we are hardwired to make sense of those social situations in particular ways that are not about discovering the essence or truth of those situations.

There have been a variety of leadership scholars[19] who suggest that vulnerability is really a strength for leaders. Although this seems counterintuitive in the face of the idea of a strong, hero–leader who is decisive, knows the right thing to do, and does it; my own experience supports the idea. When I have managed to summon the courage and be vulnerable in leadership situations, the response has almost always been very positive. I say *almost*, and that almost is a key. If our ancient ancestor leaders made themselves vulnerable and one out of twenty times someone took advantage of that vulnerability and killed the leader, then everyone else learned the lesson about the dangers of being vulnerable. The results may have been excellent the other nineteen times, but one major failure carries more weight than nineteen successes in an evolutionary sense. The cost of failure, even if the odds of failure are low, can be high, and thus we tend to not want to risk it.

In the arts, the cost of failure is generally low, and one of the great truisms about the arts and an artistic approach is that there is a willingness to fail. I heard Alberto Alessi, head of the Italian design factory, say[20] once that if half of their designs did not fail, then they were not doing the sort of cutting-edge design they wanted to do. They needed to be failing half the time to know that they were out there trying new things. The cost of failure was an accepted part of their business model. But we know that as individuals we tend to systemically overestimate the cost of failure and underestimate the cost of inaction. That is to say, we err on the side of not being open, of not risking the sort of vulnerability required for a creative process.

Most of us don't have much experience of what it is like to be open to our art, and even most artists don't have much experience of what it is like to be open to other people who are also being open to you. An exception to this is actors who engage in theater improv work. Done well, the actors are open to each other and the result is collaboration. It is collaboration of a type that most of us seldom, if ever, experience. It is the sort of collaboration where the group creates something that is not just the sum of the individuals' creativity—it is more than that, and I shall explore it in more detail in chapter 5.

What drives this conversation between the senses and sensemaking, provides the courage to be open to the world, and to be vulnerable in this way? Simply put, it's passion. Passion for what we do keeps alive our sense of curiosity and willingness to dwell in the ambiguity. Passion for the process keeps it open and ongoing. It is your passion that drives the creative mind-set, and indeed it is passion that drives you to lead. And it is passion that is the subject of the next chapter.

Exercises

To develop your ability to be in the creative mind-set, try these exercises:

- Take a friend to a place full of people such as an airport, train station, or busy street. Pick out a comfortable place to sit and engage in some high-quality people watching. Tell your friend a story about an interesting person you see. Look closely for details about that person and allow that to change the story. Let the story develop and see where it goes. Then get your friend to tell a completely different story about the same person.
- Find an interesting architectural detail in a quiet place. Get a pencil and paper and draw it. Include all of the details you can. Think about what you see as you look at the same molding/corner/whatever for a sustained period of time. What details do you notice that you didn't notice at first? How do you understand it differently as you engage closely with it for 10/15/20 minutes?
- Buy the book *How to Be an Explorer of the World*.[21] Do a different exploration from the book every day.

CHAPTER FOUR

Passion

In the job interview scenes in the previous chapter, would you hire Joe? Would you want Joe, a former weapons systems countermeasures team leader, to lead your lawn mower manufacturing engineering group? Or would you prefer someone with almost no managerial experience who races lawn mowers on the weekend? If you were Joe and you had been working at the cutting edge of technology in advanced weapons systems development, would you want to lead a lawn mower manufacturing engineering group? In the abstract, this is a question of how well leadership skills can transfer from one domain to another and a question about underlying passion. I'll look at the domain question in chapter 6 and explore the topic of passion here.

When the focus on the process is total and you are completely in the moment, when you are doing it for the joy of doing it, it is called being in the "flow" and has been found to be a characteristic of both creative processes and the aesthetic experience of engaging with art.[1] It is also the experience of competitive athletes and chess champions. It is very enjoyable and I suspect that we have all experienced it in some aspect of our lives. It only happens when we care deeply about what we are doing, or to put it another way, when we are passionate about what we are doing.

The importance of passion gets expressed in a variety of ways. Some of the best academic research on creativity is Teresa Amabile's[2] intrinsic motivation hypothesis, which says that we will be more creative when we are working on tasks that we like doing for their own sake (intrinsic motivation) rather than tasks which we are doing for the sake of some reward that we will receive upon their completion (extrinsic

motivation). A great deal of empirical research supports this hypothesis for everything other than the most mundane of tasks. The flip side of this thinking tells us that offering rewards (such as a monetary bonus) for work will result in work that is less creative than when not offering rewards, as the extrinsic motivation of the reward tends to drive out the intrinsic motivation of doing it for the sake of doing it.[3] Although we know that it is important to have passion for what you're doing, the research doesn't tell us whether we should be focused on doing things that we are passionate about or be passionate about things that we are doing.

The importance of doing things that we are passionate about has been a mainstay of popular culture for many years, at least since the 1960s when people everywhere decided to "find themselves," and probably much longer than that as youngsters ran away to join the circus or follow their dreams in some other way. Ken Robinson[4] tells story after story about how hugely successful, famous people found their passion. Gillian Lynne, the choreographer, wasn't doing well at school and was taken to a psychologist, who suggested she attend dance school. Matt Groening, the creator of *The Simpsons*, always liked to create characters and stories and wouldn't let anyone convince him to follow more traditional pursuits. Ewa Laurance, the billiards champion, found her passion when she first saw a pool table at the age of fourteen. Underneath all of these stories is the belief that everyone has their element (or passion) or perhaps even several elements and that finding the thing(s) that you are both passionate about and good at is the key to having a full and rewarding life. Of course, the being good at it part is in some ways a self-fulfilling prophecy—if like Ewa Laurance you love playing pool so much that you spend several hours a day practicing pool for several years, you are likely to become pretty good at it. That's not to say that practice makes perfect, but shear time spent perfecting your craft usually produces some results. As a teen-ager, I liked to play pool and played several hours a week, eventually becoming a reasonably skilled amateur.[5] But I did not have a great passion for pool and I did not practice several hours a day and I did not become a professional pool player.

Most of us do not know what we are passionate about from an early age. Most of us are not lucky enough to see our first pool table and fall completely and unrecoverably in love with it and then manage to find the means and support to pursue our true love. Instead we drift along, falling into jobs and pursuits that we are interested in (but not passionate about) or something that pays the bills, or perhaps a job

that someone told us we had a talent for or even just something where someone we knew could get us a job. And we do okay, but we don't have passion for what we do. In my late twenties I found myself working for a software company as a consultant helping defense contractors build project management systems that met the department of defense's criteria for cost and schedule control. It was interesting, challenging, and I was good at it. But I wasn't passionate about it, and when the time came it was remarkably easy to leave it behind.

Discovering your passion can be a difficult task and a long strange trip. There are many ways to take this journey; one of the most popular in the arts world is Julie Cameron and Mark Bryan's *The Artist's Way*.[6] When you are in a creative funk it guides you back to your passion through a variety of rejuvenating and self-discovery exercises. They suggest writing morning pages every day, which allows the chaos and monkey-mind of our lives to pour out or perhaps be skimmed off the top giving us more access to the calmer and deeper pools of ourselves. There is an implicit belief in this that if we can just get past all of the noise and demands of modern existence and look deep within ourselves we can find the thing(s) that we really care about and then we can go about our lives doing that. When we are doing what we are passionate about we will be engaged with our full selves and we will be creative and live a full and satisfying life.

An alternative view comes from Daniel Quinn,[7] author of *Ishmael*. Quinn suggests that modern civilization and the hierarchical way of organizing that supports it is fundamentally alienating for the vast majority and there is no possibility of an engaging and satisfying life for the people who sit at the bottom of the hierarchy. He argues that people lived tribally for millions of years and that method of organizing worked for humans allowing them all to live engaged and satisfying lives. Our relatively recent (it's only been going for somewhere between 10,000 and 15,000 years at this point) experiment with civilization is doomed to fail. It's a more radical statement of the problem(s) of our times (energy, climate change, population pressures, distribution of wealth, species extinction, addiction to growth), and although you may not agree with Quinn's assessment, it does raise the other side of the quest to find your passion—what if it's not there to find?

The other route to passion is to be passionate about what you do regardless of what that is. It is an approach that feels more Eastern than Western. Many years ago I was in a commune in Cambridge, Massachusetts, and I saw a sign on the dishwasher that read, "If you cannot empty the dishwasher mindfully" The implication was

that we should be mindful—fully in the present moment in everything that we do, even mundane tasks such as unloading a dishwasher. I can imagine thinking of unloading a dishwasher as a craft skill (or perhaps a collection of craft skills) and engaging it with the sort of practice and discipline that I engage in my writing. I can imagine it, but I can't (or at least I certainly don't) actually do it. When I unload the dishwasher my mind wonders, and sometimes I find myself putting a dish in the wrong place as I think about other things that are going on in my life. Unloading the dishwasher is not the only thing that I have trouble practicing as a discipline. Although I have friends who are passionate about shaving, going to great lengths to get better and better shaves, I simply want to have my face not be itchy or scratchy after a shave. I have a friend who spent many years developing better razors for Gillette, and he is very passionate about it. I find it interesting and well worth a conversation over a beer, but I am not passionate about the high-tech manufacturing processes that made the three-bladed razor a reality. This is certainly a personal limitation for me and makes it clear that I would have been a lousy Zen monk, but I suspect that the same is true for most of us (Zen monks being a relatively tiny portion of the world's population).

Regardless of whether you find your passion or bring your passion to whatever you are doing, the need for passion in creative work is central. In many ways, having passion for your art is simply another perspective on practicing the craft skills of a discipline. It means that you engage the practice of your art with your whole self, you whole mind and your whole body—every ounce of your being. It means that it is always part of you and in some important ways it is you, you are your art, your practice, your discipline. It is one of the answers to the question, "who are you?" I am a playwright. I am a scholar. I am a husband. I am a leader. There are many ways to ask the question, "who are you," and all of us have many answers.

So another way to ask the question I opened this chapter with is, "is Joe a lawn mower engineer?" Does Joe or perhaps could Joe care deeply about the issues of lawn mower engineering? This is a question for both those who are considering hiring Joe as well as for Joe. And if I want a leader who will lead creatively, the answer needs to be yes. But how do you know? How do you know what you have passion for?

In June of 2004, I was the *Leadership Arts Playwright in Residence* at the Banff Centre. While there, I took a newly revised version of their five-day class in *Foundations of Personal Leadership*. The class used theatrical mask and clown techniques to help us answer the question of who we

each were as a leader, what we valued, and what we had passion for. It was a wonderful experience that was very difficult to describe. When the class was over, I wrote a play to capture the experience.[8] The play is called *Cow Going Abstract*, and I have since adapted it into a short story,[9] which I call *What's Your Chocolate?*. It is an allegorical story of finding your passion and I include it here in order to convey something of how I have made sense of that process.

What's Your Chocolate?

It was the sort of crisp, clear, chilly morning that was typical of autumn mornings in the plains of Alberta. Alison the cow lumbered into the barn deeply engaged in casual conversation with her friend, Schecky the duck.

"Are you going to do your cold hands dance?" asked Schecky.

"You would think that Jimmy might have the common courtesy to warm his hands up before placing them on someone's private parts," answered Alison who had come to hate the cold steel of the milking machine in the morning.

"Private?" responded Schecky. "You get your teats hooked up to that machine twice a day. And we can all watch. Not that I do."

When Jimmy the farmhand came into the barn and hooked Alison up the milking machine, she jumped and shook her whole body.

"Alison and her legendary cold hands dance! She'll be performing here all week, two shows daily," cracked Schecky.

"Easy girl. It's just the milking machine," said Jimmy.

"It's just your cold hands," answered Alison. "Simple common courtesy would say that you might warm your hands and as to that machine—I'd like to see you apply freezing steel to your private parts. I'm trying to do my job here. I provide the milk that makes this whole farm run. And what do I get in return—everywhere I turn, Jimmy with his cold hands, Schecky with his jokes, grain that's starting to mold, pastures filled with mud pits."

"You tell 'em sister!," said Schecky as he picked up his guitar. Then while Alison was being milked, Schecky sang an old barnyard blues song:

> First thing in the morning, again mid afternoon
> The machine organization, milks me till I'm dry
> Winter into summer, July around to June
> No way out for me, milked until I die.

I've got the cash cow blues
They're sucking the life out of me
Come walk a mile in my shoes
And tell me who you'd rather be.

Non stop frustration, picking at my soul
Pressure from above me, complaints from below
Want to rise above it, stuck down in a hole
Gray turns to blackness, no, no, no, no, no.

Oh, I've got the cash cow blues
They're sucking the life out of me
Come walk a mile in my shoes
And tell me who you wanna be.
Come walk a mile in my shoes
And tell me who you wanna be.

When the milking was over and Jimmy had left the barn, Alison turned to Schecky.

"Why do I do this? What kind of life is this?"

"I don't know," answered Schecky, "what kind of life is this?"

"That wasn't a joke, Schecky."

"There's no punch line?"

"No."

"Then, I've got nothing. You tell me, why do you do this?"

From the thin air, Alison heard Jimmy the farmhand's voice, "You're a cow, Alison. Getting milked is what cows do."

"But can't there be more?" she asked.

"You're a cow. And nothing more. Good cows don't even ask questions like this," Jimmy's voice answered.

"That's a little harsh, " said Schecky.

"He's got a point," admitted Alison.

"Sure, he's got a point. And his point is that he wants you to get milked twice a day and that's it. No thinking, no adventure. Just get milked, eat and chew your cud," chided Schecky.

"Cud. Mmm, I like some good cud."

"So there you go, there's your purpose in life—in search of good cud."

"I like that. In search of good cud. I didn't even know I was looking."

"I was joking."

"Oh. But I do feel like I am looking for something."

"You want something more than being milked twice a day, something more than your life here on the farm?"

"I think I do."

Again, they heard Jimmy's voice. "You're just a cow. You belong on the farm. Go chew some cud and forget these silly thoughts."

"But I am just a cow," Alison said rather sadly.

"And I'm just a duck," answered Schecky. "Look, you got a choice. You can listen to Jimmy and spend the rest of your life getting milked by some guy with cold hands. Or you can do something about it."

"What can I do?"

"You can find your purpose. You said you were looking for something. You need to honor that looking."

"But I don't know what I'm looking for."

"If you knew, it would be easy."

Alison sighed and looked at Schecky for a moment. "I'm not really getting this."

"It sounds to me like you don't have a sense of purpose. You don't have a personal vision of what you'd like your life to be, you don't have a credo that you live by—unless 'I like good cud' is your credo?"

"I do like good cud."

"Is that enough for you?"

Alison paused and chewed some cud she had left over from earlier in the morning. "No. I don't think so."

"So you need to find what is. You need to discover what you're about."

"I need to find myself?"

"And you're not going to do that on the farm."

"You're saying I should leave the farm?" Alison was horrified at the idea. And a little bit excited.

"Yes I am."

"Where would I go?"

"Where do you want to go? Where have you always dreamed about going? Where is that special place that you've never been to, but somehow holds a place in your heart of hearts?"

"I don't know." Alison had never considered leaving the farm before. She had always just assumed that since she was born on the farm, she would live her whole life on the farm.

"There must be someplace," Schecky prodded. "Or something that you have some attraction to. You don't have to know why, just some place that has some deep connection for you."

"Well, maybe there is a place. I've always had thoughts about Paris."

"The eternal city, the city of light. The Eiffel Tower, the Louvre, the banks of the Seine."

"I was thinking chocolate. It's funny, I don't even know what chocolate is, I've never had any. But I heard some people talking about chocolate once and from the way they spoke it sounded better than cud."

"Better than cud?" Schecky was shocked. And intrigued.

"Yeah, better than cud. And the chocolate came from Paris."

"So you should go to Paris. In search of chocolate."

"How will that teach me about my purpose?"

"I don't know, I'm just a duck."

Alison chuckled and said. "Okay. We'll go to Paris."

"You'll go to Paris."

"And you'll come along?"

"I'm afraid not. Do you know what they do to ducks in France?"

"No."

"They force feed you and make your liver enlarge until you die and then they eat it. And frankly, my liver's got enough problems, if you know what I mean."

"I thought that was what they did to geese?"

"I'm not taking any chances. Sometimes I get mistaken for being a goose."

"Really? I wouldn't have thought so. But I can't go to Paris on my own."

Again they heard Jimmy's voice. "A cow traveling alone to France? You'll get lost. You don't speak the language. No one will milk you. You'll be lonely. You're just a cow."

"I can't go to Paris on my own," pleaded Alison.

"You've got a choice," replied Schecky. "You can listen to that voice inside you that always tells you why you can't do things. Or you can just go do the things."

Alison tried another tack, "I don't speak French."

"A good looking cow like you, you'll have no problem."

"I'll get lost."

"You get out to pasture and back everyday. I've never seen you get lost."

Jimmy's voice was louder this time. "It's not the same thing. You're just a stupid cow from Alberta. You've never been outside of Alberta. You don't know what the outside world is like."

"I've never been outside of Alberta," echoed Alison.

"All the more reason to go."

Alison looked at Schecky and then looked at herself. "You really think I could go to Paris?"

"I think you have to go to Paris."

"I don't know."

"You can stay here. Jimmy's cold hands every morning."

Alison trembled a little and then said. "Okay. You're right. I'll go." So Alison left the farm and went to the big city of Calgary where she caught a flight to Paris. When she landed in Paris she took the train into the center of the city and started walking. She walked and walked. It was very beautiful and very big and she was very lost. Luckily she bumped into an elephant named Faith.

"Bonjour, ma cher," said Faith.

"I'm sorry, I don't speak French," answered Alison.

"Pas de problème. How can I help you?"

Alison heard Jimmy's voice. "You're a stupid cow from Alberta who's lost in the streets of Paris. You've got no idea what you're even looking for or why you're here. What can this elephant possibly do to help you?"

"I think I'm lost," she answered.

You think you're lost?" said Faith. "What do you feel? Do you feel lost?"

Alison heard Jimmy's voice again. "And she's nuts. The last thing you need is an insane French elephant. I can just see the headlines— Canadian cow killed in bizarre elephant incident!"

"I'm not sure I'm following you," said Alison.

"You don't need to follow me, honey," answered Faith laughing. "Oh no, that wouldn't do at all. And I'm not going to follow you. We'll walk together. If that's alright with you?"

"But I don't know where I'm going."

"Do any of us? I mean for certain? Some may think so, but I'm not sure they really do."

"Do all French talk like you?"

Faith laughed. "No, most speak French."

"That wasn't what I meant," said Alison a bit peevishly.

"I know," said Faith. "But you're talking from your head and I never really know how to answer questions from the head. Talk from your heart, or from your gut and I'll know how to answer."

"I'm not sure what you mean."

"Listen to that voice inside you," said Faith mysteriously.

Alison heard Jimmy again. "Hearing voices inside your head makes you certifiably nuts. Run! Now, while you've got the chance! Run screaming away from here!"

"Not that voice," said Faith. It seemed that she could hear Jimmy, too.

"I don't know what voice you mean."

"One of your other voices. You'll know which one." And suddenly Schecky was standing in the streets of Paris next to Alison and Faith.

"Listen to me," said Schecky with a big grin.

Alison hugged Schecky. "Schecky! But you said you wouldn't come to France."

"And I didn't," answered Schecky.

"But I'm in France." Alison was very puzzled.

"And I'm in your head. Or your heart. Or wherever," explained Schecky.

"What are you looking for?" asked Faith.

"I came here to find the best chocolates in the world," answered Alison who was still a little shocked by Schecky's sudden appearance.

"And discover your purpose," added Schecky.

"Shhh, let's just leave that out for now," Alison said to Schecky.

"That's the important part," he answered.

"You should listen to the duck," said Faith.

"Yeah, listen to the duck," repeated Schecky.

"If Schecky is in my head, or my heart, or wherever; how can you hear him?" asked Alison.

"It's an elephant thing," answered Faith, "I don't think you would understand."

Alison gave up on trying to understand this strange French elephant and turned to Schecky. "Okay, Schecky. What's your purpose?"

"I've always wanted to open a bakery."

"And...?"

"But I couldn't raise the dough."

Faith trumpeted a snort through her long trunk at the horrible pun.

"It's your purpose that we're looking for," said Schecky. "So maybe we should get on with it."

"You want to find the best chocolates in the world," chimed in Faith. "And you've come to Paris. Let me ask you, what makes you worthy of the best chocolates in the world?"

"What do you mean?" asked Alison feeling very uncertain about her decision to leave the farm and come to Paris.

"What do you offer the world in return for its best chocolates?" continued Faith. "This isn't just a take, take, take thing. If you want the best chocolates you have to offer up something worthy in return."

Alison was stumped. "I didn't know that. I'm not very wealthy."

"I'm not talking about money. What do you have, something from deep inside you, that you offer to the world?"

"I don't know."

"Listen to the voice in your heart."

Alison turned to Schecky, who said, "I got nothing."

"Nothing?" asked Faith.

"Nothing, nada, not a thing," said Schecky.

"But you would be willing to give it to the world, once you figure out what it is?" asked Faith.

"Oh, yeah, sure," answered Alison.

"Don't be so hasty. It's quite a thing to agree to give something when you don't know what that something is."

"I know."

"But you do know that you have something to offer the world?"

Alison swallowed hard and answered, "I think I do."

"Think?"

"I believe I do."

"And you will offer that to the world?" continued Faith.

"Yes. I will," answered Alison with more confidence than she really had.

"That's good enough for me," said Faith cheerfully. Alison relaxed and quietly looked at Faith. She seemed bigger than before, big even for an elephant.

"So where do I go from here?" asked Alison.

"Well first, you need to dress properly," answered Faith.

"What do you mean?"

"That costume isn't you at all."

"It's what I wear on the farm." Alison was wearing a simple cow bell and a leather collar. It was what all the cows on the farm in Alberta wore.

"Exactly. You've let the farm dictate your costume for you. You need to dress yourself. Maybe not a complete costume change, but something better than that."

"This is all I have with me."

"Traveling light? As an elephant, it's not something I'm familiar with," said Faith.

"You always bring a trunk!" exclaimed Schecky, and Faith trumpeted another loud snort. Then Faith produced a large trunk and started pulling various scarves, hats, and necklaces out. Faith would try first one scarf then another on Alison, silently conferring with Schecky, then trying a hat, then a hat-and-necklace combination, then a scarf and necklace, then another scarf until Alison was sure that she would spend the rest of her visit to Paris trying on clothes. Finally they agreed upon the perfect scarf, tied just so around Alison's neck.

"That is it. That scarf is you," declared Faith.

"I think it is. I think it really is," Alison agreed. "How did you know?"

"You've got to have faith," quipped Schecky.

"And luckily I am here," chuckled Faith.

"Well, it is just perfect. It is so me. I feel like I could go anywhere with this scarf. But I still don't know where to go. Where do I go from here?"

Faith paused and then answered. "To find the best chocolates in the world, I suggest we visit a chocolatier."

"There must be many chocolatiers in Paris," said Alison.

"Well yes. Not as many as you might guess, but several. But not just any chocolatier will do. Luckily for you, I know the chocolatier that we should visit."

Jimmy's voice spoke loudly. "She's hooked you and now she's reeling you in. *Come with me to the magic chocolatier.*"

"Who is this chocolatier?" Alison asked.

"He's my brother."

Jimmy's voice rang out. "Oh that's good—it's a family thing, just like the mafia."

"Are you still listening to him?" asked Faith.

"It's hard not to."

"Bring him along, my brother would love to meet him." And with that, Faith, Alison, Schecky, and Jimmy's voice made their way through the streets of Paris to the chocolate shop of Faith's brother, Doubt the elephant.

"I was wondering if you'd come by today," was how Doubt greeted his sister Faith.

"But you weren't sure," responded Faith.

"Not like you'd be," answered Doubt.

"This is Alison."

"I call her 'My Aim is True,'" added Schecky.

"Pleased to meet you, Alison, My Aim is True."

"You can hear Schecky, too?," asked Alison.

"It's an elephant thing," Faith explained again.

Then Jimmy's voice rang out, "if hearing voices in your head isn't enough of a sign that you're going crazy, hanging around with elephants—elephants for crickey's sake—elephants that can hear the voices in your head!"

"I can hear that one, too," said Doubt.

"Sorry," apologized Alison. "He doesn't mean to be so negative."

"Of course he does. That's his job," replied Doubt.

"What do you mean?"

"He's your critic. It's his job to criticize things, to be negative."

"To doubt?" asked Schecky.

"No, not to doubt," said Doubt. "He's always very positive about what he knows. There's no doubt in you, is there?"

And Jimmy suddenly appeared where only his voice had been and answered. "No. No doubt at all. I know this whole trip is nuts and talking to you just makes me sure."

"I see," said Alison.

"Do you?" questioned Doubt.

"No, not really."

"So you're starting to. Just there you doubted yourself. Not in a negative way, just in way that was open to exploration and questioned the surety of what you were thinking. That's doubt." Doubt paused and then feeling satisfied that the issue was settled as much as it could be, continued on. "So you come in search of chocolate?"

"I heard that the best chocolates in the world are in Paris."

"So you came."

"She followed her belief," added Faith.

Alison asked Doubt, "do you have the best chocolates in the world?"

"I don't know," answered Doubt.

"You would say that, wouldn't you?," laughed Schecky.

"What do you mean by the best?" asked Doubt. "I have some very good chocolates. But not even my clients would agree on what are the best of my chocolates. Some like the champagne truffles. Some are simply gaga over the milk chocolate mints. And yet others come from miles for my pepper chocolates." Doubt showed Alison his display counter full of different types of chocolates.

"Pepper chocolates!" shouted Jimmy, "that just proves it, this guy is nuts and this whole trip has just taken a sharp turn into disasterville."

"Why don't you get rid of this clown?" suggested Schecky.

"If only it were so easy, but somehow I don't think it is," said Doubt.

"I think you could get rid of him if you really wanted to," said Faith.

Alison looked slightly embarrassed by Jimmy. "I'd like to get rid of him. I didn't invite him along on the trip."

"I was invited," Schecky bragged and then looked down his considerable beak at Jimmy.

"Didn't invite me?" Jimmy burned with rage. "You didn't have to invite me. I go everywhere with you. Let's face it, Alison—most of the time I am you. You are me. We are one."

Alison cowered a bit. "Oh."

"It doesn't have to be that way. You can get rid of him. I know you can," said Faith.

"Send the miserable bugger packing," jeered Schecky.

"Just try," growled Jimmy. "You haven't got what it takes. I am so much a part of you, you wouldn't know who you were if I weren't around."

"I don't want you around anymore, Jimmy."

"Nice try, but I'm not going anywhere."

"Go away!" Alison yelled.

"Ha! We are like twins joined at the hip. And the surgery to separate us isn't approved." Alison looked at the others in desperation.

"Sometimes when you can't get away from something, your best option is to go towards it instead," suggested Doubt.

"Sort of a jujitsu move," explained Faith.

"It works for me. Sometimes," added Doubt.

"So what are you suggesting?" asked Alison.

"Embrace him. Embrace your critic," answered Doubt.

"I feel like I've been doing that my whole life."

"Like this," and Schecky grabbed Jimmy and hugged him saying, "I love you, man."

Jimmy pushed Schecky away breaking free from the hug. Alison saw the opportunity and grabbed Jimmy in a huge bear hug saying, "I love you, Jimmy."

Jimmy broke away from Alison. "Oh, get off it. You don't and we both know it. You may love being me, reveling in the negativity, criticizing everything—'oh your hands are so cold,' 'you don't care about us cows,' 'nothing on this farm works right,' 'the grain is all moldy.'"

Alison looked a little sheepish and admitted, "yes I do do that. And I even like it. A little."

"I'm a guilty pleasure," sneered Jimmy. "Only before now you never felt guilty about it."

And right there in the middle of Doubt's chocolate shop in Paris a strange thing happened. Jimmy started to sing. And dance. He sang:

> Guilty pleasure
> I'm a, guilty pleasure
> Guilty pleasure
> Doing the negativity rag.

Walking right in,
Tearing it down.
Just saying no,
Wearing your frown.

Guilty pleasure
I'm a, guilty pleasure
Guilty pleasure
Doing the negativity rag.

You can't do it,
Neither can they.
No, no, no, no,
Is all you say.

And on the last refrain, Alison joined in and sang and danced with him.

Guilty pleasure
I'm a, guilty pleasure
Guilty pleasure
Doing the negativity rag.
I'm a Guilty pleasure
We're doing the negativity raaaaaaag.

And when they finished Alison turned to Jimmy and said. "Yeah, I know that song. But I don't have to sing it. Good-bye, Jimmy."

"You can't get rid of me that easily."

"I may not get rid of you, but I don't have to listen to you. So get out of my face and give me some space."

"I'll be back," promised Jimmy as he slowly faded away into nothing.

After Jimmy had faded away and the other three had given Alison encouraging nods of approval, Doubt returned to the original purpose of the visit. "So, you are interested in chocolates. What kind of chocolate are you looking for?"

"I don't know," answered Alison.

"Good," said Doubt. "And what do you have to offer the world in return?"

"I don't know. Exactly. But I do know that I have something to offer the world."

"Also good. Perhaps you should sample some? This is a milk chocolate mint, very popular with many of my clients." Doubt gave her

the chocolate and Alison carefully bit into it. A look of amazement and pleasure came over her face. "Incredible. This is what I have been searching for!"

"It is better than the chocolate you have back home?" Doubt asked.

"We have chocolate back home?" replied Alison, suddenly realizing the answer to her own question. "I mean, of course we must. It's just that I've never had chocolate before and it never occurred to me that I could have gotten chocolate in Alberta. But this is so good."

Doubt gave her a dark chocolate ganache truffle. Alison carefully bit into it and again the look of amazement and pleasure lit up her face. "Oh my. This is fantastic. It's, it's, it's beyond words."

"Which one is better?" Doubt asked her.

"I don't know. They are both so good, but so different." Doubt quietly gave her a strawberry and crème fraiche chocolate. "Oh, this is so good, too," cried Alison as she tasted her third chocolate.

"Which is best?" asked Doubt.

"It's all good!" cried out Schecky.

"I don't know," said Alison.

"So this might be a little harder than you thought," said Doubt.

"I thought finding the chocolates would be the hard part. I was wrong."

"Chocolates are everywhere," added Faith. "Finding them is easy. Finding *your* chocolate is not so easy. But worth the effort."

"I really thought this would be the end of my journey."

"Instead, it's just the beginning," added Faith.

"I don't know where to go from here. Chocolates are everywhere."

"Chocolates are everywhere," repeated Faith.

"Chocolates are everywhere," repeated Doubt.

"What is a cow to do? Chocolates are everywhere," repeated Schecky. Then he waited. "No one is going to break into song, a quick rendition of 'chocolates are everywhere'? I guess not."

One by one, Doubt offered Alison a taste of every chocolate in his shop. Each was good, each was different, but none of them were Alison's chocolate. When they were done, Doubt sighed and said, "I've never said this before, but I think I have to say it now. The best chocolates are in Brussels."

Faith almost fainted. "Oh my! You are a Parisian, you are French. And you say the Belgique make better chocolates?"

Doubt answered her. "If I'm being completely honest, yes. Not all of the Belgique chocolates are better, but the very best are better than our best. Brussels is where you need to go."

Faith turned to Alison and said. "If he says this, it must be true."

"So I should go to Brussels?" asked Alison. "But I don't know any-one in Brussels or anything about Brussels.

"You must go where your journey takes you," answered Faith.

"And we know someone in Brussels," added Doubt.

"Yes, we do. Our sibling, Tenacity lives in Brussels," explained Faith. "We will go with you." And just like that, Doubt closed his shop for the rest of the day and the foursome travelled to Brussels. In no time at all they found Faith and Doubt's sibling, Tenacity, and quickly explained the purpose of their visit and Alison's quest for her chocolate.

"So you do not like my brother's chocolates?" asked Tenacity.

"Oh, no they were wonderful."

"But they did not speak to her," explained Doubt. "They did not call her. She appreciated them for what they were, but . . . "

"They didn't do it for her," added Faith. "Everyone must find their own best chocolate."

"And what better place to find them than Brussels?" said Tenacity. "The capitol of Europe, the city of Horta, the city of chocolate."

"And what better guide than you, Tenacity?" said Faith. "That is, if you will help us?"

"How could I say no?"

"Thank you," said Alison

"Thank me when we're done," responded Tenacity.

Just then Jimmy the farmhand appeared. "Oh please, all this sancti-monious, thank me when we're done, it's an honor, great journey—what a giant load of crap. You're talking about looking for some chocolate."

"Sorry about that," apologized Alison. "You can just ignore him."

"I say, let's gird our loins for the adventure and have at it!" cried Schecky.

"The duck, I like," smiled Tenacity. "And yes, let's gird our loins. Let's have a look at you, Miss Alison. Oh no, this won't do at all. You are just not dressed right." Tenacity got rid of the cowbell and col-lar and tried on a variety of accessories as Faith, Doubt, and Schecky judged what they liked. Finally they found a very fashionable necklace that went with the scarf and gave Alison a very sophisticated look.

"What about me?" asked Schecky, "don't I get some new threads?"

"I'm afraid not," answered Faith.

"This is a journey that Alison will have to take alone," added Tenacity.

Alison was a little alarmed by the idea of traveling alone. "I thought you and Faith and Doubt were coming with me. You said you'd guide me?"

"We will," replied Tenacity. "But the duck can't come. Him either," pointing toward Jimmy with more than a little disdain.

"I come all this way and now I don't get to come along?" whined Schecky.

"Sorry, Schecky," said Faith.

"I get no respect," complained Schecky.

"Take that one with you," added Doubt motioning toward Jimmy. And without another word Schecky and Jimmy faded away into nothingness.

Alison took a deep breath and turned to the three elephants, "okay, let's go."

"Lead on and we'll be right behind you," replied Tenacity, with the others nodding in agreement.

"Aren't you supposed to be guiding me?"

"I guide best from behind."

"It really won't work unless we're following you," added Faith.

"But I don't know where to go."

"Chocolates are everywhere," smiled Tenacity.

"You're going to sing aren't you?" said Doubt, clearly not wanting to sing.

"We'll sing as we search for chocolates," said Faith. "It'll help the time go by." And with that they headed out into the streets of Brussels, wandering from chocolate shop to chocolate shop and singing:

> Chocolates are my business,
> Chocolates are everywhere.
> Chocolate is my passion,
> Chocolates are everywhere.

And various verses as Alison tasted chocolate after chocolate. Until finally Alison was exhausted and just couldn't stand the idea of eating even one more bite of chocolate. She sang:

> This one's good, this one's fair,
> Okay, excellent, tastes like pie,
> Anymore and I think I'll die
> Chocolates are everywhere.

"How can there be so many chocolates in one city?" asked Alison.

"There's other cities and they all have their chocolates, too," answered Tenacity.

"I give up. I'll never find the best chocolate."

"Don't give up, dear," said Faith. "It just may take a little longer."

Never one to give up, Tenacity added, "come on, there's a whole quarter of town we haven't even been to yet."

"I really have to stop and rest." And Alison sat right down on the sidewalk where they were.

"Perhaps your chocolate isn't here," said Doubt.

"I am so tired of looking."

"You have to believe it's the looking that matters more than the finding," said Faith.

"You can't just give up," said Tenacity.

"I don't know if I can taste any more chocolates. They're all starting to taste alike. I think I'm getting a little burnt out."

"What do you want to do?" asked Doubt.

"I don't really want to give up."

"There's no question of that," said Tenacity.

"And I do believe I will find my chocolates. Some day."

"Amen, sister," said Faith.

"But not today. And maybe not here."

The three elephants stood beside Alison watching her carefully for a while. Finally, Alison looked at them and answered their unspoken question, "I feel like going home."

"Okay," Faith.

"Okay," said Tenacity.

"Okay," said Doubt.

"Okay? That's it, 'okay'?" said Alison in disbelief.

"If that's what you feel like," answered Faith, "then that's what you should do."

"But I haven't found my chocolate. I haven't completed my journey. I'm not done."

"No, you're not done," said Tenacity. "You're just going home."

"But I'll never find my chocolate without you guys. You're my guides."

"Don't worry, we won't abandon you," said Tenacity.

"You can't get rid of us that easily," chimed in Faith.

"You'll come home with me?"

"We'll always be with you," answered Faith. "Whenever you need us."

"I can call and book some tickets to Calgary."

"You don't need to do that," said Doubt.

"But you're coming with me?"

"We'll be with you when you need us," explained Faith. "Like Schecky. Or even Jimmy."

"Oh. I see. But I don't know if my head is big enough. It's already got a duck and a farmhand in it. I don't know if there's room for three elephants, too."

"Don't worry, dear. There's room," said Faith. "There's room in your head and in your heart."

And with that being said, the elephants said their good-byes to Alison. Alison made her way to the airport and enjoyed being quiet and alone on the long flight back to Calgary. In the Calgary airport, Alison suddenly realized that she wasn't sure where she was headed. She missed the farm, but she was also pretty sure that her chocolate was not on the farm. Just then Schecky and Jimmy found her. They greeted her warmly, or at least Schecky did.

"You didn't find the chocolates, did you?" said Jimmy. "You travel halfway around the world, only to come home empty handed."

"Get lost, Jimmy," replied Alison.

"Am I right?" asked Jimmy. "Where are the chocolates?"

"I said, get lost." And with that, Jimmy disappeared.

"So at least you've learned how to get rid of him," commented Schecky.

"He was right. I didn't find the chocolates. I mean, I found chocolates, but not the best chocolates, not my chocolates."

"You went to Paris and Brussels, you tasted a lot of chocolates, you met some pretty interesting elephants—it sounds like not such a bad trip to me."

"I did fail."

"Failure, schmailure."

"No, Schecky. Listen to me for a minute. This is not Jimmy talking, this is me. I went to Paris because I didn't know my purpose in life. It was never about the chocolates. Faith asked me what I had to offer the world. I didn't know. I still don't know. I'm back in Alberta and I don't know any more than I did when I left."

"You got some nifty new threads."

"These?"

"Yeah, those. And if I didn't know you so well, if I didn't live half my life in your head, I wouldn't recognize you. You're not the same cow you were when you left."

"Yes I am. What do you mean?"

"You dress differently, you walk differently. You tell Jimmy to take a hike. And they're here." Faith, Doubt, and Tenacity popped out from behind a row of chairs, waved hello to Alison and then disappeared back behind the chairs. "It's getting down right crowded in that head of yours."

"Sorry about that."

"Better than being empty headed. And the elephants are pretty fun roommates. A lot better than Jimmy was. Hey, how can you tell if an elephant's been in your head?"

"I don't know."

"Look for the footprints in your cerebral cortex. Hah! I tell you, they really put the grey in the grey matter. Thank you, I'll be here all week, two shows nightly, don't forget to tip your waitress."

"You haven't changed."

"You didn't let me use my 'A' material."

"That was your 'A' material?"

"What a tough crowd. I get no respect."

"So how am I different?" asked Alison.

"You've started the journey."

"But I didn't get anywhere."

"It's about the journey, not the destination. The journey never ends. Faith, Doubt, Tenacity—back me up here." Faith and Doubt appeared again.

"The duck's telling you the truth," said Doubt.

"Trust him, darling," added Faith.

"I don't know. I feel I failed."

"You tried. You're still trying," said Faith. "Do you feel different than when you left?"

"Yeah. Yeah, I do."

"There you go," said Doubt.

"That's it?"

"It's a start," said Doubt.

"Give yourself credit," added Faith.

"You're on your way," chimed in Schecky. "Before you weren't. Now you are."

"Okay. I'm on my way. Home."

"And the old farm won't know what hit them," added Schecky.

Tenacity, who had been curiously absent during the last discussion, came walking down the concourse toward the group, carrying a small box of chocolates. "Check out these. They come from right here in Alberta."

Alison tried one and her face lit up in an expression that was very far past pleasure. "Oh my," was all she said.

"Try another," prodded Tenacity.

"I don't need to. This is it."

"That's it?" asked Faith "The best chocolate in the world?"

"Yes. At least for me."

"Are you sure?" asked Doubt.

"I'm sure. This is it. This is the chocolate I was looking for. What is it?"

"That's a *Cinnamon Ginger* by Bernard Callebaut," answered Tenacity.

"I declare Bernard Callebaut's cinnamon ginger, the best chocolate in the world. For me," declared Alison. The elephants and Schecky cheered loudly and danced about wildly. When things had calmed down, Doubt asked, "do you know now what you have to offer the world?"

"What do you mean?" asked Alison, vaguely recalling an earlier promise that had something to do with offering the world something or other.

"You've found your chocolate," said Faith. "Now you have to pay the price. You have to give the world what you have to offer it in exchange for your chocolate."

"Can't she just charge it on the credit card?" quipped Schecky.

"You know, Alison," said Faith. "You know what it is."

"No I don't. I still don't."

"Yes you do, ma cher," prodded Faith. "Tell us. Tell us what you have to offer the world."

"Feel the chocolate," suggested Tenacity. "Reach down inside and feel how the chocolate makes you feel. Let that feeling come out. What is it?"

"It's warm and velvety and there's the unexpected bite of the ginger," answered Alison. "And the knowing richness of the cinnamon."

"Can you give that to the world?" asked Tenacity.

"I don't know."

"You have to let yourself have it first," said Faith. "You have to give yourself the chocolate. Only then can you turn and give it to the world."

"Enjoy that feeling," added Tenacity. "Let it takeover your whole self. From the tip of your nose to the end of your tail."

"Let it flow through all four of your stomachs," added Doubt. "Feel it in your gut. Feel it in your heart. Know it in your head."

"Do you have it? Do you feel it everywhere in yourself?" asked Faith.

"Can you give that to the world?" asked Tenacity.

"Can you share that with us?" asked Faith.

"Yes. Yes, I think I can."

Jimmy suddenly appeared. "Now I've seen everything. Feel the chocolate? Give me a break. This mumbo jumbo has just gone from the ridiculous to out where the buses don't run."

"Well Jimmy, maybe I need to go out where the buses don't run," said Alison. "I don't think I've ever been there and maybe it's time I went."

"Feel the chocolate!" chanted Faith

"Be the chocolate!" chanted Tenacity.

"And Jimmy, I'd be honored if you came with me," said Alison. "You've been a big part of my life and I just can't imagine taking this next part of the journey without you."

"Now you're just talking nuts," said Jimmy.

"Some chocolate has nuts," answered Alison. "Mine doesn't."

"What? What does that mean?" said Jimmy.

"I think she's got you there," chimed in Schecky.

"What does it mean to you?" added Doubt. "Are you the nut?"

"What do you say, Jimmy, it's going to be a great journey?" said Alison.

"Do I have a choice?" asked Jimmy.

"Not really," answered Faith.

"It's really gotten crowded in here," said Jimmy. "There used to be a lot of room before you elephants moved in. I liked it better then."

"You used to get your own way then," said Schecky.

"And you didn't talk so much," responded Jimmy.

"Come on, Jimmy," said Alison. "Be one of the gang. I need you."

"I don't know about this," said Jimmy. "Maybe you're trying to trick me."

"Jimmy. Look at me. Am I trying to trick you?"

"She looks genuine to me," said Faith.

"I don't get it. Why do you all of a sudden want me?" asked Jimmy.

"She's sharing her chocolate with herself," explained Doubt. "You're part of her and she has to accept that part."

"She's got to love herself before she can give that love to the rest of the world," added Tenacity. "Are you willing to be loved?"

"I don't know," said Jimmy. "I don't know what that means."

"It could be nice to learn," smiled Faith.

"So what do you say, Jimmy?" asked Alison.

There was a long silence as the three elephants, Schecky, and Alison looked at Jimmy. Jimmy shifted uncomfortably and finally said, "Okay. Okay, I'll come along." They broke into loud cheers and got in each other's way as they tried to high-five Jimmy. When things quieted down, Jimmy said, "So I'm here, what do we do now?"

"Now, we go on," said Schecky. "So did you hear about the dyslexic, agnostic, insomniac?"

"No, what about the dyslexic, agnostic, insomniac?" answered Doubt.

"He lies awake at night wondering if there's a dog," cracked Schecky.

Faith, Doubt, and Tenacity snorted loudly through their long trunks while Alison laughed hard and Jimmy tried not to laugh.

"I've got a million of 'em," said Schecky.

The end.

For me, *What's Your Chocolate?* shows a sense of the journey to finding your passion. For those of us who don't know from early on what it is, we find ourselves searching for it, finding it, searching more, finding it again (in what may be a completely different way), and so on—the journey never ends. Along the way, we need to have faith, doubt, and tenacity (the three legs of the Zen stool), and we need to deal with our internal critic. The questions, "what's your chocolate?" and "what do you have to offer the world?" are both useful guides for the journey. But, of course, there are many ways to take the journey, because it is the journey of countless spiritual practices, it is the one journey, the hero's journey.[10] And even those of us who know our passion from an early age take the journey.

Lessons for Leadership

The importance of passion has both some fairly obvious implications and some more subtle implications for creative leadership. On the obvious side is the importance of caring about what you are doing. On the more subtle side are questions around the relationship between passion, fanaticism, and authenticity.

Certainly, there is less chance of there being creative leadership if leaders don't care deeply about what they are doing. However, if we keep in mind that creative leadership is fundamentally collaborative (which I will explore more in chapter 5), it implies that the need for passion also exists among the followers—everyone involved needs to be passionate. This is certainly a high bar and we should remember that it is not an absolute relationship between passion and creativity, but one more typical of the sort of relationships we find in empirical work about people, a general relationship that has plenty of exceptions but holds when large numbers of cases are considered. Smoking doesn't cause lung cancer in everyone who smokes, but your odds of getting

lung cancer go way up if you do smoke. In the same way, passion gives us a better chance of producing creative leadership.

I have avoided saying passionate about what, by using the rather ambiguous phrase, passionate about what they do. Simply put, the question is whether that passion needs to be about leading, or about the activity that is being led, or both? Does a creative leader in engineering need to be passionate about both engineering and leading? This is a complex issue that I will discuss in more detail later, but the simple answer is yes. This has implications for picking leaders and brings into question the business practice of bringing in leaders from other domains. Can we expect someone who has been successful at leading an accounting group and is passionate about accounting to lead a research and development group? Even if they are interested in the products being developed, we must recognize that interest is not the same as passion. Passion produces action. I am passionate about playwriting—I don't write plays because I like to write plays or even because I enjoy writing plays, I write plays because I *have* to write plays. I am interested in environmentally friendly, energy-efficient technologies for my house, but I am not passionate about them. As a result, I haven't acted and my house is still the early twentieth-century, leaky, energy-pig it has always been.

Writing plays because I have to may sound more like obsession than passion to you. Obsession is the dark side of passion, or perhaps one of the dark sides of passion. "Crime of passion" is a banal cliché. "Crime of detached, intellectual interest" makes no sense. One of the other dark sides of passion is fanaticism. It is a short walk from being passionate about something to being a fanatic. The history of artists is filled with artists who were thought to be fanatics about their own work. The fanatic cares deeply about what they are doing and believes that they are fundamentally right about their own understanding and vision of the world. There is no room for other understandings or visions of the world. Their conversation between the senses and their own sense-making is closed in an important way. All of us have places where our own sensemaking is closed off and not open to being questioned.[11] It is more obvious and central for the fanatic.

The creative leader cares deeply about what they are doing and is committed to the craft process and discipline while being open to a variety of outcomes (I'll explore this in more depth in chapter 5 on collaboration). It is a journey of discovery, not a predestined trip to a known destination. There is a tension within this idea as the line between the process and the outcome is usually not clear. I may be

committed to making "insanely great" products and claim to not care much about what the actual products are, only to find out that I don't have any interest in an insanely great toilet cleaner (let alone have passion for it). As my passion narrows, I move closer and closer to fanaticism. I see the difference between fanaticism and passion as being about the three elephants. If have faith and tenacity without doubt, I am a fanatic. When I have all three I am acting with passion and have the foundation for creative leadership. Of course, too much doubt can prevent me from acting—creative leadership requires balancing the three elephants.

Balancing faith, tenacity, and doubt requires self-knowledge and self-awareness. The idea of following your passion requires enough self-knowledge and self-awareness to be able to tell what is your passion (or at least be aware of your journey toward it) and whether you are following it or not. Self-knowledge and self-awareness are major topics in leadership research and there is a large set of research findings that show a consistent relationship between self-knowledge and self-awareness (operationalized in a variety of different ways) and leadership effectiveness. Put overly simply, the more you know yourself the better leader you are. Self-knowledge and self-awareness were also important aspects of the creative mind-set that I explored in more depth in the previous chapter.

Related to self-knowledge and passion is one of the hot topics of current leadership thinking[12]—authenticity. When you care about something and you let others see that you care and are acting from something that really matters to you, others tend to see you as being authentic—because by almost any definition you are actually being authentic. This is an important by-product of following your passion. Thinking of authenticity as a by-product moves us from focusing on how to be authentic to how to follow our passion.

Passion in our leaders is something that we usually see in sports teams and political movements where the leader wants to get the followers "fired up." Before any professional football game in the United States, we can see players intensely screaming at and with their teammates. We see coaches delivering rousing pregame or halftime speeches and no one doubts their passion. This may well be an appropriate expression of passion in the violent, physical world of professional football, but it is by no means the only way that passionate leaders express themselves. In the theatre, directors generally don't feel the need to get their actors "fired up." Instead the actors are left to follow their own ritual for preparing for performance. The director may offer encouragement, speak

of particular technical details, and/or warm up the ensemble with a few exercises, and here as well no one doubts their passion. How a leader expresses and shares his or her passion differs with different contexts, and even within the same context different leaders will express their passion differently, each in his or her own way.

Learning how to express your passion is part of the journey of finding your passion. It is also a critical part of finding your leadership voice, that combination of skills and approach to leadership that makes your leadership unique. Your leadership voice will change over time, just as an artist's work changes over time, but there is also something recognizable and consistent over time that doesn't change. The voice is an authentic expression of your passion in a way that encourages collaboration and creative exploration and avoids fanaticism.

Exercises

To explore (or perhaps discover) your passion, try these exercises:

- Ask yourself the question, if I won the lottery and had all the money I ever needed, what would I do with my life, how would I want to spend day after day if money were no object? Explore your answers and look for what is at the core of them.
- Ask yourself the question, if I learned that the world was going to be hit by a giant asteroid and life as we know it is going to end tomorrow, what would I want to do tonight? Explore your answers and look for what is at the core of them.
- Make a list of all the things you wanted to be when you grew up at anytime in your life. What are the common elements, what themes emerge?
- Do *The Artists' Way* or *The Artists' Way at Work* program. You can buy the book[13] and try it out alone or with friends, or you could sign up for one of the many workshops that are offered.
- Think about these famous words from John Ruskin[14]:

Five great intellectual professions relating to daily necessities of life have hitherto existed—three exist necessarily in every civilized nation:

The Soldier's profession is to defend it. The Pastor's to teach it. The Physician's to keep it in health. The lawyer's to enforce justice in it. The Merchant's to provide for it.

And the duty of all these men is, on due occasion, to die for it.

"On due occasion," namely: The Soldier, rather than leave his post in battle. The Physician, rather than leave his post in plague. The Pastor, rather than teach Falsehood. The lawyer, rather than countenance Injustice. The Merchant—what is his "due occasion" of death?

It is the main question for the merchant, as for all of us. For, truly, the man who does not know when to die, does not know how to live.

What would you die for?

Collaboration

The vast majority of things that we want to do are bigger and more complex than can reasonably be accomplished by a single person. Simply put, that's why we need organizations—in order to find a way to work together. It is the classic and perhaps original problem of organizational theory—how do we coordinate the efforts of multiple people working together on a single task? Usually we divide the task into smaller parts and worry about how to coordinate those smaller tasks so they fit together. Although there may be some aspects of a group creative process that can be divided into individual tasks, the creative process in general and leadership in particular—even self-leadership—require collaboration.

Collaboration is not simply working together. Collaboration is not compromise. Collaboration is that wonderful, magical experience of two plus two equals five, an experience of synergy where the self is lost and the group is far greater than the sum of its parts. That is collaboration at its best, and of course there is also collaboration at its worst when you feel like you would have been better off working alone because not only have you not gotten much of anything done, you've wasted your precious time, gotten angry at your collaborators, and produced work that you don't want your name on. Good or bad, collaboration is part of the creative process—the idea of the lone genius is fiction, not true, complete hooey.

As a starting point, let's differentiate between implicit and explicit collaboration. Explicit collaboration is when we have agreed to create together and are jointly engaged in the creative process. Implicit collaboration refers to other people's work that has an influence on the

creative process. During the time I am writing this, I also read books, hear talks, go to art museums, talk about my ideas at dinner parties and conferences with others, and so on. I hear David Cooperrider say "management is at its best when it has a shared compass" at the BAWB[1] Global Forum, and that spurs my own thinking on collaboration. I see a preproduction version of Nancy Adler's leadership journal and I start to think about the cover art for this book and I am reminded of an abstract piece that my wife, Rosemary, painted for my birthday several years ago. Neither David, nor Nancy, nor Rosemary was explicitly collaborating with me on this project, yet all implicitly collaborated. I asked Fulton 214[2] for comments on various drafts of this book, so their collaboration is more explicit, but not fully, jointly engaged in the creative process. It is easy to dismiss this sort of implicit collaboration, but the more we succeed in being open to the work and the world as we do that work, the more that world influences us and our work in a variety of ways. Thinking of everything and everyone you encounter on a daily basis as an implicit collaborator helps you to be open.

Although it is important to not dismiss the implicit collaboration that is a vital part of every creative process, it is explicit collaboration that I want to focus on as it provides insights into the nature of creative leadership. A key aspect of collaboration is that the conversation between the senses and sensemaking is about a dynamic, ever-changing reality. In the examples in the previous chapters of the drawing and playwriting, the conversation between senses and sensemaking was about a static reality, an image or an event, that didn't change as the conversation went on. Leadership in a large organization does not take place within a static reality. Collaboration involves a conversation about a reality that is constantly changing—which is typical of the social world we live in, act in, and lead in. A good example of collaboration and how it works is theatrical improvisation.[3]

At the heart of improvisation is a structure in which one person makes an offer, the other person accepts the offer and builds on it and then makes an offer in return, which the first person accepts and builds on, and so on. To accept an offer and build on it is often referred to as saying "yes and," which is in contrast to saying "yes but," "no and," or "no but." An offer is a concrete action that implies a context and moves things forward. Let's take a simple example. Bill extends his hand to Jane. Bill does this with an intent and an understanding of the situation; in this case he has in his mind that he is greeting a business associate. Jane could take the offer of the outstretched hand in a variety of ways. Jane could shake Bill's hand and accept it in the way that Bill

intended it. Jane could also take Bill's hand and spin herself, which would imply that they are dancing. She could kneel and kiss Bill's hand, which would imply that Bill is royalty. The range of choices is only limited by Jane's ability to make sense of Bill's extended hand in different ways. Let's suppose she kneels and kisses the ring on his hand. She has accepted the offer of the extended hand and built a world where Bill is the Pope and she is a supplicant, so she makes an offer by kissing his ring. What Jane has done is completely consistent with what has happened so far, even though it is also a completely different sensemaking than that which Bill was working upon. Bill now has additional sensory evidence to work with and make sense of. He makes sense of Jane's action in a way that is different from what she intended when he responds by saying, "rise my love, we are alone, we don't need to pretend," and pulls to her feet. Jane now has new sensory evidence to add into her sensemaking—she and Bill seem to be lovers—and she changes her sensemaking to reflect that. Neither Bill nor Jane knows where the scene will go, if indeed it goes anywhere, as they cocreate it in the moment. It is a complete collaboration.

If we take a social constructionist[4] view of the world, which, to oversimplify it, suggests that our entire social world is co-constructed by the participants in it, then our day-to-day world is very much like an improvised scene. People do things, they stick out their hand at us when we encounter them, they say things, they build on things, and so on; and what those things mean is cocreated. We don't cocreate everything from scratch—usually we rely upon cues from the situation to pick the most likely meaning based upon our vast experience of being a human. Thus when a colleague sticks out his hand at the start of a business meeting we assume that he is offering to shake hands as a part of a greeting ritual. If the same person rises from the table at a wedding and offers his hand, we might take it as an invitation to dance. Of course, in most situations I am trying to figure out what is meant by the person who has acted and work with that intention, while in the collaborative world of theatrical improvisation, it is more interesting if I don't get their intention exactly right, but rather build upon their action and take it in a slightly different direction than they intended. Also, in the world of theatrical improvisation the actors are trained to accept the offer—to say "yes and"—whereas in the real world we often don't accept the offer—we say "no and" or "no but" or "yes but." That is to say, when someone offers their sensemaking of the situation, we disagree with that sensemaking in some sense and offer our own sensemaking. It is as if in the example above when Bill says, "rise my love,

we are alone, we don't need to pretend," Jane insists on her own sen-semaking saying, "you are the Pope and I am a young Nun whom you have never met and we are not lovers, nor is it possible that you could love me from afar because you are the Pope." This blocks the scene, and the collaboration stops going forward.

In most environments I have been in (military, business, and aca-demic), the sort of blocking that happens when we respond to each other by saying "no and," "no but," and "yes but" is common and has the same sort of effect on the collaboration. For example, here's a hypo-thetical situation: It's the weekly Monday morning sales meeting for a company that sells work management software to the information technology groups of Fortune 500 companies. The sales force is going around the room talking about their latest prospects. Pete says, "I was in Rochester and had some good discussions at Xerox." Jack responds, "Hey, Xerox is headquartered in Connecticut, so that puts them in New England, which is *my* region." This is certainly a legitimate point, but in the terms of improvisation Pete has made an offer and Jack has responded by saying, "no and." Jack doesn't accept the offer, certainly doesn't build on it, and makes no offer in return. This may lead to an interesting discussion or a nasty argument, but it is highly unlikely it will lead to a process of mutual building and exploration—that is, good collaboration. Jack might also have said, "That's great, Xerox has real potential. I know because the headquarters is in Connecticut in my region and I've been working on them for months." This is a "yes but" response, and although it may make Pete feel heard and even a little validated, it is still unlikely to move the conversation forward in a deeply collaborative way, because although Jack has accepted the offer, Jack doesn't build on it or make an offer in return. As an experi-ment you might try to notice how people in your world respond to actions—how many "no but," how many "no and," how many "yes but," and how many "yes and" do you hear? How many of each do you do over the course of a day? What happens as a result of each?

The mainstream business education of the late twentieth century does not teach us to say "yes and," it does not teach us to collaborate (even though it may try to teach us how to work better in groups and teams). It teaches how to make decisions[5] with the implicit assumption that the job of the manager/leader is to make decisions. We make deci-sions by gathering the relevant data and analyzing it according to the relevant methods and criteria to identify the optimal choice. Theatrical improvisation is not about making decisions, it is about creating a world together and moving the action forward within that world. Although

you could describe the way an actor builds on an offer and makes an offer in return as a decision, it doesn't feel like a decision in any cognitive, thought-out way. Actors are trained to not *think* about what to do next, but rather to just *do* what comes next. If you have ever seen an improv scene or game where an actor "thinks," you'll know that the actor "stops and thinks," and the whole scene stops cold—it dies.

There is, of course, something to be said for making decisions based on rational analysis. In a world where there are clear options to choose between and analytic methods that assume the future will work the same way the past did seem appropriate, you would be foolish to not do so. But creativity is not about making decisions regarding which of the available alternatives is the best choice, it is about creating a new alternative where none existed before. Creativity is about making choices, but not about making a choice from a set of well-defined alternatives using analytic reasoning. Rather it is about making a choice based in intuitive understanding. In its ideal form, decision making is based in logic and more specifically in deductive or inductive reasoning. Deductive reasoning applies general rules to a specific situation and inductive reasoning formulates general rules from a specific situation. Both are useful ways of thinking, but nothing new has ever come from deductive or inductive reasoning[6]—nothing was ever created based on analytical decision making. This is not to say that there is some huge choice to be made between creating and decision making, surely both could be done as appropriate. And there are other ways of working as well. For example, the American legal system follows a process of opposing advocacy with the belief that the truth will come out if there are advocates arguing for their perspective (he's guilty! she's innocent!). Many engineering organizations follow a process that is similar to opposing advocacy that is often called "high bandwidth communication." The engineers argue for why their idea is best and the other ideas are not, in the belief that such engagement will reveal flaws in the various ideas and eventually, as all of the data and reasoning comes out, the single best idea will become obvious to all concerned. There may even emerge new ideas from these high bandwidth discussions. To make this sort of high bandwidth communication work, there needs to be an underlying structure that is in many ways similar to improvisation.

One engineer I know calls it, "high bandwidth, high respect." The idea is that everyone has a lot of respect for the others in the discussion and thus they listen to what they have to say with the assumption that others might have some useful insight into the situation. This means that you must be open to influence from others and not take others'

comments personally. You also don't make personal attacks, but rather attack the idea that is being discussed. The focus is on the idea or issues being discussed and it is not about the people involved. This is similar to improvisation in the way you have to be open to whatever emerges from the process and you cannot control the process to make it go where you want it to go. It is also similar to improvisation in the way that ideas get built upon and transformed as the discussion goes forward. This sort of high bandwidth communication is difficult for many people because it requires the rather difficult separation of your self from your ideas. I often feel like I *am* my ideas, my creations, my work—especially when they are in their infancy—so it is very difficult to not feel defensive when those ideas are attacked. Nonetheless, high bandwidth communication does allow for real world constraints (such as the laws of physics) in a way that theatrical improvisation does not.

Creative Problem Solving is another approach that has elements of theatrical improvisation collaboration in it. Creative Problem Solving comes out of the work of Osborn and Parnes and is based in a conception of creativity as alternating cycles of divergent and convergent thinking.[7] There are a variety of tools, the most famous of which is brainstorming, in which groups of people try to produce as many ideas about a topic as possible without making judgments about those ideas. A modern proponent of brainstorming is the design firm IDEO,[8] and in their version they encourage crazy ideas—the wilder the better—with the explicit idea that someone's wild and crazy idea will inspire something in someone else who is participating in the session. In improv terms, they are hoping that a crazy offer will inspire a reasonable and useful offer. Brainstorming has more of a "yes, yes, yes" structure than a "yes and" structure, but it does get past the potential defensiveness and arguments of high bandwidth communication that can bog down the process and prevent it from going forward. Brainstorming and Creative Problem Solving point out two other aspects of collaboration that are not obvious in my discussion of the theatrical improv. The first is the importance of keeping the process moving forward. Actors are trained to move the action forward—that is, to act, not to do nothing. In the information technology world, the term "analysis paralysis" means that the process is not moving forward, and the dread associated with analysis paralysis is typical of how we all react to a process that is stalled.

The second thing that Creative Problem Solving highlights is the role of evaluation. In the analytic description of the stages of the creative process I presented in chapter 2, evaluation follows the elaboration of an idea. At first blush, theatrical improvisation doesn't seem to

have an explicit evaluation process, it would seem to be elaboration after elaboration with no idea (or offer) being rejected. Or perhaps as each offer is taken forward in a slightly different direction than was intended by the other actor (or actors), *every* elaboration is rejected. The difficulty with thinking about elaboration in regard to theatrical improvisation and collaboration is the movement from working with a static reality to working with a dynamic reality. The idea of evaluation is fundamentally in regard to a static reality—as I draw a picture I draw a line, then look at that line and decide if it is the line I really wanted or not. But in a dynamic reality, when it is time for evaluation the situation has changed. It is as if I was drawing a moving image, so the question of whether it is the right line to capture the essence of my sensemaking of what was there moments ago when I drew it no longer makes sense. The question is now, does it capture the essence of what I now see before me? Being dynamic also applies to the form. That is to say that the representation, the sensemaking, is the scene that is unfolding, and unlike a drawing you can't go back and erase a line because it doesn't just exist in two dimensions, it exists in four dimensions, with the fourth being time. If you were to stop in mid scene and say, that didn't work at all, let me try this instead, the scene dies.[9] You can have an off-line discussion to evaluate an improvised scene after it is completed, but at that point you can't change what happened, you can only hope to learn something about what happened in the scene that will be useful in future improvisations. All of which is not to say that evaluation doesn't happen during the scene, but that the nature of evaluation is fundamentally different from the sort of linear elaboration, then evaluation, process described in chapter 2. Evaluation happens concurrently with elaboration, and the question is not a simple "is this right or not?," but rather, "given what just happened, what could/should happen next?" It is not a conscious process, but rather a holistic, embodied process in which the actor has been trained to not consciously think about it (to not censor), but rather to just do.

It is not easy to listen to your whole self while being completely engaged in the moment and just do. We have been trained to think about what we're going to do and we have learned and internalized many rules of behavior that limit our ability to just respond. We learned not to back talk or sass our elders, we learned that there were things that shouldn't or couldn't be talked about, we learned that there were fundamental assumptions that could never be questioned, and we learned that in any situation there were a variety of undiscussable topics that could not be discussed or even acknowledged to exist. We learned

to save face and we learned that in many cases it is better to lie and protect others' feelings. All of this learning requires a very sophisticated self-censoring mechanism, which actors work very hard to overcome. Collaboration does not require that we stop all self-censoring, but there is a particular form of self-censoring that is particularly harmful to collaboration, which Johnstone[10] calls "status" games.

In most of our relationships we tend to behave in a way that shows that we are of either higher or lower status than the other person. The other person may behave in the opposite way, creating a very stable status relationship, or they may compete for the same position, with both people trying to be of lower status or both people trying to be of higher status. Relative status may switch back and forth as the situation changes. We are all so good at playing these status games that we generally don't consciously notice them. What actors have learned is that they need to stop playing status games in order to create good ensemble and have really good collaboration. Playing a higher or lower status closes off too many possibilities and prevents the actors from being fully open to each other. Status games are everywhere in our world, as they are the way in which we enact the micro-dynamics of power relationships.

When I was in my late twenties I worked for a software company and part of my job was to provide technical sales support. I was at a meeting with the salesman and several people from a company that was considering buying our software. Ostensibly my job was to answer technical questions and demonstrate features of our software. After the meeting, the salesman and I chatted about the meeting.

"Do you think Mr. Watkins was convinced?" he asked me.

"Maybe," I answered, "but the real question is whether Mr. Jenks was convinced."

"Watkins is the decision maker."

"But Jenks has higher status," I said. "Jenks didn't speak much, but when he did no one interrupted him and everyone paid attention. He also interrupted Watkins a couple of times. And the body language was very clear." Having done a lot of status exercises in my acting classes, I had learned to consciously pay attention to the status games that people play. Jenks was not the formal decision maker, but Watkins was very unlikely to buy the software if Jenks did not want it. Jenks and Watkins were not collaborating, even though they were working together—it was a straightforward case of one of the hidden power hierarchies that exist in every organization.

Leadership is strongly tied to power hierarchies in organizations. Generally the person at the top of any formal authority structure is

referred to as the leader. Leaders can be people without formal authority, but when someone is recognized as a leader, that usually suggests that there are followers, which in turn implies a hierarchy even if it is not formal. The usual way that this plays out is that the leader takes on a disproportionately large amount of the sensemaking for the group. The leader shares his or her sensemaking[11] (in what can be called sensegiving) and the rest of the group adopts the leader's sensemaking as their own (this is strongly connected to ideas about having a vision). This implies that if there is a creative process with the dialogue between senses and sensemaking at its core, only the leader is involved in that process.

This highlights a key tension between creativity and leadership. Creativity includes collaboration, which at its best is explicit and peer-to-peer—free of status games. Leadership implies a power hierarchy. This tension has been worked with for many years by military Special Forces. Special Forces squads have learned to shift back and forth between a very creative, collaborative, peer-like environment and a much more rigid, rank-based hierarchy. When a decision needs to be made and action carried out they follow the hierarchical command structure. When improvisation is called for, they become collaborative. The lesson being that leadership is not always about being creative or even fostering creativity but can also be about not being creative. When we think about the "burden" of leadership and the "loneliness of command" it is about times when leadership is not about creativity.

This tension between creativity and leadership can also be seen in the way artists think about leadership. Within the plethora of books on leadership there are almost no books on leadership by artists. An exception is Piers Ibbotson's book *The Illusion of Leadership*.[12] A former theater director at the Royal Shakespeare Company in England, Ibbotson sees leadership as an illusion. Michael Spencer, a longtime violin player in the London Symphony Orchestra, told me once that he wanted to write a book about leadership and he wanted to call it *Surviving Leadership*. These two book titles provide anecdotal evidence of how artists think about leadership, which is to say that they tend to not think of it, or be very suspect of the whole idea of leadership when they do think of it.

Ultimate Collaboration

Collaboration at a high level does not exist only in the arts and theatrical improvisation. If it did, we might link collaboration with not

having an instrumental purpose, saying that improvised scenes don't have to get anywhere, they don't have to do something, and leadership is all about getting somewhere and doing something. But we also see high levels of collaboration in great sports teams—teams that are also generally acknowledged to have great leadership. Of course, there is a certain amount of after-the-fact sensemaking going on here. The leadership and collaboration may be seen as great because the team was successful. Would the 2000 New England Patriots have been considered a great team and Bill Belichick considered a great leader if they had not won the Superbowl at the end of the year? They are now remembered for refusing to do individual introductions of the players at the Superbowl, and that has become symbolic of how team-oriented they were, but would that even be remembered if they had lost? My point being that both collaboration and leadership are judged in part based on the outcomes of the collaboration.

My personal experience of high level collaboration in sports comes from playing Ultimate (originally called Ultimate Frisbee[13]) for many years. I did not play on a nationally competitive team.[14] I primarily played on a coed team in what was first the Boston Area Corporate League and later became part of the Boston Ultimate Disc Alliance (BUDA) for about fifteen years from the mid 1980s through the early 2000s. Ultimate[15] is a very fluid sport in which your team attempts to move the disc up the field by passing it from one player to another, eventually completing a pass to a teammate in the end zone. The opposing team tries to stop this from happening, and when a pass is incomplete, the defensive team immediately goes on the offense. It is rather like soccer or hockey without the offsides, and a complete twenty-five yard deep end-zone the width of the field rather than a goal. However, unlike soccer or hockey, you cannot advance the disc or score by yourself—everything is done by passing the disc from one player to another. It is a game that requires working together, it works on collaboration.

Although the roster changed over the years, at the core was a group of people whom I had known and played Ultimate with in college. By the time I stopped playing, there were people I had been playing with regularly for over twenty-five years. My friend Tim Good, who is a professor of theater at DePauw University, told me once that there is no substitute for time spent together for creating ensemble. Many years of friendship and playing together were certainly a great base for collaboration on the field. Let me offer an example of what I mean by collaboration on the field. I catch the Frisbee about twenty yards from the end zone. I scan the field and I see a clear passing lane in front of

me to the front left corner of the end zone. I also see Frank running hard into the end zone. A defender is one step behind him. Frank has a variety of choices, he can continue his run deep into the end zone, cut sharply to either side, or curl back for a shorter pass. I know that Frank has a great love for the front corner of the end zone. As Frank crosses the goal line, I fake a forehand throw to move the defensive player who is guarding me to the right and open up space to make the backhand throw to the corner. I come off the fake and see Frank's stride change slightly as he prepares to cut. I throw to the front corner of the end zone slightly before Frank makes his cut. When Frank turns back to the corner, the disc is already in the air and his defender has no chance of responding in time as Frank slides to his knees to catch the goal. We have no explicit plan to do this, but both of us have seen the field the same way, that is to say we have both seen the same things (where all of the players on the field are) and made sense of them in the same way (a pass to the front corner could work) and acted on that at the same time. I admit that I have had many situations where I have seen the field, made the pass, and have my teammate cut away from where I threw the disc as we clearly did not make sense of the situation the same way. But it is those moments when we do make sense the same way, when we are completely on the same page, that feel like the epitome of collaboration.

In professional football in America, receivers and quarterbacks are taught to make specific "reads." That is, the receiver looks at the relative positions of the defensive backs and based upon that knows which pass route to run, which cut to make. The quarterback makes the same reads and knows which pass route the receiver will run. This is an explicit attempt to have the players see the same things and make sense of them in the same way. Frank and I had no agreed upon reads. What we had was years of playing together and talking about the game.

"I saw McCool running free, so I pulled up short so that my defender wouldn't be able to make a play."

"I thought you just misjudged it," Frank would respond.

To think of this sort of collaboration in improv terms, we were both making offers at the same time. Frank's cut to the corner of the end zone is an offer for me to throw him the disc. My throw to the corner is an offer for him to cut there. If I wait until his offer is out there, that is, if I don't throw it until he has made the cut, the defender will have a chance to break up the pass—I have to anticipate his offer. If Frank makes a cut that I don't anticipate and I say to myself, "oh that would have been perfect," I file that information away and look for that cut

if a similar situation occurs later in the game. In this way we see how the sensemaking is both anticipatory and retrospective, that is to say it is never just about that particular moment, but also about everything we bring to the moment from the past and everything we hope will come in the future. It is still a case of the actions of others influencing us and kicking off small sparks, but the process is more complex than the complex back and forth of an improvised scene.

You could say that Frank and I were on the same page when we made sense of the situation the same way, which raises an interesting aspect of collaboration. It is helpful to be on the same page, but if you are completely on the same page and make sense of the situation in exactly the same way, you lose the advantages of collaboration. You get Group Think and lose the interesting new sparks that take you to places you wouldn't have thought to go on your own. Being completely on the same page makes for exceptionally good coordination, but it does not create the wonderful two plus two equals five sort of synergy that comes from high level collaboration. Coordination is a classic problem of organization. Indeed, you can argue that organizations exist in order to coordinate effort. This is done through direct supervision, standardization (of processes, outputs, and/or skills), and mutual adjustment. Direct supervision allows for the possibility of collaboration, but because it introduces a clear power relationship it is likely to be one-sided. Standardization eliminates the possibility of collaboration, or at the very most it allows for collaboration in the domains where the standardization fails. Mutual adjustment, on the other hand, allows for collaboration of the sort in an improvised scene, or between Frank and me on the ultimate field.

Even though it was several years ago, I can recall throwing the disc to Frank, and countless moments like it, with great clarity. I can recall making a particular pass in a pickup basketball game. I can recall particular moments of improvised scenes from acting classes. I can recall all of these because I love the feeling of collaboration, that feeling of working together to create something that neither of you could have created on your own. The feeling of solitary creation, where the collaboration is implicit, is good, but the feeling of joint creation with explicit collaboration is better. That feeling is the great intrinsic reward of creative leadership.

Lessons for Leadership

The question for leaders is how to encourage collaboration and thus creativity in their own practice as well as in others' practice. Encouraging

implicit collaboration is in some ways very simple. Implicit collaboration means coming into contact with a wide variety of interesting stuff. It means reading broadly, visiting art museums, traveling; in short, it means having a full and rich life outside of your work, in which you are curious and open to the wonders that the world has to offer. It means that if you are in Paris on business you should take the time to visit the museums, to walk the streets, to sit in a café and watch the world go by—to enjoy the wonders of Paris.

Encouraging explicit collaboration is more difficult because of the power relationships, the reward structures, and the cultural conditions required for high level collaboration. Exceptional collaboration requires that we don't play status games, and yet the very idea of leadership connotes status. Reward structures generally reward the individual rather than the group. Collaboration requires a culture of high mutual respect, a willingness to play, and treating mistakes as interesting opportunities to learn. All of these ideas have been raised in the management and leadership literature at length in the arguments for a humanist, theory Y, enlightened—call it what you will—view of organizations.

There have also been hints of what leadership that enables and encourages collaboration looks like. Over 2,500 years ago, the Chinese philosopher Lao Tzu[16] said:

> To lead people, walk beside them... As for the best leaders, the people do not notice their existence. The next best, the people honor and praise. The next, the people fear; and the next, the people hate... When the best leader's work is done the people say, "We did it ourselves!"

This hints at a mode of leadership that encourages people to collaborate with each other. It also suggests a mode of leadership that is not about the leader's ego. A modern version of this is Jim Collins[17] idea of Level 5 Leadership. Collins looked at how good companies become great companies and found that it required leaders who had both fierce resolve and exceptional humility. I understand the fierce drive as helping to create a context where things need to happen and the humility as helping to create an environment where collaboration is the way that those things can happen. These leaders were not headline-making, charismatic figures. Collins was not looking for leadership as an explanation for how companies went from good to great, but he found it, nonetheless.

Of course, these large, somewhat abstract ideas about collaboration tell us very little about what a leader actually does to encourage and

enable collaboration, very little about what the practice of encouraging and enabling collaboration looks like.[18] One way to think about the practice of encouraging and enabling collaboration is to think of the leader as an artist whose medium is the sense of connection between people.[19] The leader works the context, the physical and cultural spaces where connection occurs, as well as works the connection between people directly. They use a variety of techniques, often inventing them as they go. It is a conscious practice in which the leader develops and refines his or her technique over time.

Exercises

To explore and develop your ability to collaborate, try these exercises:

- Make a tally sheet with the columns, "yes and," "yes but," "no and," and "no but." Keep track of every interaction you have by marking which column it belongs in. Keep track of others' responses as well as your own. What does that tell you about the world you live in?
- Go to a museum, read a Nobel prize–winning book, and tour a great work of architecture. What do these works of art inspire in you?
- At your next meeting, watch for the relative status of the participants.[20] Who is high status, who is low status? How do they enact these status differences?

CHAPTER SIX

Creative Domain

So far, I have suggested that if leadership is a creative process, then we need to focus on the practice of leadership, but I have not yet really talked about what the *practice of leadership* is (other than the example of the Action Inquiry skills at the end of chapter 2) or even what *leadership* is. This is in part because defining leadership and a practice of leadership is not as simple as it might seem. When Michael Jordan was leading the Chicago Bulls to six championships, when was he leading and when was he just playing basketball? When he would take the ball at the end of the game and make the winning shot, was that an example of his greatness as a basketball player or his greatness as a leader, or both? When the director of research and development for a consumer products company puts together a team to develop a new deodorant, is he or she being a leader? To answer these questions in any reasonable way, we have to define the domain of leadership.

An important question about creativity is how do we know if something is creative? How would we know if an act of leadership was creative? Within the organizational literature, something is generally defined as creative if it is both novel and useful. Many things can be novel but not useful in the "I've never seen anyone put on their shoes that way," as you may think that there seems to be no purpose in spending an hour to put on your shoes using only your tongue. And hopefully most of what we do in organizations is useful, if not novel—the same old thing, producing the same old result. It is only when something new has some value in terms of what we are trying to do that we describe it as creative.

But who is this "we" that determines if something is "new" and is "useful"? These two questions are not absolute and only have meaning

within a specific domain—thus, the importance of knowing what the domain is. An idea that has been kicking around the halls of evolutionary biology for years may be brought into the study of organizations where it is both new and useful. So the idea that is creative in one domain may not be in another. An idea that is useful in one domain may not be useful in another. So when we are talking about whether something is creative, we are really talking about whether it is creative within a specific domain. And what counts as novel and useful within a domain is determined by the gatekeepers for that domain. The gatekeepers are the experts who have the respect of the important others within the domain. Within some domains, gatekeepers are easy to identify. Within academia, gatekeepers are the editors of the high prestige journals and the high reputation professors at elite universities. Within the art world, the gatekeepers are art critics, curators, and to some degree the gallery owners and collectors. Within organizations it is not generally so clear.

It is very unusual for someone to make a significant creative contribution to a domain without having a good working knowledge of that domain. That is to say that you don't make an interesting discovery that is both novel and useful in physics unless you have a good understanding of physics. There are stories of outsider artists who are suddenly lauded as having made great art without any formal training or knowledge of the art world, but by and large that is more of a marketing story than an accurate description of events.

There is a truism about writing that says, to learn to write you need to write. And to read. And to have your writing critiqued. It's a process of doing, being helped to reflect on that doing, and reflecting on the work of masters in the field. You learn to read, not for pleasure, not for content, but for technique, for craft. How does Hemingway do that? How does Beckett manage to make a play work where nothing happens? What is working well in your own writing? A good teacher points you toward work that may help you in your own writing. After writing *Soft Targets*, the play with the job interview scenes in chapter 3, a teacher said that I should check out the expressionist playwrights who were writing in Germany right after World War I. It helped me figure out what I was doing and how those who were more skilled than I did it. For those of us who are lucky enough to work in organizations that have great leaders, we can learn a lot by watching what those leaders do and all the while critically assessing how they do it.

Learning domain knowledge changes how you interact with the domain. When I was an undergraduate, I took the third course in the

standard physics sequence that was on waves and optics. We spent a week on rainbows. We looked at how light reflected and diffracted as it encountered a raindrop. We calculated where the primary, secondary, tertiary, and quaternary rainbows would appear in relation to the sun. We calculated the relative intensities of the rainbows. I learned that you generally do not see the primary rainbow because it requires looking almost directly at the sun—it is the secondary rainbow we see. And when we see a double rainbow, it is the secondary and the quaternary we see. The quaternary is much less intense, so we seldom see it, even though it is always there. I stopped looking at rainbows and saying to myself, "wow, isn't that beautiful."

As I learn a domain, I am learning the content of the domain and the rules of the domain. The content tells me what is part of the domain and what is not part of the domain. For physics, I learn that everything that happens in the physical, nonliving, material world is part of the domain, but that what happens in the living and nonmaterial worlds, such as when I have a pleasant conversation with someone, is not part of the domain. The rules of the domain define what I am supposed to do in order to be a proper physicist. For example, I am supposed to ask how physical processes work and write precise mathematical formulas that allow me to predict what will happen in a specific situation. I should discover that the gravitational force between two objects is proportional to the product of the masses of those objects and inversely proportional to the square of the distance between the objects. I should not ask why this is the case.

The line between content and rules is not particularly sharp, nor does it need to be. The main point is that we tend to be explicitly taught the content of the domain, and often the rules of the domain are tacit assumptions that everyone in the domain knows and follows but are not spoken. For example, when I watch a movie, I say to my wife (who has a degree in film and considerable domain knowledge), "that was a gratuitous match cut," or "oh, there's plot point one[1] and we're off to the races." *Match Cuts* and *Plot Point One* are part of the content of the domain, and the domain knowledge gives me a language for talking about the technique and craft skills of what is happening in the drama. *Plot Point One* is part of the language of dramatic structure and refers to the point that happens about twenty to twenty-five minutes into a two-hour, feature film where something happens that kicks off the main action of the drama. For a stage play it is often called *The Inciting Incident*. For example, in the 1939 classic film *The Wizard of Oz*, Plot Point One is when the tornado picks up Dorothy's house and she lands

in Oz. This kicks off the main action of the film, which is Dorothy's search for a way to get back home. The unspoken rule for feature films is that the film must follow the standard dramatic structure.

There is a truism in writing that says that you have to know the rules before you can break them. For example, in my first class on playwriting, the professor, A. R. Gurney, Jr., talked about Chekov's gun. He said that if you bring a gun onto the stage, someone has to use it. You can't have a character come onstage, wave a gun around, and then not have the gun be used later on in the play. The gun has established an expectation, and plays are a tight form in which nothing should be wasted. Every action moves the plot forward, and big actions like bringing a gun onstage must move the action forward in an important way—the gun must be used later in the play. The rule tells us something about the relationship with the audience—if you bring a gun onstage and don't use it, you're just messing with the audience, setting up an expectation and then not living up to it. Of course, playwrights do break the rules, and often what is considered the most creative work in any domain breaks the rules in an important way. But the rule on rule breaking is that rule breaking must serve a larger purpose and be done intentionally. It is not done willy-nilly just for the sake of breaking rules, nor out of ignorance of the rules.

Domain knowledge is never complete, that is to say no individual ever knows everything there is to know within a domain. I am always learning new things about writing—whenever I read something, whenever I see a good movie or play, I learn something new about my domain. This means that I am constantly open to learning and always looking to improve my practice. Not long ago, my friend Nancy was at the Banff Centre as an artist in residence and she invited me to her studio. Another friend who was also a painter, Alistair, was in Banff and had spent the day with Nancy painting in her studio. Nancy and Alistair spent the day sharing techniques and trying out different ways of painting that they learned from each other. Both had a lifelong practice as painters and both were excited to learn new things about their domain.

The Domain of Leadership

Let's go back to a central question—what is the domain knowledge required for leadership? Do you need to have domain knowledge in the domain being led—that is to say, do you have to know engineering to lead engineers? Is there a separate domain of knowledge called

"leadership," and if so, do you need to have a good working knowledge of that domain? If you do, of what does that domain of knowledge consist?

Any description of the domain of leadership is based in a specific conceptualization of leadership. In the early twentieth century, researchers tried to identify the traits of a good leader. It turned out that one of the most consistent traits that leaders have is above-average height—leaders tend to be tall. Researchers then tried to understand leadership in terms of behaviors. The next move was to look at the context and distill contingency theories of leadership—what is the best way to lead in a given situation? There has been research into followers and followership as a way of understanding leadership. We have theories of charismatic leadership, transformational leadership, and authentic leadership. In short, there are almost as many ways of thinking about leadership as there are people who think about leadership. I have not the intent nor capacity to discuss them all,[2] but will instead draw upon some ideas that I find useful.

One way of thinking about leadership is on a continuum from indirect to direct.[3] Indirect leaders are people such as Albert Einstein, whose work had a huge impact on his field of physics as well as the rest of society in the twentieth century. Direct leaders are people such as President Ronald Reagan or Prime Minister Margaret Thatcher, who led their country. Most of the research and thinking on leadership implicitly works with an idea of direct leadership, but I will start with indirect leadership because that tells us a variety of useful things about the domain of leadership.

The purely indirect leaders excel in their domain—physics for Einstein—and there is no question of a second domain of leadership knowledge. This is perhaps the simplest form of leadership, sometimes called "modeling," sometimes referred to as "walking your talk." This is a type of leadership that plays a strong role in sports teams. The star players are often leaders because they are stars, because they get better results than the other players. Those better results are often associated with better practice habits, coming in earlier, staying later, and working harder than anyone else. Of course, when those practice habits don't produce superior results in the game—think of the less than talented athlete who has to work harder than anyone else just to make the team—they aren't seen as leaders in the same way.

Staying with sports teams, those same stars are often not just indirect leaders who lead by example, but also direct leaders who take on "leadership" activities such as calling out other players when their

performance or practice ethic isn't up to par or keeping everyone relaxed when needed. Such players are often made the team captain, which is the beginning of a hierarchical authority structure. It is a different form of leadership when a teammate critiques another player than when a coach critiques the same payer. The introduction of an authority hierarchy starts to bring in issues of power, command, management, and administration that get conflated with direct leadership. Researchers are fond of trying to identify the differences between concepts such as management and leadership, and certainly we have all probably heard something like, "management is about doing things right; leadership is about doing the right thing." The same distinction can be applied to the difference between efficiency and effectiveness. But for most people in organizations it is not particularly helpful to make this distinction. You need to do the right things *and* you need to do those things right. That is to say, you have one practice, one set of things that you do on a day-to-day basis and some of that could probably be called administration, and some of it could be called leadership, and some of it is probably an actual functional discipline like engineering or marketing or finance, and some could be called exercising authority or decision making—you could slice it and dice it in a variety of ways, but it is still *it*, your practice is still your practice. Power, formal authority, and countless other things play a role in that practice, and focusing on your practice with these various lens in mind will provide different insights into your practice.

However, I am not going to let myself off the hook that easily. It is still important to define what leadership is if we are to get an understanding of the content and rules of the domain. In its broadest sense, I think of leadership as being a force that moves organizations. Just as Newton's laws of motion tell us that an object at rest tends to stay at rest and an object in motion tends to stay in motion unless a force is applied to that object, I think that an organization at rest tends to stay at rest and an organization in motion tends to stay in motion unless leadership is applied to that organization. This rather amorphous idea of leadership as a force is broad enough to include leaders, followers, and the spaces in between them. It doesn't tell us anything about the content or rules of the domain knowledge for leadership, but it does help to draw some boundaries around the idea in such a way that not everything is leadership.

The idea that leadership is a creative process is a short step from the rather common idea that leadership is an art. This is often used to suggest that leadership is not a science and thus can't be defined with any

precision. However, some authors[4] have taken the idea further than that. Leadership theorist Keith Grint offers a model of four arts of leadership: (1) the philosophical art of identity, (2) the fine art of strategic vision, (3) the martial art of organizational tactics, and (4) the performing art of persuasive communication. Grint[5] says:

Leadership is critically concerned with establishing and coordinating the relationships between four things: the *who*, the *what*, the *how*, and the *why*:

- *Who* are you?—An identity.
- *What* does the organization want to achieve—A strategic vision.
- *How* will they achieve this—Organizational tactics.
- *Why* should followers want to embody the identity, pursue the strategic vision, and adopt the organizational tactics—Persuasive communication.

This suggests that rather than looking for one practice of leadership, there are at least four different practices for leaders—all of which they need to master. There may also be various arts and the associated practices of those arts for followers. Looking at a practice in detail is one way to start to map the domain of leadership. For example, when we look at the practice of drawing, we start to understand what a drawer does and what domain knowledge is associated with doing that. If I am drawing a house I need to be able to scale that house down to a size that fits on the paper. Thus, part of my domain knowledge for drawing is a knowledge of scaling. That knowledge may not be explicit; that is to say, I may not be able to tell you the conceptual principles of scaling or even explain how I do it, but I must be able to do it, I must have an embodied knowledge of scaling. The same is true for leadership. So following Grint's model, as a leader I need some embodied knowledge of persuasive communication (as well as the other three arts); that is to say, I need to be able to communicate in a persuasive way. For Einstein this was through the scientific articles he wrote, for Martin Luther King, Jr. it was through his speeches.

Grint provides one answer to the question of what leaders do with his four arts of leadership. Another answer comes from Barbara Czarniawska,[6] who describes leadership as service and ascribes three functions to leaders. The first is to set the orientation of the company in the future—to set the strategic direction. The second is to represent the organization to the rest of the world. The third is to play an important

role in creating the organizational culture. All three of these are services that the organization needs and the direct leader (generally the CEO) provides, much in the way that accountants provide accounting services such as monitoring the cash flow and preparing profit and loss statements for the organization. In this sense, leadership has no special place, it is simply one more function of an organization that needs to be done by someone within the organization. In all three cases the leader's role is to represent the organization. Setting a strategic direction is about representing where the organization wants to go and what the organization's identity is for both people inside the organization and outside of the organization. Representing the organization to the rest of the world is about being the embodiment, the public face or persona that the world outside of the organization associates with the organization. And the leader's representation of how people are expected to behave (partly through modeling and partly through explicit talk) is an embodiment or representation of the organizational culture[7] for those within the organization. This is very similar to Howard Gardner's[8] conception of leadership as relating and embodying the identity story of the group.

Czarniawska points out that what is most interesting about these three functions is what they do *not* include—the leader does not determine what others in the organization do, nor do they make decisions. Researchers have consistently failed to show a link between leader behavior and subordinate productivity. Research also shows that although decisions happen, they happen in a more collective and less linear manner than we might imagine. That is to say that the image of an organization as a machine where those at the top make decisions and those decisions are executed by those at the lower levels bears as little resemblance to what actually happens in organizations as Coleridge's account of the creative process does to how creative processes actually unfold.

If we compare this back to the competency model from the Banff Centre in chapter 2, we see something of how these functions are translated into practice. The first competency was *Self-Mastery*, which serves as a foundation for being able to consciously make choices about the representations that the leader is embodying. The second competency of *Futuring* is about setting the strategic direction. The third competency of *Sense Making* is critical for making explicit representations about the complex and ambiguous nexus that is an organization. I understand the fourth competency, *Design of Intelligent Action*, as a practice for communicating the organizations strategic direction and

translating that strategic direction into day-to-day action or what Grint would call *tactics*. The fifth and sixth competencies, *Aligning People to Action* and *Adaptive Learning*, are practices for shaping the culture in a positive way.

Still, all of these practices are somewhat abstract and perhaps difficult to relate to what people do in organizations. Finnish researcher Perttu Salovaara[9] looked at the leadership practices of a large manufacturing company and identified four themes: (1) answering questions, (2) knowing, (3) delivering results, and (4) confronting. These were the practices that the leaders within the organization themselves saw as leadership. These practices highlight how leaders practice leadership on a day-to-day basis and where the other conceptual models of leadership offered us ways to make sense of the content of the leadership domain, this also starts to hint at some of the rules of leadership. For example, perhaps a leader confronts others because in addition to having the content knowledge of how the group is expected to behave, the leader is expected to enforce that behavior. This is a step beyond simply representing the group or embodying the identity story of the group. We might also guess that the leadership practice of knowing implies a rule that the leader must be an expert. This may mean being an expert in a functional domain, but more likely it implies that the leader is an expert in how the organization works and how to make it work, which is connected to the practice of delivering results.

I am rather tentative in identifying rules, as I know of no research into the rules of leadership and there may well be very different rules for different organizations. Leadership research has focused on the content, and even there we have to recognize that there is no agreed upon way of defining that content. But, as a playwright, I know that the knowledge of domain content alone is not enough to be creative in the domain, I need to know the rules—if only to know what rules I want to break. So if I am a political leader in the United States, a duly elected official, I need to know that there is a rule that says, "don't be a hypocrite." If I base my political identity in pushing for the importance of family values, I should not have an illicit affair. If I base my political identity in promoting peace, I should not support war. Or if I am going to break that rule, I need to justify why I am ostensibly being a hypocrite—explaining why supporting a war is really about promoting peace in a wider sense. And I should be prepared for the uproar that comes when you break the rules. Artists often like this sort of uproar, but leaders may not.

Recap

Within the context of thinking about both the content and rules of the domain of leadership, let's revisit where we have been. In chapter 2, I talked about creativity as a process. Rather than focusing on the creative sparks, the focus should be on the elaboration, the practice. Focusing on the sparks makes being creative a random, unmanageable event based in divine inspiration. Focusing on the practice makes being creative the result of hard work and practicing your practice. For creative leadership, a focus on the practice means shifting from focusing on the leader's vision to focusing on what the leader does on a moment-by-moment basis. This means thinking about the content of the domain of leadership in a different way than has typically been done by leadership theorists. It means that the creative leader is more concerned with the execution of a strategy than with the brilliance of the strategic value proposition. It means that the hard work of operations is more important than the glory of intellectual property. For leadership research and development it means that we need to pay attention to the moment-by-moment practice of leading more than the lofty visions or great speeches of leaders (which, of course, requires much more difficult and labor intensive research methods).

A creative mind-set means paying attention to what your senses are telling you about the world and maintaining an active, ongoing conversation between senses and sensemaking as you seek new ways of making sense of the world. If we take this as a rule for leadership—that leaders should maintain an active dialogue between senses and sensemaking—it raises multiple tensions. As an organization grows larger, it becomes harder and harder to stay in direct contact with what is happening—you lose the direct sensory experience of the organization, of your customers, of your problems, of your people. Modern management approaches attempt to substitute numerical data for the missing sensory data, but numbers are an abstraction that has been stripped of its richness. It is hard to make art from numbers and it is hard to engage in an ongoing dialogue between the numbers and your sensemaking. Numbers convey a finality and a certainty that tends to freeze understanding into a static frame. On the other side of the conversation, there is a strong need from members of an organization to have a sense of stability and confidence in the leaders (there may be an implicit rule that leaders are expected to be consistent). Constantly shifting sensemaking and sensegiving can undermine that. As action is based in a specific sensemaking, there needs to be some stability in understanding in order

to do anything.[10] The danger here is that forces that push us to stick with a specific sensemaking are very strong. The creative leader has to fight sensemaking inertia without destabilizing the organization.

In chapter 4, I talked about the importance of passion for what you do. For leaders, this is one of many reasons that self-mastery is important and suggests that the self is a critical part of the content of the domain knowledge. The creative leader needs to know what drives them, what they care about, and why they care about it. The creative leader also encourages others to find their passion and follow it. Of course, this may leave us with seemingly vital roles in an organization unfilled—what does it mean if we can't find anyone who is passionate about doing cost accounting for industrial abrasives? Does the creative leader take a somewhat Zen or perhaps Maoist[11] approach and help people to become passionate about whatever role they find themselves in? Or does the creative leader work to find different ways of organizing ourselves that don't include jobs that no one is passionate about? Here, we should not confuse passion with an immature and short-sighted hedonism in which you only do what you feel like doing in the moment. Passion is within the context of a disciplined practice. I don't always want to write,[12] but I do have a passion for writing. The creative leader is deeply connected to what they do and fosters that same sort of connection in others.

In chapter 5 on collaboration I raised the issue of the tension between power hierarchies and collaboration. Another way of putting this is the tension between mutuality and authority. A creative leader must do both—exercise authority and create mutuality.[13] Authority and power can be used to encourage (force is too strong of a word) collaboration in what has been called unilaterally creating mutuality. This is a difficult dance and requires giving up control of outcomes in the way that theatrical improvisers give up control of where the scene is going. However, it also requires keeping control of processes—such as working to make sure everyone follows the rule of "yes and" in an improvisation. Giving up control, or perhaps more accurately giving up the desire for and illusion of control, can be very liberating. I don't have any data to back this up, but I have often thought that many people become managers and try to rise in organizational hierarchy in large part because of their desire for control. If that is so, then the very leaders who I am suggesting need to learn to give up a desire for control are the portion of the population who most desire it, and perhaps you are one of them.

The idea of domain knowledge that has been the topic of this chapter also highlights the conception of leadership as a practice, but in

a different way than chapter 2 did. Domain knowledge takes an intellectual rather than an embodied look at practice and raises questions about what we have to know to be a leader and practice leadership. I suspect that the answer is different for each of us and that it is also constantly changing for each of us. I can always learn from others' practice of leadership and expand my own domain knowledge and repertoire of practice. For an artist this is a good thing, as it is one of the ways that you keep things interesting—by always learning. Many organizational theorists[14] have touted the idea of learning organizations and have suggested that we all should be constantly learning. Creative leadership suggests that a critical part of this learning should be focused on our own practice.

Implications for Leadership

In many ways the picture of leadership that I have been developing is not very different from a lot of the current, normative ideas about leadership. The leader serves the organization, they should be passionate about what they do, they should foster collaboration, be participative in what they do, and make sense of events in a particular way. However, it is different in the way that it focuses on leadership as a practice. In the arts, we recognize that being a practice means that one devotes a lifetime to that practice, constantly learning and changing, exploring and developing. Such a practice cannot be defined in absolute terms—there can be no single, definitive theory of leadership as a practice. There could be schools of practice, but within each school, each leader practices leadership a little differently. Roy Lichtenstein and Andy Warhol both painted pop art, but even the most casual fan can tell a Lichtenstein from a Warhol in the first glance.

As an example, let's look at how the Tisch school of drama at New York University teaches acting to its undergraduates. Incoming students are assigned to one of several acting studios, such as the Stella Adler Conservatory, the Meisner Studio, or the Lee Strasburg Studio. Each studio teaches the practice and craft of acting in its own unique way.[15] The students study at the studio for two years and then have the option of doing advanced work in that studio or one or more of the other studios. I can imagine leadership studios based in various leadership development approaches, such as Kouzes and Posner's *Leadership Challenge*,[16] authentic leadership,[17] charismatic leadership, or servant

leadership. Students of leadership would first develop their practice in a particular studio and then later enrich their practice with other approaches.

Approaching leadership as a practice means that we focus on the whole practice. It is pointless to try and separate your practice as a leader from your practice as an engineer when you are leading engineers—it is all one practice. The implication of taking a holistic approach to leadership is that we would stop trying to separate ethics from instrumental effectiveness. In other words, the classic question of leadership about Adolf Hitler as a leader becomes moot. We know that his practice was unethical by almost any ethical standard, regardless of how effective it might have been in certain respects, and we have to look at the practice as a whole.

Too much of our modern approach to leadership development and management education is based in separating practice into disciplines. We teach finance in one class, operations in another, marketing in another, and interpersonal skills in yet another. There are, of course, many reasons for separating these in order to teach them, but there is also a cost. It may be overstating the case to suggest that the financial meltdown of the fall of 2008 was caused by analytically separating things that are indivisible in the real world, but it certainly was greatly facilitated by that separation. Mortgages were separated from the physical houses, ethics was separated from financial return, value was separated from the tangible world and lives of ordinary people— all necessary steps in creating the gigantic house of cards that was the financial system that came crashing down.

For me, one of the greatest separations has been the separation of the aesthetic from the instrumental and ethical. Aesthetics have been relegated to the world of art and been given at best a marginal place in the business world.[18] We may care a bit about the aesthetics of product design and advertising, but ideas about beauty and other aesthetic categories seem to have no place in the mainstream discussion of leadership and organizations. However, aesthetics has a central role in creativity and thus a central role in leadership as a creative act. It is our aesthetic sense that guides the dialogue between senses and sensemaking— leading us toward the beautiful, the sublime, and the sacred, and away from the ugly, the disgusting, and the grotesque. It is our aesthetic sense that guides our practice as a whole, that deals with the complexity of leadership practice without analytically separating it into functional components. Aesthetics is also one way to separate a craft from an art, but more on that in the next chapter.

Exercises

To develop your awareness of your own domain, try the following
exercises:

- Keep track of everything you do over the course of a day, or even
 a few hours. Break it down into individual actions. What are the
 things that you do over and over? What are the things that you
 did only once?
- What is the one thing[19] that if you got better at it would have the
 most impact on your life (and the lives of those you interact with)?
 What could you do to get better at it?
- What have you often thought about doing that you know would
 be "breaking the rules" of your domain? What is the rule that you
 want to break? Why does that rule exist?

CHAPTER SEVEN

Craft and Art

So far I have been exploring the way in which the craft and art of leadership are similar in that they are both creative processes. I now turn to looking at ways in which they are different and how the two interact in the dance between craft and art.

Let's start with a case where craft aspires to be art and fails. Consider the B movie (or the bad made-for-television movie, or the direct to DVD movie). What is the difference between a B movie and a great movie that might be considered a work of art? I have to believe that the creative process in both is similar—in both cases it is a process where the script gets written and rewritten, designs are created, scenes are acted and filmed, it gets edited, and so on. But in the case of the B movie we say that the writing is poor, the lines are cliché or banal, while with the great movie the lines are memorable, surprising yet believable. In the B movie the acting is wooden and inauthentic— it doesn't seem like real people doing things, but rather actors saying lines. In the great movie, the acting moves us; we believe in the reality of the scene and more than that we feel what is going on for the characters in a way that we don't often feel for most of the other people in our world. In a sense, the artists (actors/writers/director/designers) in the great movie have transcended their craft to the point where the craft has disappeared. In the B movie, we see the actor emoting wildly and are aware that they are crying to indicate their distress. In the great movie we are no longer aware of the craft, we simply feel their distress. The aesthetic experience is rich and strong enough to reach us directly and bypass our intellectual, cognitive filtering.

In this example, the craft of filmmaking (which is really a set of different crafts—writing, acting, directing, editing, and so on) fails to become art—even though there is desire to do so—because the aesthetic experience is not strong enough. When we are not completely engaged by the aesthetic experience, we tend to engage in our cognitive, intellectual, and usually skeptical mind and question the artifice, the artificiality of the craft. When the writing is not very good, we say to ourselves, "what a banal cliché," or "no one would ever say that." When the acting is great, we don't say anything to ourselves, instead we cry (or laugh). This is certainly not the only way of thinking about the relationship between craft and art, but it does point toward a way in which the craft of leadership becomes the art of leadership. In this way, when a leader's craft skills of leadership are executed in a way that produces a very strong, felt response in others, we might start to speak of it as an art of leadership, or perhaps more simply, artful leadership. Of course, the easy example of this is when a charismatic leader, such as Martin Luther King, Jr., gives his *I Have a Dream* speech. The pure, aesthetic power of this speech is overwhelming and it was impossible to hear it in its original context and not be moved.

We tend to make a rather straightforward aesthetic judgment of the relative quality of the B movie versus the great movie (which is implicit in the adjectives "B" and "great"), that the great movie is better than the B movie. We would say that the acting is better, and the writing is better. We tend to attribute this to the individual—the actors in the great movie are better than the actors in the B movie, the writer in the great movie is better—even though we may have seen the actors in the great movie give lousy performances in other movies. The premise being that some actors have more talent than others, which comes across as they show greater skill in producing a richer aesthetic experience. We intuitively apply this same reasoning in other domains as well, such as when we say that Wayne Gretzky and Sidney Crosby are incredibly talented hockey players and that talent translates into their amazing puck-handling and goal-scoring skills (which many hockey fans, such as myself, describe as being beautiful and emotionally moving in much the same way that an exceptional performance in a film can be emotionally moving).[1] Of course, there is an element of truth in this, Gretzky and Crosby have talent—lots of it. But they also have put in tens of thousands of hours of hard work in perfecting their skills.[2]

As a general rule of thumb it takes about 10,000 hours (which often takes about 10 years) of practice to master a discipline. This rule applies to acting, playing hockey, and writing music, and although there hasn't

been any empirical research to verify this that I know of, I would guess that it applies to leadership as well. This isn't to say that a relative novice can't show exceptional skill from time to time. But to consistently exhibit mastery and exceptional skill, to consistently be able to produce the richness of aesthetic experience that has the potential to move a craft into an art, you have to put in the work.

This line of thinking takes us to the first idea about craft and art. When craft is pursued with a high level of skill (which takes 10,000 hours to develop) and the result produces a rich aesthetic experience for the audience, we might consider the result to be art. That rich aesthetic experience[3] overwhelms our cognitive filtering and we are moved by the experience—that is, we feel something deeply. That feeling serves as the starting point for us to go someplace new, it serves as a departure.

As an example of craft that for me rises to the level of art, let's revisit the harp chair designed by Jorgen Hovelskov (see figure 1.1). When I first saw it (in a store in Copenhagen), I was overwhelmed (I admit to having something of a chair fetish, so my reaction is a bit more extreme than most people's would be). There's something about the curves of the wood, the airiness, and the lightness of the seat made of string that is overwhelming to me. After the initial rush of the aesthetic experience I started to realize that my whole sense of what a chair can be has been changed. The harp chair looks like a chair in that I immediately recognize that that's what it is, but it also doesn't look like any chair I have ever seen before. I've seen three-legged chairs[4] before but not like this. When I sit in the chair I find that it is comfortable, sort of like sitting in a hammock. For me, the chair is art. Hovelskov has, through the craft of chair design, created a rich, aesthetic experience that launches me into a whole new understanding of chairs. The same thing can happen for leadership. The craft skills of the philosophic art of identity, the fine art of strategic vision, the martial art of tactics, and the performing art of persuasive communication[5] can be raised to a level where the aesthetic experience is overwhelming and transports us to someplace we have never been.

We can easily imagine exceptional craft skill that does not rise to or even aspire to being art. For example, I watch a carpenter fix my old sash windows. He replaces the old, worn parting bead with a piece that he has crafted from red cedar. He adjusts and tinkers until the window works perfectly, sliding up and down as it was meant to do, as I imagine it once did 90 years ago when it was new. The final product is a window that works, which does its job so well I never think of it.

I am not overwhelmed with the aesthetic experience, but rather I don't notice the experience of opening and shutting the window at all. The craft skill is so good that it has made the window disappear from my consciousness—which is a long way from the way in which it previously made me swear every time I tried to open or close it. But there is no departure, there is no aesthetic experience that launches me into someplace I have never been before. The restored window is not art.

But not all art follows this path of exceptional craft skill producing an overwhelming aesthetic experience. The example that comes to mind is Marcel Duchamp's famous piece from 1917, *Fountain. Fountain* is an ordinary urinal, which Duchamp signed (with the pseudonym R. Mutt) and exhibited as a work of art. Over the years, it has variously been described as shocking, ridiculous, revolutionary, and changing the rules of the art world. It is clearly not a case of exquisite craft skills and a rich aesthetic experience. Or is it? It is difficult to imagine that at the time, seeing a urinal hung as a work of art did not produce a strong, felt reaction. That reaction may have been one of disgust or revulsion, rather than beauty and awe, but it was a strong aesthetic reaction nonetheless. However, the aesthetic reaction is not a result of the execution of craft skills in the sense that I have been talking about with the example of the B movie or Hovelskov's harp chair.

Duchamp had a creative process, and if we look at *Fountain* in the context of his other work we can start to see it for what it is. Duchamp called *Fountain* and other works that used found objects "readymades." The first readymade was called *Bicycle Wheel* and consists of the front wheel from a bicycle mounted on an ordinary stool. It was created in 1913, four years before *Fountain.* It wasn't a pure readymade in the sense that it was constructed from found objects rather than being just a found object. Duchamp's first pure readymade was *Bottle Rack*, in 1914. When we look at the series of readymades we see that Duchamp didn't just have the idea of exhibiting a urinal out of the blue. It was an idea that developed over time as he created various readymades. The craft skills consisted largely of what we might normally think of as the commercial aspects of the art world. The craft skills of the readymades were not in the making of the pieces, but rather in identifying the pieces as art and arranging to have them exhibited to the world as pieces of art. Speaking as a playwright who has a lot of trouble getting his plays produced, I can attest to the importance and difficulty of the craft skills of getting the world to accept your work as a piece of art, so I have great respect for Duchamp's ability to do this with a urinal—which might not seem like such a big deal now, but remember it was 1914.

The focus on the idea (while ignoring the larger creative process) is also found in the business world. I listened to futurist Joel Barker[6] give a speech about how innovation exists at the "verge," the place where different ideas (or domains) come together. As an example, he talked about the gift bag. Gift wrap became popular in the United States in the 1920s (in the gift wrap world, it is widely recounted that Hallmark accidentally discovered the gift wrap market in 1917). Paper bags had been around even longer (Francis Wolle patented the first paper bag–making machine in 1852). But the obvious combination of the two ideas didn't happen for decades because no one thought of it. Margaret Cirelli applied for a patent for the gift bag in 1993. So for over 50 years the idea was there to be had by anyone who thought to bring the domains (wrapping paper and paper bags) together. Once Margaret Cirelli had the idea, the rest was trivial.

Of course, with even a little bit of thought, one has to question the premise. A little historical research will reveal that the Victorians often gave their gifts in decorated bags—which is not to say that Margaret Cirelli wasn't being creative when she applied to patent the gift bag. It does say that she may have implicitly collaborated with others in the past, which, as I have already said, is always a part of the creative process. We might also wonder if the gift bag had been introduced in the 1930s whether or not it would have been successful. I would guess that it would not have been successful, that during the great depression people would not have been interested in spending a little more to save a little time on wrapping a present. It's hard to say when the culture had changed enough to make gift bags acceptable—I know that when I first saw one I thought the person using the gift bag was being lazy, as my sense of the appropriate cultural customs for gift giving was violated. Now my sense of those customs has changed, and I am quite happy to use a gift bag myself. We might also wonder if the gift bag had an easy path from idea to actually appearing in the market place. The innovation literature is full of stories of how difficult, how much individual persistence and raw luck were required for a product to make it to the market place. 3M's Post-it Notes are cited as a prime example. In retrospect, Post-it Notes are a brilliant product that we can't imagine living without. But that was not obvious before they were invented, or even when they were first invented. I can imagine scoffing at the idea of gift bags before they became a part of our world.

The point I wish to make here is that even with art that seems to be about the idea, there has been a creative process. The craft skills of that process are focused more on the process and thus don't show up in the

work of art. That is to say that when we think of craft skills producing an overwhelming experience we are thinking of the craft skills being applied to the outcome of the process, such as in wood carving, painting, writing, and so on. But when we think about art that does not have a strong aesthetic experience that comes from the application of craft skills (such as Duchamp's *Fountain*), the craft skills of the creative process have probably been more about the process. The second point is that although we can see how the creation of gift bags was a creative process and that it probably took some craft skills to reach the end of that process and get the gift bags to market, we certainly would not consider gift bags to be art. Gift bags are clearly about a destination and not about a departure.

I'm going to digress briefly and make a couple of points about ideas and the creative process. First, Barker's idea that creative ideas often live at the "verge" or at the intersection of two domains is a good one. New things often come from those places where worlds collide. The second point is that ideas are everywhere. The author Steven Pressfield tells us that artists don't get an idea and then set to work on it, but rather that ideas come from working:

> Because the most important thing about art is to work. Nothing else matters except sitting down every day and trying.
> Why is this so important?
> Because when we sit down day after day and keep grinding, something mysterious starts to happen. A process is set into motion by which, inevitably and infallibly, heaven comes to our aid. Unseen forces enlist in our cause; serendipity reinforces our purpose.
> This is the other secret that real artists know and wannabe writers don't. When we sit down each day and do our work, power concentrates around us. The Muse takes note of our dedication. She approves. We have earned favor in her sight. When we sit down and work, we become like a magnetized rod that attracts iron filings. Ideas come. Insights accrete.[7]

But we should also recognize the nature of ideas. They come out half-baked and ill-formed and they need to be crafted, worked-with, and developed. Most business environments are very poor at doing this. As Piers Ibbotson says:

> Even in the best of these sorts of meetings the victorious suggestions are then appropriated, adapted or ignored by the powerful,

according to other agenda, that are seldom explicit at the meeting. This is not a creative process: it is a competitive, reductive one. It is a model for quickly reducing the numbers of ideas in the room to one—and usually the one that fits with the predetermined objectives of the most senior people present. Another trouble with debating rituals is that they oblige the participants to deny or disguise the fact that their ideas are half-baked; they need to be developed and changed and in a group situation some of this work needs to be done collaboratively. The debate is not good at this. If you are in an essentially competitive conversational space, you will find yourself very quickly defending the indefensible, or at least making bigger claims for a fragmentary idea than is wise.[8]

Most art processes recognize that ideas tend to be half-baked when they first appear in the world and work to nurture and develop them. As Ibbotson points out, most businesses are not very good at doing that.

So where does this leave us in our thinking about craft and art? First and foremost, for both art and craft there's always a creative process. Sometimes the craft skills of the process are focused on the outcome or product and produce an overwhelming aesthetic experience that results in a departure experience for the audience, and we call it art. The departure experience may or may not have been intended. I would guess that in most cases the craftspersons are simply trying to do their craft as well as they can and they don't really care about whether people call it craft or art—the chair maker simply wants to make a great chair. In other cases, the creative craft skills are applied to the process to get a departure-making idea out there. Here the intent is clearly to make art, to shake things up, to create a departure experience for the audience. Of course, this raises the question—how does this apply to leadership, what insight comes from thinking of leadership in terms of a craft of leadership and an art of leadership? This is perhaps the question you might have had in your mind from the moment you saw the title of this book, and it certainly seems about time I finally tried to answer it.

Leadership Craft and Art

To see how these ideas of craft and art apply to leadership, we'll start by looking at some examples. First, the well-known and oft-discussed case

of Martin Luther King, Jr.'s *I Have a Dream* speech, which I see as leadership craft executed with such skill that it produces an overwhelming aesthetic response and becomes art. Then I will turn to a pair of examples that are about departure ideas in leadership that don't seem to be based in the mastery of the classic craft skills of leadership (although they may be based in other craft skills). Finally I look at when and where a craft and an art of leadership might be appropriate.

The exceptional craft skill of MLK's *I Have a Dream Speech* has been analyzed in detail elsewhere,[9] so I will just hit the high points. King used rhetorical devices such as repetition of the same phrase at the beginning of sentences and peppering the speech with biblical allusions that the crowd would recognize, as well as having the sort of performative presence in the moment that makes us see a leader as being authentic.[10] It's hard to imagine a better speech. Did King intend for it to be art? I suspect he didn't care whether it was craft or art (although it seems clear that he paid a lot of attention to the craft of making speeches—a craft he had developed in his training and practice as a preacher). I think his intention was to inspire the crowd that day. I believe that he wanted to create a departure for the audience, to make them see something new—his dream of a nation where his children will not be judged by the color of their skin. I don't see this as an arrival in the sense that I have been talking about craft, because it requires such a significant act of imagination on the part of the audience. I also see it as art because it was a departure for King himself. He departed from his prepared text and improvised the latter half of the speech as the moment took him. It was a journey where he didn't know the exact destination.

This highlights one of the important aspects of leadership as an art. The leader suggests a journey, proposes a vision, says "let's go do this," but doesn't know where it will lead. The leader may have a general idea, such as King's notion of a nation where his children will not be judged by the color of their skin, but he doesn't know a lot of detail of what that will look like or, in all likelihood, how to get there. It is a departure where the destination is foggy at best. A CEO may have a vision of providing customer delight or he may have a vision of increasing sales by 20 percent. Increasing sales by 20 percent is a destination, and the greatest craft skills in selling that to the employees will never rise to being art. Providing customer delight just might.

It is fairly easy to see how the craft skills of the performing art of persuasive communication can rise to be art; it takes a little bit more imagination and thought to see how the craft skills of the other three of

Keith Grint's arts of leadership can become art. I find the strategy of the *Trader Joe's* chain of specialty grocery stores to come close to being art. A maxim of business strategy is that there are only two strategies: low-cost, and differentiation. *Trader Joe's* manages to provide high quality items that you can't find elsewhere, which I would call differentiation and at the same time be low-cost. When I first figured out their strategy, it was a huge departure for me. I had always thought of the two classic strategies of low-cost and differentiation as being mutually exclusive. They manage to do both. *Trader Joe's* strategy is about both trading up[11] in the way that luxury brands are about trading up, and being low-cost. It's incredible, it's beautiful (at least to me, as something of a business nerd), and it has made me totally rethink strategy. That's starting to feel a lot like art to me.

I notice that the role of expertise starts to become exposed here. I suspect that there's a lot of people who haven't spent any part of their lives thinking about corporate strategy who would not see *Trader Joe's* strategy as being in any way art. In the world of modern art there are always cutting-edge pieces that those who are deep within the art world and have a great deal of expertise see as art and others without that expertise don't see as art. The appreciation of something as art is not an innate thing, but it is instead a learned skill that is particular to a specific domain. The performing art of persuasive communication is the easiest of the leadership arts to see as being art because it is one with which we all have a great deal of familiarity—we live in a world that is filled with persuasive communication, so we have all developed an appreciation for it. Most of us haven't developed as much of an appreciation for the fine art of strategic vision, the philosophic art of identity, or the martial art of tactics. Add to this that leadership has long been considered a sort of craft that is more like the carpenter repairing my sash windows—one that is not noticeable when executed well. Recall the words of the Chinese philosopher Lao Tzu[12] that I quoted in chapter 5:

> To lead people, walk beside them... As for the best leaders, the people do not notice their existence. The next best, the people honor and praise. The next, the people fear; and the next, the people hate... When the best leader's work is done the people say, "We did it ourselves!"

It's hard to say "we did it ourselves" after a great speech. But it is perhaps easy to say so when faced with artful strategies, identities, and

tactics. So it is not surprising that we have not developed an appreciation for these other leadership arts as art.

Let's now turn to acts of leadership as art that are more about the ideas and less about the craft skills of leadership (such as persuasive communication and strategic vision). As a first case, let's look at the White Factory, a story that comes from Daved Barry and Stefan Meisiek's work:

> Hydro Aluminum Corporation was an old line manufacturing corporation where none of the stakeholders had professional training in the Arts. As Eirik Irgens describes it (Irgens, 2000):
>
> When the Hydro Aluminum Corporation (HAP) board asked Johnny Undeli to go to the town of Raufoss to become the new CEO of HAP-Raufoss, they had seen the writing on the wall, and it was written in red. The company was facing economic ruin in a market for aluminum products that was anything but promising. "We were more than 300 employees in a company that seemed like a social club. We hardly knew what it meant to be profitable," said former union chairman Armann Myrland.
>
> Undeli's intention was to create a "world class" company. Given that the company was in a mediocre industry, the only way that it would be worth holding on to was if it could somehow be turned into a leading performer. He began with a series of conventional, craft-like acts. He halved the number of top leaders from ten to five, did away with privileges like company cars, and moved the executive parking lot outside the fence, forcing the managers to mix together with other employees. Then, despite the company being deeply in debt, he spent a million Norwegian crowns (about 130,000 Euros) on painting the production hall, floors and all, completely white. The factory was known for being extremely dark, dirty, and oily, which made the job that much more difficult. The employees thought he was out of his mind, but went along with it in the end.... Employees also got flowers and other small presents. Social arrangements became common. Finally, at Christmas, without telling anyone, Undeli bought two whole pages in the local newspaper where he published the picture of all the employees with a seasonal greeting from HAP. During Undeli's tenure, HAP went from being the worst company in its industry to becoming one of the world's best.[13]

As I read this, it seems to me that Undeli was intent upon changing the culture from one where the employees were used to seeing the factory as a dark and dirty place that lost money, to a bright, cheerful place that made money.[14] Painting the factory white stands out as a largely symbolic act that helped people imagine themselves and the organization differently. It acted to inspire a departure for the employees. The symbolic act was supported by a variety of more functional acts, such as reducing the social distance between the managers and the workers, which served to create an overall more positive working environment.

If we step back and place this in a broader context of what leadership is, we can start to imagine something of the creative process in play. Remember, Barbara Czarniawska[15] tells us that one of the three functions of leadership is to play an important role in creating the organizational culture. But how do you do that? How do you create culture and even more importantly how do you change culture?[16] In the story of the White Factory, we see a couple of different tactics that Undeli employed. His tactic for creating less distance between the managers and the workers was to make them park in the same parking lot and to get rid of company cars—decreasing both physical distance and symbolic distance. His tactic for changing how workers experienced the work environment was to change the physical work environment—to paint it white. Painting the factory white made it clear that things were different; this was no longer the dirty old factory. It left a lot to the imagination of how things were different, and Undeli never offered an explanation for why he painted the factory white. An explanation would have taken away possibilities, engaged the imagination less, and probably engaged the rational, critical reactions of the employees more. The simple, unexplained act of painting the factory white pushed the employees to make sense of it on their own; it served as a departure for them. Looking more broadly, painting the factory white was an unusual tactic that seemed to be part of a larger creative process to change the culture of the organization.

I say this is an unusual tactic, but my second example of leadership art that is seemingly more about the idea is also a case of creating a powerful visual statement that serves as a departure for the employees.

If you ask every single employee who was there what day they remember best, they will say that Friday in 1995 at the warehouse.—Plant Operator

In the spring of 1995, the fourteen hundred employees of Unilever Vlees Groupe Nederland (UVGN) assembled in the early morning at their factories and boarded motor buses for a field trip. Their destination? Unknown. The purpose of the trip? Top Secret.

"I thought we were going on a trip to the Efteling amusement park or even to Disneyland," said one of UVGN's machine operators. Instead, they arrived at a warehouse, where they were greeted by recently appointed UVGN manufacturing director Hans Synhaeve and the company's brand new chairman, Tex Gunning.

Inside, 3,700 pallets of rejected goods towered in stacks from floor to ceiling. The warehouse reeked with the nauseating smell of rotten food. As far as the eye could see—left, right, front, back—were piles of products unfit for sale: spoiled sausages in defective tins and vacuum packs, leaking cans of soups and sauces, poorly sealed packages of dry soup and mixes. Products worth 9 million guilders, the equivalent of 4.3 million euros. Ready for destruction.

When the sight and stench of the warehouse of waste had begun to sink in, Gunning started to talk. As a production line worker recalls, "He spoke very quietly in the beginning, but in the end gave us hell." Then managers and accountants, quality experts and production workers walked aisle after aisle counting cans, calculating the money lost, and contemplating the waste of their time and talent. Later, a parade of forklifts trucked the pallets outside to a large, lined pit, where the worthless goods were unceremoniously dumped in and covered with earth.[17]

In the larger story, the warehouse full of spoiled product is part of a longer creative process. It is one tactic in an effort to change the culture at Unilever. It feels like art because it had an overwhelming felt impact on the employees that worked as a departure—it pushed them to someplace new, someplace they hadn't been before. It doesn't feel like there are any exceptional craft skills required to assemble a bunch of products in a warehouse. It feels like a really creative idea, much in the way that Duchamp's *Fountain* felt like a creative idea.

We don't know much about the behind-the-scenes process that made this happen. We can imagine the new CEO, Tex Gunning, at Unilever saying that he wanted to do something unusual. The consultant who tells the story of the overall change effort, Phil Mirvis, has a well-established reputation for designing unusual organizational interventions—I think he is the most gifted experience designer working in

organizational consulting in our time. I am sure there was a process in which the idea grew and matured and which convinced Unilever to go forward with it. They were convinced in part because of Phil Mirvis' reputation for unusual interventions that work, much in the way that I am sure Duchamp was able to exhibit *Fountain* in part because of his reputation as an artist. Their reputation facilitated the collaboration that was needed to make the creative process happen.

In these two cases of leadership actions that might be considered to be art, we see the same thing we saw in the art that wasn't based in exemplary craft skills. There was a creative process; however, the craft skills associated with the process were not related directly to the aesthetic properties of the art product but were more focused on making the process happen. And there was an intention to create a departure, to open up the imagination of the audience and take them someplace they had not been before.

Most of what has been written about leadership is about leadership as craft in the sense that it is about destinations, it is about how to get others to follow you toward your vision, or about how to get others to want to do what you want them to do. However, there is also leadership that has the aim of being art in the sense that it aims at creating departures for others. For me, transformational leadership is about creating departures, and part of the difference between ordinary transactional leadership and true transformational leadership is that no one, not even the leader, really knows what the transformed organization will look like. If they do know, then it's not really a transformation, it's just the craft of navigating toward the known destination.

If most of leadership seems to be about craft rather than art, the obvious question is when should we be looking for leadership as art. To answer that, let me use a way of thinking about leadership that comes from Mark Rice.[18] Mark draws the pyramid pictured in figure 7.2 and says that the bottom third of the pyramid is ongoing operations. This is what management education is traditionally focused on. These ongoing operations are the majority of the efforts for most large businesses, and the rational analytic approaches of the various management disciplines are well-suited to optimizing these ongoing operations. I will call this base of the pyramid "management" and leave leadership for the next two sections. The middle section of the pyramid is incremental innovation that responds to customer feedback. This requires a craft of leadership. It is about successfully navigating to new destinations that both the organization and the customers can see. It is the top section of the pyramid—what Mark calls breakthrough innovations that change

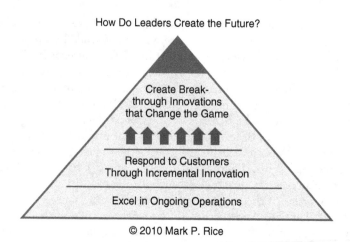

Figure 7.2 How leaders create the future

the game—that calls for leadership as art. It is this top section that calls for departures.

The relative amounts of the three sections of the pyramid will be different in different organizations at different times. But if we are to solve the really big problems that we face in today's world—energy, climate change, addiction to growth—then we are in desperate need of game changers. We need leaders to practice an art that creates departures for others, rather than a craft that takes followers to a destination (of the leaders' choosing), if we are to take advantage of all of the human capital—if we are to engage the creative potential of all humans rather than just a select few (who happen to be leaders).

PART II

Practice

CHAPTER EIGHT

Leadership in the West Wing
(With Yacan Gao and Giuseppe Contini)

So far I have talked about the creative process of leadership craft and leadership art in terms of different aspects of the model—process, collaboration, mind-set, creativity, and domain—as if they were really separate activities. Of course, they are not separate, and in practice they are all part of the same leadership process. Here, as we turn from theory to practice, we shall look at how these different aspects play out and interact in the craft and art of leadership.

In order to look at the practice of leadership, we need to be able to somehow observe the day-to-day, moment-by-moment actions of leaders. I spent some time looking for detailed-enough historical records of leaders, and I came up empty. I then considered trying to find leaders who would be willing to be videotaped 24/7 for some time (and of course this would also mean getting permission from everyone with whom they interacted to record the interactions). That seemed overly difficult to me, so instead I broadened my search for detailed records of leadership practice to include fictional characters.

I found *The West Wing*, a popular and award-winning television show that had 155 episodes over 7 seasons from 1999 to 2006. It was created by Aaron Sorkin and shows us the daily activities of the senior staff of a fictional White House while they try to lead the government in complex and difficult situations. Although it was fictional, it was generally accepted as being a fairly accurate representation of what goes on in the west wing of the White House if you only looked at the exciting parts and left out all of the boring, mundane bits. I think that the exciting parts are the best place to look for examples of leadership,

which is not to say that the boring, mundane bits aren't important; they just don't tell us as much about the practice of leadership.

I'll start by looking at the interaction of the creative mind-set and collaboration. In order to do that, it is helpful to expand the model of the creative process from being for a single person to looking at how two people interact. We can think of this as a conversation between sensory information and sensemaking for each of the people (see figure 8.1). In each case when one person acts (which for our purposes will generally be when they say something), that action becomes new sensory information for the other person, which they make sense of. The second person then acts based on that sensemaking, which becomes new sensory information for the first person and so on as the conversation continues. Of course, this can be extended to interactions with three, four, or however many people are in the room, with each person's actions becoming new sensory data information for all of the other people. We show it as two instances for the sake of simplicity. And of course, all this assumes that the people are actually listening to each other and not simply acting based on their own preexisting sensemaking—or, in other words, they are actively engaged in the conversation between sense and sensemaking in a creative way.

Working with two of my graduate students, Guiseppe Contini and Yacan Gao, we have been watching *The West Wing* and selecting scenes that provide an opportunity to show something of the practice of the

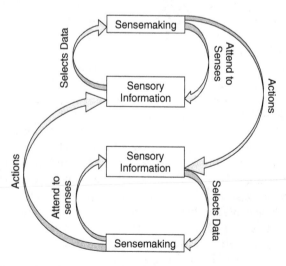

Figure 8.1 Interaction of conversations between sensemaking and sensory information

craft and art of leadership. The scene we want to use to talk about the interaction of the creative mind-set and collaboration comes from *The Short List*, which is episode nine of season one. In one of the plotlines of this episode, Lillienfield, a headline-seeking congressman, accuses the White House staff of substance abuse, claiming that a third of them were on drugs. This gave rise to heated discussion among the White House staff. In this scene, the staff gathered in Leo's (the chief of staff) office and began to discuss the issue. Although it would probably work best to show you the video of the scene, in tables 8.1 to 8.7 below, we include our analysis in the left-hand column and the dialogue from the scene in the right-hand column.

In terms of collaboration, C.J. and Sam engage in "yes, but" responses that allow the conversation to continue, but don't foster a lot of real collaboration. Sam has a strong intention to do a little venting and C.J. doesn't see that as productive. They have made sense of the external situation in different ways and act based upon their different senses of what an appropriate response is. As the scene continues, we see other White House staffers offer their own sensemaking to the conversation. As with most human action, they don't explain how they understand it, but rather imply what their sensemaking is in their actions.

The pattern between Mandy and Josh is a rather typical one of disagreement and argument. They have made sense of things differently and neither seems willing to consider changing their own sensemaking based on what the other says. There is no collaborative "yes and"

Table 8.1 *West Wing* scene one

Analysis	Dialogue
Sam has heard Lillenfield's accusations and makes sense of them with the theory that Lillenfield is a jackass. He then offers this to C.J. with the hope of generating a cathartic Lillenfield-bashing session.	SAM: [pops his head and walks in] Is it possible for Peter Lillienfield to be a bigger jackass? You think if he tried hard, there's room for him to be a slightly bigger horse's ass than he's being right now?
C.J. takes in Sam's question, and recognizes that Sam is angry. She takes Sam's offer and builds on it in an unexpected (and humorous) way by answering the actual question rather than responding to the general anger and implied invitation to bash Lillenfield.	C.J.: At some point, you hit your head on the ceiling, don't you?
Sam accepts C.J.'s offer to answer the actual question, but rather than taking it in a new direction with a "yes and" response, he argues with more of a "yes, but" response.	SAM: I think there's unexplored potential.

Table 8.2 *West Wing* scene two

	JOSH: [comes in] 'Sup? MANDY: Josh.
Josh has made sense of Lillenfield's comments as not being a big deal, so he offers a joke based upon the idea that a third of White House staffers are on drugs.	JOSH: Five White House staffers in the room. I would like to say to the 1.6 of you who are stoned right now, that it's time to share. [Everyone laughs except Mandy.]
Mandy believes that Lillenfield's comments are potentially a big deal, so she responds to Josh's offer by saying "no" and blocking it.	MANDY: This isn't funny, Josh.
Josh doesn't accept Mandy's block and reiterates his sensemaking with a "no, and" response.	JOSH: Mandy, if you can't laugh at this, then you're just not having enough fun in show business.
Mandy again blocks with a "no" response.	MANDY: Josh?
Josh responds with another "no and" response elaborating on why he has made sense of the situation as not being a big deal.	JOSH: He's a featherweight, Mandy. He's a hairdo.
Sam builds on Josh's statement by repeating his earlier offer to engage in a full-on Lillenfield-bashing session.	SAM: I think if he put his shoulder into it, he could be a slightly bigger gasbag.
Josh accepts his offer with a "yes" response, but doesn't build on it or take it anywhere.	JOSH: Yeah.
Sam adds to his offer in the hopes of keeping it alive.	SAM: You know, if he really reaches for the stars.

building on what each other say, instead they constantly try to block the others' offers with "no" responses. There seems to be little hope of anything productive coming out of this sort of dynamic. One of them might eventually give in and the other would "win," but that is hardly collaboration and unlikely to produce a creative response. As the scene continues, we start to see some leadership being practiced by Toby and Leo as they try to move the conversation forward in a productive way.

Although it is tempting to say that this suggests that collaboration—a "yes and" response—will always win out over arguing, it's not that simple. We do see the power of the "yes and" exchange between C.J. and Mandy and how it eventually convinced Josh and the others. We see how difficult it is to say "yes and" to another's action if you are fundamentally making sense of the situation in a different and contradictory way than the other person is. As we watched episode after episode of *The West Wing*, we realized that there was comparatively little "yes and" collaboration; and when we did see it, it was often short-lived, such as in the above example. This is probably the case in most organizations—we tend to spend more time fighting over

Table 8.3 *West Wing* scene three

	TOBY: [quickly walks in] Good morning. C.J.: Hey.
Toby is also angry, but he turns his anger toward the staff rather than outward at Lillenfield.	TOBY: There's no way you saw this coming?
	LEO: Toby...
Toby continues from his sensemaking that the staff should have been proactive and that they have been caught unaware, which is unacceptable.	TOBY: Leo, I know I'm in your office. Forgive me. [yells] But nobody saw this coming?!
C.J. takes up Toby's offer and goes with it in order to mock it. By saying "yes and" to Toby's offer, she shows just how absurd his sensemaking is.	C.J.: Yeah. I can't believe my psychic didn't tell me, Toby. Rest assured, I'm gonna get my twenty bucks back.
Leo acts as the leader he is here, directing the conversation into the practical realm of what should be done and away from arguments and blaming.	LEO: Short-term, long-term?
Josh accepts the offer to move into the practical realm, but still works from his sensemaking that it isn't a big deal.	JOSH: Short-term nothing.
C.J. blocks Josh's offer/suggestion with a simple "no" response.	C.J.: I can't go with nothing.
Josh still keeps the same sensemaking and challenges C.J.'s previous block.	JOSH: Why not?
C.J. stays with her sensemaking that this is a big deal and tries to go with it to mock it, much in the same way she did with Toby earlier.	C.J.: Pretend we didn't see it?
Josh continues to argue from his position as they fall back into arguing from their own sensemaking of the situation.	JOSH: He's a liar. He's a fool. Categorically deny it and move on.
Mandy accepts C.J.'s offer because she shares C.J.'s sensemaking that it is a big deal.	MANDY: She can't.
	C.J.: I can't. JOSH: Why not?
C.J. makes a new offer to illustrate her own sensemaking.	C.J.: Because more than 1300 people work for the White House, Josh. I go to the Press Room and categorically deny that anyone uses drugs, and it turns out that three guys in the photo lab blew a joint over the weekend, which is not like out of the realm of possibility. And my next question is...
	MANDY: But you categorically denied it, now you admit there are three.
Mandy accepts C.J.'s offer and gives with a "yes and" response in which she builds upon C.J.'s scenario.	
The collaboration between C.J. and Mandy builds as C.J. builds on Mandy's offer.	C.J.: Yes. Well, I categorically deny that there are any more than three. [Toby paces.]

Continued

Table 8.3 Continued

Mandy responds by building on C.J.'s offer.	MANDY: But now it seems that the assistant to the deputy director of White House beverages…
Josh finally sees the logic behind C.J. and Mandy's sensemaking and stops arguing.	JOSH: All right.
Mandy continues to build on the collaboration with C.J. ignoring Josh's capitulation.	MANDY:…is confessing to a life of a closet junkie.
C.J. seems to be enjoying the "yes and" back and forth with Mandy and continues it.	C.J.: Yes, and I understand she's selling her story to Random House for a middle six-figure advance.
Toby sees that C.J. and Mandy's sensemaking has prevailed and stops the collaboration between them.	TOBY: [now has his head against the wall] All right. Are we done with Masterpiece Theater?
Leo accepts the sensemaking and builds on it by offering what action C.J. will take in response to questions from the press.	LEO: C.J., we're looking into it, okay?

competing ways of making sense of a situation than we do building on each others' offers.

This also shows a critical aspect of the craft of leadership, which is when Toby and Leo take action to stop the back-and-forth discussion (even when it has been a productive collaboration) and move ahead to action. In the moment-by-moment detail of the craft of leadership, this is about knowing when to stop, feeling when you're done, and moving on. This is not a particularly artful moment in that there's nothing here that engages the imagination and takes people to a new place. Rather, it is craft; it is the straightforward process of getting to the destination of knowing what tactics will be used in response to questions from the press about Lillenfield's statements of White House staff drug use.

In contrast to this example of the craft of leadership, let's turn to an example of the art of leadership—again, in the day-to-day activities of the White House staff. This example comes from episode twenty-six of the second season of *The West Wing*, titled *In This White House*. President Bartlett, a Democrat, decides to hire a Republican reporter, Ainsley Hayes, to work in the White House.[1] Ainsley has appeared opposite Sam Seaborn, the White House communications director, on the televised political talk show "Capital Beat." After seeing Ainsley's understanding of the discussion and her passion in holding her position, the president decides she would be a valuable asset to the White House. In the following scene, Bartlet tells his chief of staff, Leo, to hire Ainsley.

Table 8.4 *West Wing* scene four

With no framing about his own sensemaking, Bartlet makes an offer.	BARTLET: We should hire her.
For Leo the thought is so ridiculous that he takes it be a joke.	LEO: That'd be funny!
Bartlet suggests he is serious.	BARTLET: No, I mean it.
Leo still cannot even imagine how Bartlet is making sense of things.	LEO: Mean what?
Bartlet simply asserts his offer again. Notice that he doesn't offer any framing, but rather lets Leo work out what he means.	BARTLET: We should hire her.
Leo is still not understanding Bartlet's sensemaking of the situation.	LEO: What, you mean as a joke on Sam?
Bartlet finally explains himself a little more, but still doesn't explain his own sensemaking of the situation.	BARTLET: No, not as a joke, I mean we should hire her as a reality. We should hire her.
The shear impossibility of hiring a Republican tells us what a departure this would be for Leo.	LEO: She's a Republican.
Bartlet doesn't explain his sensemaking directly, but instead pokes at Leo's sensemaking that as Democrats they should only hire Democrats.	BARTLET: So are half the people in this country.
Leo's half-hearted defense is the start of a departure for him.	LEO: Well, that half lost, so…
Bartlet has now opened up the possibility of something as radical as hiring a Republican and moves on to why he wants this Republican in particular.	BARTLET: She's smart, she's not just carping. She feels a sense of something.
Leo is open to a departure, but he's not quite ready to accept it yet.	LEO: Of what?
	CHARLIE [entering the room]: Mr. President.
Bartlet now offers Leo a sense of what has driven his own sensemaking, now that Leo is ready for it.	BARTLET: Yeah. [to Leo] Of duty. Of civic duty.
Leo remains skeptical – departures don't happen instantaneously, nor are most of us anxious to depart from our established sensemaking.	LEO [as they leave the room]: How many pieces by her did you read?
	BARTLET: Three.
Leo still hesitates, but we can see that he has largely accepted Bartlet's decision.	LEO: And you're certain of her sense of civic duty?
Bartlet makes a claim for his own intuition, his own artistic sensibilities for picking staff.	BARTLET: I can sense civic duty a mile away.

Leo is then faced with trying to actually hire Ainsley. He invites her to the White House for a meeting. In short, Leo is faced with the task of creating a departure for Ainsley in much the same way that Bartlet created a departure for him. However, Leo does not have the same sort

Table 8.5 *West Wing* scene five

Leo starts with a compliment, which catches Ainsley by surprise.	LEO [returning to his desk]: So, I have to tell you, I've never seen Sam Seaborn get beat the way you beat him on Monday.
	AINSLEY [sitting] : Yes, well, Mr. McGarry...
	LEO: Leo.
Ainsley is clearly defensive, because she has made sense of the invitation as being about Leo calling her in to reprimand her for besting Sam on the television show.	AINSLEY: Yes, sir. I've been thinking about that ever since your office called me on Tuesday, and I have something to say on my own behalf, if you'll permit me a moment to say it, and I understand if you won't, but I would really appreciate it if you did.
	LEO: I ... didn't really follow that, but whatever.
Ainsley continues to work from her sensemaking of the situation, with no possibility that it could be anything else. She is completely convinced she has made sense of the situation "correctly."	AINSLEY: I think that it is wrong for a man in your position to summon someone to the White House to reprimand them for voicing opposition. I think that that is wrong, and it is inappropriate. It's inappropriate, and I'll tell you what else.
Leo is paying attention to his senses and engages with what she is saying.	LEO [nodding slightly]: It's wrong?
Leo tells her that her sensemaking of the situation is wrong.	AINSLEY: Yes.
	LEO: That's fine, except you weren't summoned here to be reprimanded.
Ainsley stays with her framing of the situation as being about her being punished by the White House in some way.	AINSLEY: Well, then, if you'll permit me, why was I summoned?
Leo engages her in some banter, perhaps because he feels that Ainsley isn't ready yet to hear his offer.	LEO: You have an interesting conversational style, do you know that?
	AINSLEY: It's a nervous condition.
	LEO: I used to have a nervous condition.
Leo empathizes and tries to connect to Ainsley as a person.	
Ainsley responds a bit to Leo's offer to connect as people rather than opponents.	AINSLEY: How did yours manifest itself?
It's well known that Leo is a recovering alcoholic, so this admission isn't very revealing, but it is self-effacing.	LEO: I drank a lot of scotch.
Ainsley lets her defenses down slightly and answers as a person.	AINSLEY: I get sick when I drink too much.
Leo continues the person to person connection.	LEO: I get drunk when I drink too much.
Ainsley feels vulnerable and raises her defenses again.	AINSLEY: Well, Mr. McGarry...
	LEO: Leo.

Continued

Table 8.5 Continued

Ainsley comes back to her previous sensemaking of the situation and moves back to her oppositional frame.	AINSLEY: Yes, sir. I'll ask again: for what purpose was I brought here today?
Leo feels he has her attention and makes his offer.	LEO: So I could offer you a job.
Ainsley hears Leo, but doesn't process what he says because it is not a possibility within her own sensemaking of the situation. She continues with her response to what she is expecting from Leo.	AINSLEY: I'm asking because I do not think that it is fair that I be expected to play the role of the mouse to the White House's cat in the game of, well, you know the game.
	LEO: Cat and mouse?
Ainsley finally processes what Leo has said and her sensemaking of the world is rocked. It is the start of a departure moment for her as it opens up a possibility that was completely impossible before.	AINSLEY: Yes. And it's not like I'm not, you know...the fact that I may not look like some of the other Republicans who have crossed your path does not mean I am any less inclined towards...[comes to a sudden stop]
	LEO: Here it comes.
She double checks the evidence of her senses because it is so contrary to her sensemaking.	AINSLEY: Did you say offer me a job?

of authority over Ainsley that Bartlet as president has over Leo as chief of staff. The following is the meeting where Leo offers Ainsley a job in the White House.

We can see here that Ainsley walked into the room with a clear sensemaking that she was going to be attacked and needed to defend herself. She was so set in this mind-set that she did not even process Leo's words (her sensory information) when he offered her a job. It took awhile for her to even realize it. When she actually pays attention to the sensory information that she is being offered a job in the White House, it is a huge departure for her and it calls into question much of how she previously thought of herself, as we see in the following conversation.

The next day Ainsley comes back to the White House with the intent of telling Leo that she has decided that she is not going to accept the job. She considered the new way of making sense that Leo offered her the previous day, but she was still passionate about holding her position as a Republican and that meant being in opposition to the Democrats, not working with them. Leo has tried to create a departure moment for her, but it hasn't worked, she has not found a new sensemaking.

Table 8.6 *West Wing* scene six

Her sensemaking is deeply informed by her own sense of her identity as a republican.	AINSLEY: I have always been a Republican. My father is a Republican. His father was State Chairman of the North Carolina Republican Party. LEO: Yes.
Ainsley is still struggling with her lifelong image of herself and how that conflicts with the possibility of working in this White House.	AINSLEY: When I was young, I was a Young Republican.
Leo is patient, seemingly aware that much in the way it took him a while to get his head around the idea, it would also take her a while to come to terms with the new sensemaking that the working in the White House would require.	LEO: [sitting up] Yeah, Ainsley, even if you hadn't already told me all of this, you know, many, many times, I would know it anyway, 'cause I have this FBI file.
	AINSLEY: You have my FBI file? LEO: Yes. AINSLEY: I can't believe that! You have my FBI file? LEO: Yes. AINSLEY: I have an FBI file? LEO: Ainsley...
Ainsley is working through the problems that her established ways of making sense of the world raise.	AINSLEY: Mr. McGarry, I loathe almost everything you believe in. [stands up]
	LEO: Where are you going? AINSLEY: I'm not going anywhere, I'm standing up, which is how one speaks in opposition in a civilized world.
Leo continues to give her time and space to work out a new sensemaking.	LEO: Well, you go, girl.
Ainsley starts to share the deeper aspects of her sensemaking that are troubling her.	AINSLEY: I find this administration smug and patronizing, and under the impression that those who disagree with them are less than they are, and with colder hearts.
Leo disagrees, but lets her have her say.	LEO: I don't think that's true. The two spar back and forth as Ainsley struggles to find a new sensemaking that the departure moment has launched her into.
Leo offers a new sensemaking that sums it up in a way that he believes Ainsley will find compelling.	LEO: The President likes smart people who disagree with him. He wants to hear from you. The President's asking you to serve. And everything else is crap. [He gets up and goes to open the door for her.] Think about it overnight. Come back here at six tomorrow and give me your answer.

Table 8.7 *West Wing* scene seven

He has been consistently working from the same sort of oppositional sensemaking that Ainsley has. Ainsley now has questioned that sensemaking.	BRUCE: Tell me about the look on [Leo] McGarry's face. AINSLEY: What? BRUCE: When you said no. AINSLEY: I, um, couldn't see him. He had to…he was called in to…
Ainsley struggles to come to terms with the change in her sensemaking –with the departure from her previous way of seeing the world.	
She realizes that she can't share what she has seen.	HARRIET: What's wrong? AINSLEY: Nothing. He had to…something happened. BRUCE: Uh, damn. I wanted you to say it to his face. I wanted to see… HARRIET: I hate these people.
She offers up their previously shared oppositional sensemaking. Bruce extends the attack to the personal level. Ainsley realizes that she must speak from her new sensemaking.	BRUCE: Did you meet anyone there who isn't worthless? AINSLEY: [quietly] Don't say that. BRUCE: Did you meet anyone there who has any…?
Ainsley speaks firmly and passionately from her new sensemaking of the world, just as she had previously spoken firmly and passionately from her old sensemaking.	AINSLEY: [more firmly] I said don't say that. Say they're smug and superior, say their approach to public policy makes you want to tear your hair out, say they like high taxes and spending your money, say they want to take your guns and open your borders, but don't call them worthless. At least don't do it in front of me. [Bruce and Harriet exchange a look.]
She finally tells her friends that she has taken the job and is now working for what had previously been defined as "the enemy."	AINSLEY: The people that I have met have been extraordinarily qualified, their intent is good. Their commitment is true, they are righteous, and they are patriots. [after a moment, with tears in her eyes] And I'm their lawyer.

Ainsley waits for Leo and spars briefly with Sam, Josh, and Toby, which shows her oppositional sensemaking. While she is waiting, Toby is handed a note, and all three staffers quickly leave. Ainsley realizes that something is happening. Left alone, she wonders up to the door of the oval office, where the president is having a conversation with the president of Equatorial Kundu (a fictional African country), explaining to him how a military coup d'état has occurred in his country, and that

the opposition has taken the capital as well as control of the radio and television stations. President Bartlett attempts to console the president of Equatorial Kundu and help him, as they learned that his brother and two sons may have been murdered, and his wife has likely gone into hiding. While this is happening, Ainsley is watching quietly.

We don't know how Ainsley has been affected by seeing President Bartlet and the president of Equatorial Kundu, until the next scene, when she meets up with some of her Republican friends.

Watching President Bartlet talk to the president of Equatorial Kundu became the true departure moment for Ainsley. Somehow, in that moment, she saw the work that the president and the White Staff do as being more important than her opposition to the Democrats. She had a real departure and recognized that there was something bigger than partisanship and that she was being asked to be part of it. Perhaps it connected to her lifelong dream of working in the White House (which she had acknowledged earlier), and she realized that it wasn't about being a Republican or a Democrat; it was about doing important work with honor and integrity. However it worked, Ainsley had a real departure moment as a result of her experience in the White House.

Ainsley's decision to work at the White House may seem like a fairly small departure. After all, she is a lawyer working in politics, and she has always wanted to work at the White House. But it is a departure in the sense that it required her to change her own sensemaking in a radical way that she had never imagined doing. These departures—both the departure for Leo created by Bartlet's decision and the departure created for Ainsley when she is offered the job—are good examples of the art of leadership at the sort of everyday, moment-by-moment level where most of us as leaders might hope to practice it.

These micro-departures are the building blocks of larger change efforts. With sufficient distance, we can see enormous shifts in the sensemaking in social groups, such as the civil rights movement in the United States. And we tend to want to point to individual leaders, such as Martin Luther King, Jr., and specific acts, such as his *I Have a Dream* speech. And those individuals and acts are important, but they existed in a sea of smaller departures that happened one person at a time, and for a variety of reasons. At some point there was a tipping point[2] and the change accelerated, and from a distance we could say that it had happened. But along the way, whether it was created by a speech or by some simple individual action and real human connection, there was departure after departure.

When we look at the departures of both Leo and Ainsley we see that both took some time. It was not a simple case of a brilliant leadership act opening their eyes to a new way of thinking. They needed some time to get their heads around the possibility of the departure. When you go to an art museum, you are probably already prepared for the possibility of departure—in some fashion that's why you are there. But in our day-to-day experience, most of us are not prepared or looking for departure experiences. We are not looking for the art of leadership and we are not ready for it when it finds us. Artful leaders realize this—as both Bartlet and Leo did—and they allow time for the process to happen.

We might say that being aware of the process and working within that is part of the craft of the art of leadership. It shows an ability to pay attention to the evidence of your senses and assess how ready for the departure the other is. It is an ability to listen to your intuitive assessment of what is happening with the other and act accordingly. These are not questions of science, but the complex questions of a craft discipline. These are fundamental questions of leadership practice.

CHAPTER NINE

Your Own Process

One of the hallmarks of artists and craftspeople who spend their lives engaged in a creative process is the way in which they pay attention to their own practice, their own creative process. The same is true for leaders who see leadership as a creative process, whether or not they aspire to a craft or an art of leadership. For leaders the critical issue comes down to three steps.[1] First they need to understand how their own actions contribute to creating social interactions. Second they need to figure out why they act in that particular way (as opposed to the countless ways that others might act in the same situation). And third, they need to actively experiment with other ways of acting. By doing this, the leader takes conscious control of her own leadership practice. These three steps may sound simple, but in reality they are very difficult. Luckily there are some helpful techniques that anyone can use to become more aware of her own practice.

Let's look at this practice of looking at your own process through one of my student's, Osana's, story.[2] Osana had been having issues with her middle sister, Aura, which had a negative effect on her family as a whole. These issues tend to come up when Osana is home from school and staying with her family. Since part of the creative mind-set is about staying with your senses and looking for new ways to make sense of a situation, we'll start with a very concrete example of the issue that Osana has with Aura. The first step is to present the example of the problem using a simple two-column format, which includes what each person said in the right-hand column and what the leader who is looking at their own process was thinking and feeling in the left-hand column. This example serves as the data that we can continue to come back to and stay with as new sensemaking of the situation develops.

The example takes place the day before Osana returns to the USA for the next semester of grad school. Her family, including her older sister Maria, her mother, her sister Aura, and Maria's husband Raul were all going out to dinner. They were waiting at the door for Maria and Raul to be ready to go. Aura was in a rush to leave because she needed to wake up very early the next day. She wanted to go to dinner as early as possible to come back home as early as possible and go to sleep (see table 9.1).

Most of us tend to reflect on difficult situations that ended poorly such as this one. However, it is all too human for that reflection to take a form I like to call, "crying in your beer." When you're crying in your

Table 9.1　Osana's problem

What Osana thought and felt	What was said
Aura is in a rush and in a bad mood, like usual.	**AURA:** Come on, MARIA, let's go!!! I need to wake up early tomorrow.
That's totally fine with me, but I won't say anything because I don't make the decisions here anyways! Don't want to "hurt" anyone or piss off Aura more.	**MARIA:** You guys go ahead; I'll meet you there because my husband isn't ready.
Fine with me! Can't believe we are still arguing about this.	**AURA:** Oh my god, always so slow.
I am sooo mad, but I won't say anything! I would rather not fight for some stupid thing.	**MOM:** No, let's wait for them, that way we don't have to take as many cars.
Ok, so I'm leaving tomorrow and won't see you again for months, and you still can't make a small sacrifice to spend more time with me tonight? If you don't sleep your entire 8 hrs tonight is not the end of the world, why can't you make a small sacrifice for me, and sleep one or two less hrs tonight? I don't understand.	**AURA:** I'm just sick of waiting, I have to wake up the next day very early, I want to be back home by 8:30PM.
Just leave and don't complain any more please.	**MOM:** Alright then do whatever you want to do.
Ok, so now I am the rude one and inpatient. I haven't said a word, and now that I just told you to get the hell out of here, you tell ME that I'm rude? You never realize that you are ALWAYS THE RUDE ONE!! And when I say ONE thing that might be a little rude, then you have to yell back at me saying that I AM THE RUDE ONE?!?!?!?!?!? Arghhhhh…	**OSANA:** You know what AURA, just pick up your damn car and go.
I want to yell at her and tell her she is being annoying.	**AURA:** Don't be rude.
Last day I will be hanging out with her for a long while and we are arguing about some stupid thing, great! Now I feel bad. And my mom is now probably sad, just great!	**OSANA:** Oh god, I can't do this right now. I'm going upstairs, let me know when we are leaving and I'll come down.

beer, you start with a conclusion, a way to make sense of what happened, and look for evidence in the situation that supports your conclusion. After considerable thought (and beer—literal or metaphoric) you have hardened your conclusion into rock solid, unquestionable fact. Osana could have taken this approach and focused on all of the ways that her sister was being self-centered, uncaring, and hurtful and justified her immediate feelings of anger and betrayal. But she didn't.

Instead, Osana used a technique called *The Ladder of Reflection*,[3] which offers a simple template for working your way from the data of what actually happened up through how you made sense of it and what the likely impact will be for you. It starts by identifying what data was selected (and thus implies what data was ignored). Then it moves on to how that data was described, what theories are implied in that description (explanation), what prediction about future behavior follows from that, and finally what sort of judgments or evaluations are made based on this line of reasoning. This slows down the process and creates potential space for alternatives at each step of the process. Below is how Osana reflected on the problematic interaction with her sister (see table 9.2).

This reflection allows Osana to slow down the almost instantaneous process of making sense and go back and reconnect with the evidence of her senses and understand it in a different way. She doesn't reify her initial feelings, but rather gains a new understanding of how her own behavior has contributed to the problematic interaction. The next step for Osana is to understand why she acted this way, why she responded to her sister the way she did rather than any of the countless other ways that she might have responded.

In order to make sense of why she acted the way she did, Osana used a very simple model called the learning pathways grid.[4] The grid pushes you to identify the actual outcomes of the situation being analyzed, the specific actions that you took, and finally the beliefs about the world or frames that led you to take those actions. The grid includes one row for what actually happened and a second row for what you would like to happen in a similar situation. When we look at Osana's learning pathways grid below, we can see that she acts the way she does because she wants to avoid conflict and she believes that the best way to avoid conflict is to keep her feelings bottled up inside. Unfortunately, her feelings become too much for her and she blows up. I'm sure we've all experienced this in our lives, probably on both the giving and receiving sides. When she suggests possible alternative ways to understand the situation in her desired frames box, Osana suggests taking a stance

Table 9.2 Osana's Ladder of Reflection

Select:	Aura said that Maria and her husband are always so slow. Mom said that we should wait for them anyways. Aura said she is sick of waiting for them. I finally said that Aura should just take her car and leave. Aura then said I was rude. I said that I could not do this right now and that I was going to go to my room until we were actually leaving to the restaurant.
Describe:	Aura wanted to leave to the restaurant earlier than everyone else. Mom told her we would wait and take just one car for all of us. Aura exclaimed that she did not want to wait. I did not say anything for a long time. After a little bit, while we were waiting for Maria and husband, I yelled at Aura. Then Aura responded to my comment immediately. I went upstairs and waited by myself in my room.
Explain:	Because Aura has to wake up early in the morning the next day, she wants to eat early and go to bed early. Because the parking is limited at the restaurant we were going, my Mom wanted us to just take one car. Because Aura, my Mom, and Maria were having a disagreement, I was frustrated. Because my frustration built up, I yelled at Aura for her to just take her car and go and have her do what she wanted. Because I was rude to Aura, she yelled back at me and told me not to be rude. Because my frustration increased even more, I decided to just go upstairs and avoid further arguments with Aura.
Predict:	By letting us know that she wanted to come back early, she hurt my feelings since she made me feel that she couldn't make a small sacrifice for me. Since my mom wanted Aura to wait, this contributed to her bad anxiety and mood. Her bad anxiety and moodiness contributed to my frustration and anger even more. Aura saying she did not want to wait also increased my frustration. The built-up anger and frustration caused by our behaviors contributed to yelling. My yelling led Aura to be angry at me. By going up to my room, I avoided further conflict. This avoidance could have hurt Aura's feelings. Quitting the conversation could have contributed to Aura's assumptions that I am careless. After looking at this interaction in more detail, I can predict that if my behavior does not change, same situations will continue happening with my sister. We will both continue feeling frustrated at each other for different reasons and with different perspectives, which can just worsen the relationship overall.
Evaluate:	Aura's statements made me feel hurt. My actions were negative, since I let anger build up inside me and just exploded at her at the end once all the frustration was built up. My yelling did not solve anything. My behavior just made Aura pissed at me, and instead of avoiding conflict, it created more conflict. My actions were totally ineffective. My interactions with Aura show that avoiding conflict and letting frustration and anger build up inside me is not an effective way to interact with people. Leaving conflicts unresolved, as I did when I just turned and left to my room, just increases my resentment against Aura and maybe even Aura's resentment against me. Going up to my room was very ineffective since the conflict was not resolved.

where she shares her feelings before they blow up, with the belief that it could bring her closer to her sister. This is hardly radical advice; again I suspect we have all heard it and perhaps even given it at one time or another in our lives. Which of course begs the question—if the advice

Table 9.3 Osana's learning pathways grid

	FRAMES	ACTIONS	RESULTS
A C T U A L	• If I don't speak up or say anything to Aura I will avoid further conflict. • Since I'm the youngest, I don't make any decisions in this house. • If I keep my feelings to myself, then no one else will get hurt or pissed off. • Selfish people are bad people. • People who only care about themselves aren't considerate. • If Aura increases her tone of voice, it is because she is in a bad mood and angry.	• When Aura speaks with a strong tone I just allow my anger and frustration to build up inside me and then explode at her after all that build up. • I lost my patience and was rude and mean to Aura. • I quit the conversation and left the scene. • I made obvious and notorious faces at her. • I never inquired why Aura was feeling anxious. • I didn't inquire how Aura felt about this situation. • I got defensive at the end of the conversation, which led me to only frame and advocate. There was no inquiring or illustrating whatsoever in any point during the conversation from my part.	• I feel angry, frustrated, and hurt. • I feel that Aura doesn't care that I'm leaving the next day. • I feel blamed for the situation. • I feel that Aura only cares about herself. • I am charged with negative emotions inside me. • My relationship with Aura suffered. • The issue is never resolved. • Everyone in the family suffers. • I seem careless.
D E S I R E D	• Letting Aura know how I am feeling will make her sympathize with me. • Avoiding conflict only creates more conflict. • Speaking up for myself is OK and shows others how I'm feeling. • Everyone should be treated with respect.. • Aura's tone of voice is louder than normal by nature.	• Determine, through more inquiry, how Aura is feeling at the moment. • Instead of keeping my feelings to myself, I should illustrate to Aura how I feel about the entire situation. • I should do more illustrating and inquiring at every point of the conversation. • By doing more inquiring, everyone in the family will have a better knowledge of how everyone is feeling.	• I want everybody in the family to be happy and satisfied. • I want to feel supported and appreciated by my sister when I leave the country. • I want everybody to be in agreement with each other. • I want everybody to feel free to do whatever they want to do.

is obvious, what makes it so hard for Osana to follow it, why doesn't she just naturally share her feelings with her sister, why does she avoid conflict by bottling up her feelings instead? To understand this requires a bit of digging into Osana's past (see table 9.3).

Why does Osana try to avoid conflict by keeping her feelings bottled up inside her? She doesn't like this aspect of her own behavior. When she reflects on it she thinks back to when her parents almost got divorced. Nine years before, when she was fourteen, her parents were going through a difficult time. They would constantly get into heated arguments. Osana's sisters were away at college and so Osana was the only witness to her parents' fights. Her mother came to her for emotional support and talked about the problems she was having with Osana's father. This made Osana very emotional, but she didn't tell her mother that it was too much for her, instead she tried to be supportive as best she could. And she became resentful of both her mother and father. To her, the arguments were stupid. Neither one of them would compromise. And most importantly for her future behavior, Osana learned that conflict was bad—really, really bad, and it should be avoided.

This desire to avoid conflict fit nicely with Osana's self-declared role of family peacemaker. Her desire to make everyone in her family happy at all times made her unwilling to risk making things worse by expressing her own feelings. She felt that if she just stayed quiet she wouldn't hurt or anger anyone. This was also a case of justifying and reinforcing her existing behavior. Osana is the youngest child and had felt from an early age that she wouldn't be listened to because she was the youngest. There is a videotape of her family on vacation at Disney World when she is four years old, and in the tape, Aura, who is nine at the time, constantly puts her down, doesn't let her finish sentences, and generally makes fun of her younger sister. Osana learned to stay quiet at an early age. The flip side of staying quiet is that you become a good listener, which Osana did, and all her sisters learned to come and share their problems with Osana because she was such a good listener.

Having her sisters come to her with their problems was a reward for keeping her emotions bottled up inside, for not causing conflict. Her parents also rewarded this behavior and Osana liked the fact that her mother said she was the only rational one. She developed a reputation within the family for being "chill," which she liked very much. So, in short, Osana developed a theory, a way to make sense of the world, by the time she was four years old that said it was better to stay quiet. As she grew older, she paid attention to the evidence of her senses that reinforced this theory and gradually refined the theory into it being best to avoid conflict by staying quiet about her own feelings. And that is why Osana acted the way she did and not some other way. She acted based upon theories of the world and her own behavior in it that she had been developing and refining all of her life. This is true for all of

us. Our practice as people, our practice as leaders, is often based in how we started making sense of the world when we were very young. Those ways of making sense may have worked when we were young, but they may not be the best way of acting now that we are adults. Osana quickly realized there were negative consequences of her tendency to silence her feelings to avoid conflict. Do her sisters then see her as being uncaring since she doesn't share her feelings? Perhaps they do. At the very least, being emotionally closed off leaves her less connected to her family than she would have liked. Being away at college in the USA has allowed her to develop into a stronger and more confident person and she finds herself less and less able to keep her emotions bottled up, and she explodes more often with her sisters. Osana now sees how her own behavior contributes to a problematic situation and she understands why she behaves as she does. Now for the third step—to actively experiment with other ways of behaving, to *seek* new and different ways of making sense of the world and *acting* from those new and different ways of making sense of situations.

Osana's first experiment is to be more assertive with her roommate at college. Her roommate had developed the habit of not cleaning up around their apartment. Osana had been afraid to confront him about it because she believed that if she confronted him he would get very mad at her and their relationship would suffer, perhaps even end. But she also realized that if she continued to bottle up her feelings, she would eventually explode just as she had done with her sister. She decided to raise the subject before that happened. Here's how it went (see table 9.4).

Although Osana may not have gotten her roommate to clean up, she did get an agreement from him that he would. And more importantly, she didn't get the horrible results that she feared. Her roommate didn't get mad at her, their relationship didn't suffer, and it didn't end. This sort of direct evidence that her theory of the world, her frame or sensemaking of how things worked, wasn't completely accurate allows her to start to change. She has tried something new and it has worked better than expected. This gives her the confidence to try an experiment with her sister.

The opportunity came when she went to Mexico for her sister's, Aura's, wedding. Osana was relaxing outside with her mother and sister, Maria, when Aura came out of the house in a highly agitated state because she could not find her passport. In the past Osana would have tried to avoid the high level of emotion her sister was displaying, but she now saw that as part of her own pattern and chose to act differently (see table 9.5).

Table 9.4 Osana's first experiment

What Osana thought and felt	*What was said*
Inquire, inquire, inquire. Do not advocate Osana.	**Osana:** Hey G. how is it going? How are classes going?
I hope you clean! You always take breaks and sleep but never use the free time to clean. And then you say you don't have time to clean dishes!! Argg!!!	**G:** Good but very busy. **Osana:** I see. Do you have a lot of work to do now?
I cannot build this up inside me anymore. I have got to speak up and illustrate my feelings. If I keep avoiding this confrontation, I will burst! Because I am about to burst right now.	**G:** I do, but I am going to take a break before I start more homework. **Osana:** Nice! **G:** Yeaup, then I will go to the library all night. **Osana:**... silent for a minute.
Ok, Osana, you have got to react. Talk to him nicely! DO it....DO IT! Don't be afraid.	**Osana:** Actually G., would you mind cleaning your dishes today? Would you have time to do it? I would really appreciate it if you could clean them as soon as you can, especially because my favorite pots and pans are dirty and I would like to cook with them.
I don't understand why you don't use your free time to do dishes, but oh well; at least you are going to finally clean.	**G:** Oh, yea, yea. You are absolutely right, don't worry about it. I will clean when I get back from the library tonight.
That did not go so bad after all!! It did not go bad at all!!!	

When Aura started yelling, Osana immediately felt annoyed. Now that Osana was paying attention to her own practice, she realized that she needed to do something other than stay quiet and make faces, which would have been her response in the past. She chose to inquire about the passport and help her sister. Later that day, Aura found her passport and Osana and Aura were able to talk about how stressed Aura was and share their feelings with each other a bit.

In the first experiment, Osana has reflected on her own behavior and consciously planned out a chance to experiment based on that reflection. This is how you start, how you learn to question your own sensemaking and act from a different understanding. In the second experiment, Osana does not act on a predetermined plan, but instead sees the opportunity to change her practice in real-time. She pays attention to the evidence of her senses as she sees and hears her sister becoming more emotional and she recognizes that she is getting frustrated. She then recognizes her usual sensemaking, which is to avoid conflict by keeping her emotions bottled up and retreating. She then consciously chooses a new way of making sense of the situation, which is that she should inquire and try and be helpful, and her actions are based upon that new sensemaking. This is the creative process of a leader in action.

Table 9.5 Osana's second experiment

What Osana thought and felt	What was said
What is Aura screaming about now? Oh no....here she comes! Ok so why does she have to overreact!?!?!? She always does this...I am starting to feel frustrationnnn! Maybe she has a reason to be angry and with a high tone!? Time to reframe!! Maybe I'll speak up and be affectionate to see if this works? I can't let anger built up inside me!! And she is rude again!!! Maybe she has a good reason for this. I see the pattern of actions starting here! I have to reframe again! Ok, she is thinking with me now! We can maybe solve this issue together. Maybe inquiring will help!!	**Aura:** Shit! Shit! Shit!...I can't find my passport anywhere!!!!! I definitely lost it...Ok, so now I'm not going to have a honeymoon, just great!!!!! **Osana.:** I am sure you will find it Aura, don't worry! I'm sure everything will be O.K.! **Aura:** NO, Osana, I searched everywhere and couldn't find it. **Osana:** When did you use your passport last? **Aura:** Hm, I don't remember. Wait...It was last year when I went to Colombia.
	Osana: Ok, good. Do you remember that night when you came back from Colombia? Where do you think you could have put it that day? Could you have given it to Juan Pablo for him to save it somewhere?
Ok, I'm getting a response!! And with a better tone, good good!!! I'll illustrate ideas to solve the issue!!	**Aura:** I'm sure Juan Pablo does not have it. So I have to have it somewhere but I don't remember where I put it at all!!!! Shit...No honeymoon! **Osana:** Well at least you found out about this with some days of anticipation. Worst case you can always get a new passport in one day.
Huh, this is turning better than I expected!! She is calming down...wow!!!! And I'm speaking up!!!! Great! I feel really good!!!!	**Aura:** That's true, but I don't have time. Do you think you could help me with this? **Osana:** Of course, Aura, you know I'm there for you always. **Aura:** Thank you so much!!

You might question whether Osana's experiments are really acts of leadership. I suggest they are. In the first experiment, she takes the initiative in solving a problem—she actively works to both make the apartment cleaner and to make the organization that is her room-mate and herself work better. In the second, she takes the initiative to resolve the issue she has been having with her sister and make the family better. That's what leaders do—they take the initiative and act to make things better. And simply because there are a lot more opportunities for leadership in the smaller organizations in our lives (families, teams, friends), that's where most leadership happens. It may affect more people when a leader acts in a large organization

(a business or government perhaps), but the underlying creative process is the same.

Is Osana's leadership craft or art? Her use of various techniques to reflect is a craft skill, as is her use of the idea that she should inquire and illustrate rather than simply advocate.[5] It's hard to say if it rises to the level of art, but certainly in the second experiment there is some evidence that Osana's actions have acted as a departure for her relationship with Aura to go someplace new. That someplace new may really be someplace old for the two of them, but it is certainly someplace they have not been to recently. Again, it is a small action, and if it is a departure, it is a small departure. But just as creativity is not generally about a single big idea, but is rather more about a process, leadership is generally not about a single big action, but is rather more about a process of many small actions.

Of course, being a creative process, every leader's practice is different. So, let's look at another example of a former student of mine engaging with his own practice as he tries to improve a difficult situation in his work life. Randy was the Director of New Technology and he had a continuing conflict with the Engineering Services Manager (ESM). Randy constantly criticized the ESM for being inefficient and bureaucratic and pushed him to move things faster to get results. In return the ESM called Randy a loose cannon and criticized him for not playing by the rules. Here is a typical conversation between the two of them (see table 9.6).

Such conversations left Randy angry and frustrated. He was angry at the ESM for making a big deal out of such a small thing, but also angry with himself for taking the bait and spending more time arguing about the need to fix the typo than it would have taken to make the correction. To try and understand why he acted this way, Randy used a tool called the Change Immunity Map.[6] He started the Change Immunity Map by listing his complaints about the situation. The complaints point us toward the second column, which is the commitment that is being violated. The reflection starts with the next column in which Randy lists things that he is either doing or not doing that are preventing him from fully realizing the commitment in the previous column. In other words, here is where Randy has to identify the ways in which his own behaviors are contributing to the problem. In the next column he identifies what is driving those behaviors—what he is committed to that causes him to behave the way he does. This is generally some form of self-protection that we are not anxious to admit to. Randy is not proud of the fact that he seems to be more committed to being right than to

Table 9.6 Randy's problem

What Randy thought	*What was said*
For Christ sake, this is a $500 approval renewal and you're calling me wasting my time to talk about a typographical error. The intent was clear, just process it. Here we go again, engineering more worried about their paperwork than getting the job done.	**ESM**: I have your request for RP2 Approval for the [product]. I looked at the project charter and noticed that in one section you reference China but the request is for PAVUS.
Maybe if you didn't insist that Product Management fill out a full project charter for every little paperwork approval renewal, and then go over each one with a fine tooth comb, we could stop wasting each other's time and actually accomplish something.	**Randy**: Thanks for the notice, it's just a typo. I have so many of your forms to fill out to get a project moving that I use old ones as templates and just change what I need to and sometimes I miss a section. It is very clear however that the project is for PAVUS approval and has nothing to do with China.
You have got to be kidding me. The document is clear, it's a typo, and the only one that's ever going to read this is you.	**ESM**: Well if you can just go ahead and make the corrections then I'll submit this up to [VP of Engineering] for final approval.
Getting angry that he's being so unreasonable.	**Randy**: You've got to be kidding. Since you got the charter open, can't you just fix the typo and submit it. And really, it doesn't need to be fixed at all…it's a minor section and it's clear that its PAVUS not China.
Talk about a passive aggressive jerk…the only reason he's holding this up is to demonstrate that he's got control…he doesn't care at all about a typo.	**ESM**: The document isn't correct, so just let me know when you fix it and I'll process it.
We used to just do all this stuff by making a quick phone call or maybe sending an e-mail. It's his system that's caused everything to be so slow. He should know that the problem isn't that everyone isn't following his system, it's that his system just doesn't work.	**Randy**: If you're holding things up because of typographical errors, then there is a serious flaw in your system. It's bad enough we need to fill out these charters at all…we're never going to make any progress if we are worrying about clerical errors in inconsequential paperwork.
I'll fix it right now so he doesn't have any more excuses to delay…then I can nail him again for being slow if he doesn't turn this around immediately.	**ESM**: Our process says that the project charters need to be clear and concise, typographical errors cause confusion so we're not going to accept them unless they are right.
Bet he didn't see that coming. He probably didn't realize I could fix it while he was still looking at it. This guy should lose his job for pulling this kind of nonsense.	**Randy**: Whatever, I've already fixed it. Just submit the damn thing…(sarcastically) I'm sure the correction will have a real impact on our ability to get this project done.

Table 9.7 Randy's change immunity map

Complaints	I am committed to the value of	Doing/ Not Doing	Competing Commitments	My Big Assumption
Many people seem to believe that process is more important than result.	Process not getting in the way of achieving the desired results as quickly as possible.	I'm refusing to acknowledge that in many cases a standard process can improve results.	I am more committed to being right than I am committed to the results.	
The ESM uses his position as gatekeeper to force people to comply with his system, even if they don't agree to it.	Teamwork and collaboration, we all win together or we lose alone.	I'm not striving toward positions of teamwork and collaboration with people I don't agree with. I build teams of like-minded people.	I am committed to convincing other people that I'm right.	Admitting that I'm wrong, or even complying with a request I don't necessarily agree with, will lead people to believe that I'm unsure of what I'm doing, and therefore, not worthy of respect.
The ESM and others aren't willing to listen to the needs of other functions.	Trying to see the big picture and the impact of any action on the entire business.	I don't always see the impact of my specific actions on the entire business, only the actions of others.	I am committed to winning my personal battles at the expense of the business.	
There are a lot of arguments about topics that, in reality, aren't worth the energy put into the disagreement.	I don't want to be the cause of non-value-added disruptions in the business.	I often let myself get pulled into, or even start, these petty debates. I have trouble separating the big issues from the small ones.	I am committed to winning my personal battles at the expense of the business.	

getting the results, but that's where his analysis led him. In the final column he digs deeper and identifies the belief he has that drives the competing commitment in the previous column (see table 9.7).

Randy generally sees himself as a highly successful, highly competent business person. He is outwardly calm and competent, but when a situation comes up that calls his competence into question he is likely to react in a way that protects his own identity at the expense of those with whom he's trying to work. Digging deeper into why this is the case, Randy traces it back to his experience growing up. His family

moved to a small town when he was young and as an outsider he experienced a lot of taunting for being a "smart kid." Randy writes:

> The impact of these experiences on my personality and approach
> to interpersonal relationships may have only become apparent
> when I reached a senior position at an exceptionally rapid pace,
> followed by what I perceived as direct challenges to my compe-
> tency in these roles of increasing responsibility. At some level, it
> was the fifth grade all over again but this time I was in a position
> of power and influence, and I was (at least subconsciously) doing
> everything in my power to keep from sliding back into that role of
> the smart, quiet kid that got pushed around a lot. I perceived that
> the ESM (and others certainly) viewed me as a junior colleague
> that didn't really know much and therefore need to be humored,
> but didn't deserve the respect of those who had dedicated entire
> careers to the organization.

Once he was aware of how he contributed to the situation and why
he was acting the way he was, Randy took the next step and experi-
mented with behaving differently. When he felt himself falling back
into the familiar antagonistic pattern, he tried to stop himself from
attacking and began to inquire to learn more about how the ESM was
thinking (see table 9.8).

For Randy, this conversation provided evidence that the ESM was
concerned about the needs of the business in much the same way as
Randy. It wasn't easy for Randy to actually listen to the ESM, but
when he did he found that his own sensemaking about the ESM's
motives was incorrect. This opened up the ground for further experi-
mentation. Randy moved from simply inquiring and trying to under-
stand the ESM to actively trying to collaborate with the ESM and go
into discussions with an active willingness to change his own position
(see table 9.9).

It took a great deal of effort and focus for Randy to not fall back into
his old antagonist pattern with the ESM—which is typical of changing
your own practice. But these small changes, these small experiments
with acting differently, are the foundation of working with your own
creative process of leadership. It's probably not obvious to the rest of
the world, but it's a big step for Randy to not spend his time in petty
arguments that are really about his childhood needs to win, to control,
and to have power. We've all been part of those arguments, so we all

Table 9.8 Randy's first experiment

What Randy thought	*What was said*
(Immediately begins to tense up) We don't need anymore process mapping, process maps are not the solution to every problem. Take a deep breath, let's try to explore the alternate frames.	**ESM**: I think it would be valuable to develop a more detailed process map for approval renewals.
Try to keep an open mind, let's see what he says about why he wants more process mapping.	**Randy**: Ok [ESM] lets talk about that. How will the additional process details help us execute this better?
That makes sense, a couple of weeks ago I had to jump through all kinds of hoops to get a long-standing business partner who happens to be from Europe permission to visit R & D, and I know that the processes for government official travel particularly related to China is a nightmare.	**ESM**: Well corporate has added a bunch of new requirements for foreign national visitors, and there are a lot of forms and requirements that have to be met simply to arrange the plant audit. We have a lot of new people in new roles and they get confused about what they need to do and when. Providing them a roadmap would help them know they are doing the right thing.
Oops, falling back into old habits. Don't attack his process, stick to trying to understand why he wants to do this.	**Randy**: That sounds like it might be reasonable, but can we do this in a way so that we can help everyone understand what they need to do without adding a bunch of non-value-added activity to the process?
This looks like the familiar old pattern, but I started it so I need to get this conversation back on track.	**ESM**: We need to have a standard process across the whole business that everyone understands and can follow.
That wasn't a very eloquent way to do this, sounds a bit combative and threatening.	**Randy**: Can we discuss the impact of any changes on Product Management, Marketing, and Manufacturing?
So [the ESM] believes that the other functions aren't giving engineering everything that they need. I don't know that I agree with that, but he does seem sincere in his desire to make things happen faster and not slower.	**ESM**: We can talk about that. We want this process to occur faster, not slower. Currently it takes us more than 18 months to process an approval renewal in China and we know that this isn't consistent with the needs of product management, but we don't always get what we need from the other functions in a timely manner, which delays our own process.
This seems more collaborative than past interactions, even though I still don't agree with everything [the ESM] has said.	**Randy**: Ok, before we start talking about the details of how we do approval renewals, let's try to talk specifically about the needs of each function. Then we can look at ways to improve our ability to get this stuff done, including adding details about the process if needed.

Table 9.9 Randy's second experiment

What Randy thought	What was said
This really isn't good... we processed all these months ago and I know that engineering hasn't been working on them.	**ESM**: There is a problem with the China approvals, it looks like we aren't going to get most of these renewed before the current certificates lapse.
I need Jim to know that this isn't just a schedule issue; we will lose a lot of revenue if we don't get these renewed. Try not to do it in a threatening way though... be positive and proactive.	**Randy**: That's unfortunate, is there anything we can do to help accelerate the schedule. There will be a big hit to the business if we can't get them renewed on time.
(Getting a little angry) we have been turning these around in less than a month, so saying that time is getting lost because of product management isn't really accurate. Focus on not turning this into an argument, it's a small issue.	**ESM**: Part of the problem is with getting Visas and travel arrangements on time; it can take six months to make the arrangements. I think that people don't understand that it really does take 18 months to process these things, but by the time product management has developed the project charters and handed them over to engineering we have already lost 2 or 3 months. We really want product management to turn these around in a couple of weeks.
I'm not sure we can turn these things around any faster than we have, but if [the ESM] thinks we are a source of delay then we can probably work to make sure we aren't.	**Randy**: I think we can try to do that. I can't guarantee we will always be successful because we are really short-staffed and have a lot of other things going on, but I bet we can turn at least 80 percent of them around in a week or two if that would help.
Deep breaths, deep breaths...	**ESM**: I think that would help some, but they can't just be done fast they have to be done right.
Maybe we can kill two birds with one stone. If we have a telecom and WebEx with each charter then we can quickly identify and resolve any typos or errors, and it will also help engineering know what is coming down the chute.	**Randy**: I know we had the issue a couple of weeks ago with a typo in one of them. I wonder if it would be useful to have a quick WebEx when we submit each one so that we can review it together, and if any changes or corrections are required we can make them right then.
Try to ignore the process comment, focus on the change in dynamic here.	**ESM**: That's not really how the process is set up, because you have to submit things through the system, but if you do want to go over the charters before you put them through I think we would eliminate some of the potential areas of confusion.
	Randy: OK, let's try it. I'll give you a call when the next one comes up.

know how little they really accomplish. It takes the sort of reflection, analysis, and attention to his own practice that Randy showed to lead yourself and those you are fighting with out of such destructive and wasteful interpersonal dynamics.

Osana and Randy's stories aren't important in terms of the content— even though you may be able to relate to their issues. The lesson here is about the technique of looking at your own practice by first under- standing how your own behavior contributes to the situation, then figuring out why you act the way you do, and finally experimenting with new ways of making sense of the situation and acting differently. This is the great meta-skill of creative leadership practice that acts as an umbrella over all of the other leadership skills. It is the practice of looking at your own practice that contains and enhances the other arts of leadership.

Great athletes all have coaches that constantly provide feedback on what they're doing so they can constantly get better at what they do. Very few of us have coaches that constantly watch our performance as leaders and offer feedback. But imagine if we did. Osana's coach would talk with her about her initial blow up with her sister. They would spend Monday morning in the film room watching it over and over, looking at exactly where Osana went wrong and then doing the analy- sis together about why she acted that way. They would spend time on the practice field doing drills to build the muscle memory needed for Osana to be able to react differently the next time. They would run simulations with someone playing the part of Aura, so that Osana could practice acting differently.

But Osana didn't have a coach. Instead of film, she had to create a two-column case that she could look at again and again. Her practice field was her own apartment and her interaction with her roommate. The success there gave her the confidence to try to act differently with her sister. Just as professional football players will tell you that Sunday's game was won or lost in practice the week before, leadership success is built on little moments like the ones that Osana and Randy describe and the ability to reflect on and learn from these moments.

CHAPTER TEN

Going Deeper

Engaging with your own practice as described in the previous chapter is a critical skill for developing your own leadership craft. Alongside the practice of looking at your own process is a second critical practice that I call *going deeper*. It is connected to the exploration we saw in the previous chapter where Osana looked at why she avoided conflict and Randy looked at why he needed to win. It is an exploration of your self—who are you, where do you come from, what is your passion, what jazzes you, where do you want to go? These are questions fundamental to identity and leadership.

The practice of going deeper never ends. It's not about finding *the* answer and then moving on from there. The answers change over time. It is about being engaged in a dialogue with yourself and learning to connect to those deepest parts of yourself. There are many ways that you can engage in the process of connecting with yourself, from meditation practices to autobiographical writing. I like to ask my students to tell stories about who they are as a leader and who they want to be as a leader. In the process of developing their stories they try to address those fundamental questions of identity. Here is one such story:

It's been said that people are products of their environment. I think this has been true in my case. My management style had become a product of many years of anger, a lot of ambition, and life's lessons. When I was young my parents made sure I understood the important things in life.

1. Boys don't cry. Girls cry. My father was no hypocrite. I never saw him cry, not even when his parents died. My father wanted me to be tough. Weak people got walked all over.

2. Don't ever lie. When I was eleven I found out that lying will get your hand burned on the kitchen stove.
3. Life's not fair, so get over it. I remember getting a lesson in this when my dog had been killed by a car. My father told me to walk to the end of the street and get the dog and bury him in the woods behind the house. So I walked down the street and found my dog. I sat with him for a few minutes so that my father wouldn't see that I was upset, and then I carried him home and buried him like I was told.

These lessons affected me greatly. I became desensitized to people's emotions, and I was unsympathetic to their problems.

On the positive side, I was a hard worker and very rarely missed any time. This was often enough to make my bosses look the other way when I'd lose my temper and verbally abuse someone. Of course, this was usually when someone lied to me. That was one thing that I could never accept.

As time passed, I seemed to get worse. My boss, Jeff, decided it was time to talk to me about it when I refused to give an employee extra time off for a death in the family. I remember exactly what he said. "George, I know you're following company policy, but they're people first and employees second." Then he asked me, "do you play chess?" When I said "yes," he told me to get a chessboard for my office, and to find time to play a game with Bob when he returned from bereavement leave. "Such a strange request," I thought. As usual, I did what I was told. To my surprise, Bob was a nice guy.

Soon after, I decided that it was time for change. I was determined to remember that employees were people first and employees second. Also, after going back to school, I realized that I was no longer interested in climbing the corporate ladder. Academia had become my calling.

I now wanted to contribute to society by helping to educate people, and maybe one day coming up with a new idea that greatly affects the way we do business. The journey toward this goal has been tough, and I sometimes find myself slipping back into past habits, but I've made some great strides.

Although neither of us still works at the same company, I still talk to Bob from time to time. He has no idea of the impact he had on my life. And as for my old boss, Jeff, as irony would have

it, he was fired for not being strict enough. But I will continue to work on my goals, and, hopefully, when I get there my leadership style will be much like his. Not as a product of my environment, but by my choice.

It took a lot of soul-searching and reflection for George to figure out the three rules that he had been taught to live by. These are the sort of deeply rooted assumptions that we unconsciously treat as facts and it takes some work to bring them out into the light of day and recognize that they don't have to guide our actions. Once George identified the things about his own leadership that he didn't like, he takes the creative step of choosing what sort of leader he wants to be. In the creative process of leadership, the raw material that you are working with is yourself, and rather than trying to fit your own behaviors into a preexisting model of what someone has told you leadership is, the creative leader makes his own conception of leadership through his actions with others. George may decide to model himself as a leader on Jeff, but none of us imagines that he will be the exact same leader as Jeff. George will be George, perhaps in the genre of "people first, employees second," but uniquely George nonetheless.

George also points out that it has been a tough journey, and I would emphasize that it is a journey that never ends. Five years after telling that story in class, I spoke with George about it. He said:

Rereading my story got me thinking. When I did that assignment, I wanted to acknowledge some of my shortcomings. At the time, I thought that the lessons that my parents taught me had negatively affected my management style. As such, when I was digging deeper to developing my craft (to use your words), I mistakenly thought my error was the way I viewed employees. Now, I see it very differently. My parents taught me courage, honesty, and to be strong. While I learned these virtues well, I hadn't learned to be virtuous. Instead, what I needed to do was to develop a broader set of virtues, which likely would have mediated my behavior. I guess I should have read Aristotle earlier in life.

George now teaches business ethics, and his doctoral research has changed how he sees his own story. His story is like a river—you can't stick your hand in the same water twice, but in some important way it is the same river.

We each have a unique story to tell and a unique way to tell it. Having gone through a similar process of reflection, another student told the following story:

> When my oldest daughter was five, I was responsible for her nighttime routine. I would pick her up from school and ask her how her day was, and she would say "fine" and leave it at that, and I learned not to bug her about it. At bedtime we would sit and read and chat. After relaxing for a while, she would often begin telling stories about her day—long and winding stories that I wished would go on forever. I learned that she needed time to make sense of her day before she could talk about it.
>
> Within three months of 9/11, I went to the Middle East. I was responsible for the security of a 5,000-person base and had over a hundred people working for me. There was a protest. Things started out smoothly—the crowd seemed like they were enjoying themselves chanting and burning effigies of Bush. Things took a turn for the worse like they always do. Tired of chanting and out of stuff to burn, they directed their attention at us. They gave us the "shoe," which is the Arab equivalent of the finger. They got bored with that, and it just takes one person to throw a rock and you find yourself under a downpour of debris. My guys were starting to get antsy, and the radio started squawking with requests for permission to start shooting if they feel the need. So I'm thinking, "*no way* are we going to start unloading on a crowd unless we come under fire," and I've got to communicate this to my troops in the least spastic manner possible, which I do. In the middle of all this my boss calls me back to the rear. He says, "Since the crowd is focusing all of their energy on your security troops, I think if we just pull back the crowd will settle down." I wanted to choke him. Backing down would have only shown the crowd that *they* had the power, and the whole thing would have gotten worse. So you've got to picture these scene—it's a thousand degrees out, my guys are looking to get some trigger time, rocks and junk are still hitting the ground all around us, and this guy wants me to do something totally ridiculous. I suppose it would have been pretty easy to salute smartly and pull back. So now I've got to be very tactful and tell him nicely that his idea sucks, and that's what I did. To which he responds, "I really think we should pull back"; to which I respond, "I don't think that's a good idea"; to which he responds, "I'm sure your second in command would

agree with me." To which I think "he's going to relieve me" and I say, "my second in command would probably want to keep our troops where they are"; to which he responds, in total frustration, "OKOKOK...keep your men in place but if this gets out of control...it's on you." It was a lonely moment—leadership can be isolating.

So I went back closer to the action and we stayed where we were and got hammered by debris for what seemed like a lifetime. I was getting pretty tired of it and asked a colleague, "What do you think about throwing some tear gas at them?" "Let's give them another few minutes...they are starting to slow down." Sure enough, the crowd ran out of steam and went home to celebrate or take a nap or whatever people do after a riot.

After the dust settled we were standing around joking when I noticed something wrong in one of my grenadier's vest. A grenadier has a grenade launcher under his rifle, and he wears a vest full of shootable grenades. I had told him to draw a bunch of tear gas from the ammo dump before the protest, and he had gotten a few crates and handed out ammo to all my other grenadiers, and I'm sitting there looking at his vest and at the color of the tips of the grenades—and they are gold. All of them. "I told you to draw tear gas." "I did," he says, his smile disappearing. "Those have gold tips" "...So..." "A gold tip means they're HE." And tears started welling up in his eyes.

HE stands for High Explosive—the kind of grenade that blows off your limbs. If I had given the order to use tear gas, we would have launched grenades into a crowd full of kids.

So what am I supposed to do with this guy? What would you have done? He was one of my best troops—and he had made the mistake either out of ignorance or exhaustion. Well, military law would say Court Martial—he would go to jail. We were getting ready to go forward, and I needed to keep him as a productive member of the team. I decided not to prosecute him, and we dealt with it informally, and it was one of the most compassionate things I've done. A few months later he made up for his mistake. During a firefight, he used the vehicle that he was driving to protect his team, and he received an award for heroism.

During my second tour in Afghanistan I helped plan the war. I was not a commander, I was more of a specialist. My boss was exceptionally bright (he had taught applied mathematics at West Point), and he was equally as intimidating. He seemed to tolerate

me, but I never got the feeling he was satisfied with my work and the quality of my analyses. It was the first time in my professional life that I felt I was disappointing.

Someone once said that people tend to dedicate their lives to compensating for past shortcomings. If you were nerdy in high school, you try extra hard not to be a nerd in College. If you got dumped by a girlfriend because you didn't give her enough space, you might be aloof in future relationships. So, over the past three years, since working for the Mathematician, I had this need to prove myself as a sharp analytic thinker. And I've honed my skills and developed into a fairly talented analyst—but there's a downside. I've turned into a not-so-nice person when dealing with my troops, and I would rather spend my time working on spreadsheets. It's a giant step back from the compassionate, decisive, and principled leader I used to be.

I told my wife Nelly about this protest story, and she said, rather surprised, "There were protests?" I don't usually talk about the details of what went on overseas—I struggle to put them into words—just like my daughter did after school, I haven't been able to integrate those experiences and make meaning of them. This exercise helped me figure out what kind of leader I used to be, who I am today, and why I have been undermining my full potential—one spreadsheet at a time.[1]

There's a depth of understanding of self in this story—about what matters to him (compassion and analytic ability), as well as an understanding of his journey as a leader. There is also an engagement with the shadow—the dark part that lives in all of us—in both of these stories. In the first story we see the dark side of a focus on task and instrumental effectiveness, which is a lack of compassion and human connection. In the second we are told that he has lost some of his compassion because of his focus on his analytic ability. Including the shadow, the dark side of ourselves and our passion, is a critical part of going deeper.

Working with our shadow side is an important aspect of knowing ourselves, and at first blush it is as simple as that—a key part of the never ending pursuit of self-knowledge. But in terms of leadership practice, working with your shadow is tricky and requires a delicate balancing act. As an example, think about a military officer who is about to lead his troops into battle. Certainly, he is scared and at some level his troops know that he is afraid. But his troops need him to be brave, to project a sense of knowing that everything will turn out all right, even though

he may be far from sure that they will. The troops might not follow a commanding officer who is openly afraid, but they also won't want to follow a leader who is openly foolhardy about the very real dangers of the upcoming battle. It is a delicate balance between fear and bravery, between the probable and the possible. It is a balance that is easier to strike if leaders know themselves more, which includes their shadow side, too.

Taking the example farther, once the leader knows herself, what then? If the military officer knows that he is afraid and at the same time the operation must be carried out, what then? It's not a simple matter of screwing your courage to the sticking point and boldly going forward. It is a complex question of practice, of what to do with your fear, of how much of yourself to share with your troops, and of how to practice your own particular form of leadership in a difficult situation. It is a question of how best to construct and enact your leaderly self. In the previous chapter we looked at how various leaders saw how their own behavior contributed to making a situation difficult. They then experimented with different ways of behaving that improved the situation. Here the question is broader. How might we construct and enact our leaderly self in new situations, in difficult situations?

Constructing and Enacting Your Leaderly Self

The problem of how to construct and enact your leaderly self is in one sense a very simple one. We do it all the time in every situation that we enter, whether we like it or not. The real question is how to do it choicefully and construct and enact the leaderly self we choose to be rather than simply being the product of our environment and personal history. Luckily, this process is very similar to the craft of theatrical acting, in which actors carefully construct and enact a character on stage.[2] Donna Ladkin and I have looked at how actors create characters and have translated that into a simple model of how leaders can choicefully construct and enact their leaderly selves. We think of it in terms of three practices: self-exposure, relating, and leaderly choices.

Self-exposure is important because followers want to know their leader. The important thing is the sort of knowing that this is about. It's not about knowing the leader's past history or his or her favorite color or any other set of facts about the leader. Rather, it is an embodied sort of knowing, a direct sort of knowing that comes from experiencing

the other. In an age when our political leaders are experts at staying on message and our corporate leaders learn that being professional means never being emotional, in an age when almost anything you say or do could be recorded and appear on the Internet, leaders have become guarded. When we encounter people who are guarded, we have a sense that we're not really experiencing them, that they are hiding some part of themselves from us. It is that hidden part that followers want to know. Or perhaps, more to the point, we want to think that we know "the real" leader, and as long as we have a sense that something of him is hidden, we feel that we don't know him.

This doesn't mean that as a leader we need to expose every aspect of our inner self to all potential followers. It does mean that we need to expose something of ourselves in a way that feels authentic to the followers and allows them to connect, and not have a sense that some part of the leader is being hidden. There can be tremendous feelings of vulnerability when revealing parts of ourselves that we usually keep hidden. I think that some feelings of unease and vulnerability are natural, and this is also an essential part of the practice of leadership. In fact, the feelings of vulnerability are generally a guidepost that there is an important part of yourself that you may want to share in some way.

If we imagine our military officer leading his troops into battle, he will probably feel vulnerable if he admits that he is afraid to his troops. But if he owns his fear, his troops will in all probability see him as being brave. And not only will they see him as being brave, they will have a model for their own actions—a model of how to continue on and be brave even when afraid. And in this example is a more general lesson for self-exposure. Leaders can share those vulnerable parts of themselves if they know those parts and have them under their control. This is part of why exploring your own shadow is so critical for leadership. The officer who cannot admit to himself that he is afraid cannot very well share that with his troops. The troops will probably be aware of the officer's fear, unless the officer is an incredibly skilled actor and this knowledge creates a tension between what the officer says and how the troops understand it. The troops might see the officer as a hypocrite, saying one thing and doing another. The troops might not trust the officer, thinking that he is not telling them something. It will be clear to them that he is hiding something from them, or at least trying to hide something. But the officer that knows his own fear and shares it in an appropriate way enhances the sense that he knows what's what and that others should follow him. Of course, the key word in all of this is *appropriate* self-exposure. How do you know what is appropriate?

The answer to that comes from the other two practices—relating and leaderly choices.

Relating, in its simplest form, consists of being completely in the present moment, of being in the here-and-now and paying full attention to the evidence of all your senses and how you intuitively make sense of that evidence. Of course, in practice this is hardly simple. Being fully present in the moment is itself a discipline. We all have our moments of being in the moment, but it is far too easy to be dominated by our past sensemaking or focus on the future we are trying to create. That is to say, it is far too easy to be dominated by what is going on inside our own head, which may be an important part of what is going on in the moment, but it is only one aspect of the moment. Real relating requires attending to the other as much as or even more than we are attending to ourselves.

Relating is one of the ways that a leader forms a connection with others. It responds to the need we all have to be heard, to have others truly see us. When we try to relate to a leader we are looking for someone who understands us, who "gets" our needs and thus will lead in a way that includes addressing those needs in some fashion. As a faculty member, part of my job is to advise undergraduate students—and I believe that giving advice to others is an act of leadership. However, I am now thirty years older than the average undergrad, and relating to them is not always easy. There is a generational divide in that the undergrads are in some ways fundamentally different from me (for example, I don't like to text), but nonetheless I need to be able to relate to them, I need for them to be able to feel that they are heard and seen by me.

Recently I met with a student who wanted to talk about changing his major from engineering to management. He spoke about the difficulty he had with his engineering courses and admitted that he had perhaps spent too much time on extracurricular activities, in particular his duties as social chairman of his fraternity. I listened carefully and was tempted to tell him a story or two of my own youthful excesses. But I was also listening to myself and I realized that the desire to tell him of my own undergraduate partying was largely a competitive instinct. I was finding his story to be pretty lame and I wanted to tell him what *real* partying was (surely enhanced by being thirty years in the past). I suspect that he would not have found that helpful and at some level he would have understood that I was just trying to one-up him. Instead I continued to listen and decided that the issue he had was about being so close to finishing his engineering degree and not really wanting to finish it. He told me that it wasn't the engineering problems that interested him and

he didn't like cranking through the equations. He couldn't imagine graduating and spending his life doing that. What he liked was working in groups with other people. He thought that management would be more about working with other people and it might lead to a job that was more about working in groups with people and less about individual engineering work. But even after having all those realizations, he felt badly about not finishing his engineering degree.

As I listened to him, I also listened to my own intuitive sensemaking, and I decided that the idea of not finishing his engineering degree was the real issue for him, not partying too much. I asked him about how he felt about that. We talked about the detailed logistics—it turned out that he could change majors and still graduate on time. I told him that it would be okay and he looked at me with a look that seemed to suggest that I couldn't possibly relate to his experience. My guess is that he thought, as a professor, I must have always known what I wanted to study and what I wanted to do. So I told him about my own story of switching majors from aeronautical engineering to playwriting in my junior year. I told him the hardest part was the conversation with my father about it. My father thought it was a bad decision—I was only four courses short of the engineering degree, surely I should just slog through and finish. But he also said it was my life and my choice. My student said that he had had a similar conversation with his parents, and in that moment we related.

A key aspect of creating the relationship with my student was appropriate self-exposure. I listened to both him and myself, I inquired and I told a story from my past. It showed that we did have common ground, that I did understand what he was going through, and I was pretty sure that he felt heard and seen. In the moment, I made the choice not to tell a story about my own youthful partying, because I considered it was more about my own competitive needs than it was about what the student needed. A story about partying would have probably also created some connection between us—I think he would have related. But it wouldn't have helped very much with the real issue. It would also not have been a leaderly choice, the third practice in creating and enacting your leaderly self.

Leaderly choices highlight the idea that you can relate to others and share parts of yourself with others in ways that are not leaderly. A leader is concerned about reinforcing the identity of the group, connecting to their own values, and moving things forward. Going back to the conversation with my student, the question of which story to share is informed by my sense of the group identity—in this case, I see the

most salient group identity as the Business School. The identity of the Business School is related to the academic mission. Although there is certainly important learning that happens through the extracurricular activities at college, sharing my story of youthful partying would not have reinforced the identity of the university as an academic institution. It would also not have connected to the values I have about academic advising. I believe that part of my role is to help students explore and discover what they are passionate about and then pursue those passions. And finally the story about partying would not have moved things forward. We might have bonded a little, I might have gained some new respect in the student's eyes, or he might have simply thought that I was being a jerk who was trying to capture his lost youth by one-upping his story. None of those results would have moved us closer to making the decision about changing his major. However, I think talking about the conversation I had had with my father thirty years earlier did help him in some way. Perhaps it made him realize that he wasn't alone, that others had gone through what he was going through and come through it okay. Perhaps it simply made him feel like I had heard him and I saw what he was going through (and it's hard to overestimate how important that can be).

The conversation with my student seems like a small moment, and it is a small moment. But it is in the countless small moments such as this that the craft of leadership is enacted. And it is in these countless small moments where we have the opportunity to share ourselves with others that we also have the opportunity to construct our leadership self. Because there is not time to stop and think about what to do in every moment, it is critical to know the identity of the group and how your own values connect to that identity. That knowledge can only come from a deeper exploration of ourselves, from an ongoing process of deep questioning and reflection.

CHAPTER ELEVEN

Developing the Craft and Art of Leadership

The practices of looking at your own process and of going deeper are crucial, lifelong practices of the creative process of leadership that is at the core of both the craft and the art of leadership. But they are by no means the only aspects of learning to be a creative leader. In order to talk a bit about the larger picture of developing creative leaders, let me introduce a brief model of learning.[1] The model starts with the three things that influence how we make sense of the world, which are our personal history, the specific context, and our technical knowledge (see figure 11.1). These then determine our frames, which are the theories and beliefs we have about the world that guide how we make sense of things. Based on these frames, we act. The actions produce outcomes. We learn about our own practice as we create representations of what happened and reflect upon them. Different learning modalities focus on different pieces of this process.

Traditional lecturing is intended to build technical knowledge. This practice comes from an information-processing view of learning, which sees learning as being about accumulating technical knowledge such as facts, theories, and specific problem-solving skills. Technical knowledge is an important aspect of domain knowledge. It also has a huge influence upon how we see the world. For example, once we are trained in classical economics, we see humans acting from self-interest and maximizing their own utility. If we are taught the traditional business school disciplines, we see the world in terms of market segments, value propositions, return on investment, cost-benefit analysis, and cash flow. As we internalize these disciplinary ways of knowing, they become powerful tools for making sense of the world and guiding our

Figure 11.1 Model of learning

actions.[2] As they become internalized and unconscious, they also *limit* how we can make sense of the world.

The second half of lecturing is problem solving. Very broadly, in the information processing view, we act by solving problems with the technical knowledge that has been the subject of the lecture. The physics student is asked to determine where the cannon ball will land based upon a theory of ballistic motion. The engineer is asked to specify the trusses for a bridge given the expected loads. The students of literature make the case that Laertes plays a critical role in how Hamlet changes[3] over the course of the play, drawing upon the technical skills of argument and rhetoric that they have learned. And to the degree that our role in the world consists of identifying problems and coming up with solutions for those problems, this may be all that you need. That is to say, if I am teaching fire protection engineers who will be constructing specifications for sprinkler systems for different buildings, then lecturing them about the technical knowledge and teaching them to solve problems based upon that knowledge may be sufficient. But if I am developing artful leaders, it is probably not.

There is a significant stream of leadership development that is about personal exploration. In its more scientific form it involves filling out various psychometric instruments that can be scored and then reveal something about the person. For example, filling out a Myers Briggs[4] test might reveal that an individual is an INTJ. There is then a large amount of theory to be digested that explains what an INTJ is and how that is different from being an ESFP. The individual might then understand something of their own personal approach to the world and how that differs from that of others. There are many other instruments that will tell you things such as what type of learner you are, what type of leadership style you prefer, what your preference for handling conflict is, and so on.

There are also less scientific methods of personal exploration, such as autobiographical writing, that see each individual as having a unique story that brought the individual to where he or she is today. Many artistic traditions encourage individuals to explore their own past as a source of material for creating their art. Perhaps the most intense form of personal exploration is psychotherapy. Regardless of the form of self-exploration, the intent is to learn about yourself so that you can identify the particular ways in which you make sense of the world and the frames you have for sensemaking. Whether it is called understanding your own biases, your own preferences, or your own history, it is about providing an awareness of the tendencies in your own sensemaking process.

While lecturing aims to give us a useful and scientifically validated set of frames with which to make sense of the world, and self-exploration seeks to help us understand the peculiarities of our own process, training in creativity tries to develop the creative mind-set. In its simplest form, the creative mind-set is the tendency to make sense of things in a new way rather than finding an existing way of articulating the evidence of our senses. For example, my friend Tracy has a creative mind-set when it comes to paying attention to what she hears. Like many of us, she may mishear what others say, but rather than apply her existing frames about what is being said and making a guess of what was really said, Tracy tries to find a new way to make sense of what she heard. When she first heard the Police song *De Do Do Do, De Da Da Da*, when they sang "their eloquence escapes me" she heard "the elephants escape me," and she tried to figure out what "the elephants escape me" might mean in that context. With a less creative mind-set, Tracy might have thought that the lyrics she heard were obviously wrong, since they didn't make sense, and tried to figure out what was actually being sung.

Instead, the phrase "the elephants escape me" became an interesting departure for Tracy, taking her to places she hadn't been before.

Of course, the flip side of the creative mind-set is an ability to stay with the evidence of your senses and allow that to change your sense-making. There is a classic *Peanuts* cartoon in which Lucy finds a butterfly. She speculates on the long journey the butterfly has made from Brazil to the United States. Then Linus looks closely at the butterfly and announces that it is really a potato chip. Lucy then responds, "I wonder how that potato chip got all the way up here from Brazil?" It's funny because Lucy doesn't adjust her sensemaking when provided with the new information that it is a potato chip and not a butterfly. Creativity training is focused on learning to both look for new ways to make sense of what is happening and staying with the evidence of your senses and letting that change how you make sense of things.

A critical question then arises about how the disciplinary knowledge developed through lecturing interacts with a creative mind-set. There seems to be a tension between a disciplinary knowledge that teaches us to make sense of things in a particular way and a creative approach that teaches us to make sense of things in a new way. But we also know that creativity is associated with expertise, with years of practice, and thus a depth of disciplinary knowledge. The clearest example of how disciplinary knowledge and the creative mind-set work together is the process of differential diagnosis,[5] which is how medical doctors are trained to approach situations. Doctors are trained to generate a variety of possible diagnoses of the situation based upon their disciplinary training. They compare the diagnoses and decide upon which to act (a combination of which is most likely and the consequences of each). They then treat the patient based upon that diagnosis and pay attention to what happens as a result of their treatment. This information, this evidence from their senses, then feeds back into the evaluation of the diagnoses. If the symptoms go away, that is probably evidence that the diagnosis was correct. If the symptoms get worse, then they change their sensemaking of the situation and consider the next best diagnosis. The important thing to note about this is that the conversation between sensemaking and the senses continues and the sensemaking that is based on the disciplinary knowledge is held as a theory to be tested rather than truth taken as fact.

Of course, how that disciplinary knowledge is tested matters, bringing us to the next box in my model, skills—which for the sake of simplicity I shall refer to as focusing on *how* things are done. For example, when I teach the skills of negotiation, it is obvious that how you present

your position generally makes as much of a difference as the actual position. In the arts, skills are developed in studio work, where the teachers work with students in an embodied way. The teacher shows the students how to do things—"more like this" the teacher might say, or "try it this way," as they demonstrate how. In leadership training, we use simulations, role-plays, and experiential exercises to focus on *how* leadership is enacted. More often, leadership skills are honed on the job in leadership positions through feedback from mentors.

The arts use studios in part because they can. Painting students can go into a studio and paint. Acting students can go into a studio and rehearse scenes. That is to say, the studio presents an environment where the actual practice the student is being trained in can be undertaken. This is more difficult for leadership because it is hard to create an environment that allows students to practice being a leader in the same conditions that we want them to be able to be leaders when they have finished their education. Projects, service learning, and the classroom as organization model of teaching provide some opportunities for some students to practice being leaders. But even within those models we don't tend to see the same sort of hands-on work with the skills and techniques that we do in the studio models of the arts.[6] We don't see teachers stopping a group and saying to a student, "try saying that with a little less edge in your voice and make eye contact as you say it." This may be because those teaching leadership may not be master leaders themselves, or it may be more a question of the traditions of how leadership has been taught. It may even be based in a belief that we all have to discover our own sense of what leadership is, discover our own style of leadership, and thus teachers don't want to be too directive.[7] Whatever the reason, this feels to me like an area where leadership education could learn from the arts and try and find ways to develop leadership studios.

Of course, even with the arts there is a difference between the studio and the "real world." It is one thing to rehearse and perform scenes in an acting studio and quite another thing to perform in an actual production in front of a paying audience. There are properties of the "real world" that cannot be simulated, perhaps most importantly real outcomes. In chapter 9 on looking at your own process, the students engaged in experiments with their own leadership practices in the real world, and those experiments had real outcomes with real consequences if things went badly or if things went well.

There may also be something more profound about working in the "real world" where there are real consequences. The philosopher and

motorcycle mechanic Matthew Crawford argues that our very sense of self can only be defined when we work with a real world that imposes real and tangible limits to our work—in other words, a world where there are real consequences to what we do.

> One can't be a musician without learning to play a particular instrument, subjecting one's fingers to the discipline of frets or keys. The musician's power of expression is founded upon a prior obedience; her musical agency is built up from an ongoing sub-mission. To what? To her teacher, perhaps, but this is incidental rather than primary—there is such a thing as the self-taught musi-cian. Her obedience rather is to the mechanical realities of her instrument, which in turn answer to certain natural necessities of music that can be expressed mathematically. For example, halv-ing a length of string under a given tension raises its pitch by an octave. These facts do not arise from the human will, and there is no altering them. I believe the example of the musician sheds light on the basic character of human agency, namely, that it arises only within concrete limits that are not of our making.[8]

The consequences of our behavior in a classroom always have a sense of having been constructed by others—generally the teacher. And although getting a C may be a crushing experience for some students it does not seem to develop the sense of submission to a physical world, of which Crawford speaks. That ongoing submission fuels the ability and need to stay with your senses as the conversation between sensemaking and senses unfolds.

The final piece in my model is the meta-skill of reflection. In its simplest terms this is an explicit effort to learn from what happened, to make sense of the outcomes of your actions, and change those actions and/or the frames that led to those actions. It starts with some sort of representation of what happened—whether that is a story, a two-column case, or simply just the memory. We all reflect upon and learn from what we do, but the quality of that reflection can be very dif-ferent depending upon how developed our skill of reflection is. If the skill is undeveloped, reflection often consists of remembering what happened and reifying our own immediate sensemaking. For example, suppose my boss made a joke about me being late in a staff meeting. I am embarrassed and a little bit irritated by the comment, but I don't say anything. As I think about it, I remember additional details that confirm my initial feeling that my boss was being a jerk. I talk with

a supportive colleague who adds some more details and tells a couple of personal examples of my boss being a jerk toward her. After a couple of drinks we have collectively learned that my boss is a horrible human being who doesn't deserve or appreciate our loyalty and hard work. I call this sort of reflection "crying in your beer," and it is characterized by a search for data that confirms the initial sensemaking based in the initial emotional reaction to the events.

Effective reflection starts with a representation of what happened, because the representation (whether that is a story, a two-column case, or a painting) allows us to get some distance from the events and start to see them from a more neutral perspective. Effective reflection also looks for understanding of what happened rather than seeking blame and looking for data that disconfirms your initial emotional sensemaking in some respects. Effective reflection looks for a variety of ways to understand the situation (the medical model of differential diagnosis is a good one here as well) as a way of loosening our attachment to our own emotional-reaction-based way of understanding. There is a discipline to reflection that does not happen naturally for most people. This discipline can be learned with the help of cognitive tools such as those described in chapter 9. It can also be learned as a spiritual discipline. But my point is that it generally needs to be learned.

Historically, craft, particularly craft that might rise to the level of art, was learned through a system of apprenticeship, in which the apprentice worked for a master.[9] The apprentice would do menial tasks and slowly, through observation, and perhaps even osmosis, learn something of the craft—whether that was blacksmithing, carpentry, or sculpture. The apprenticeship would end and they would become a journeyman. After further study and work, the journeyman might become a master and take on apprentices of his own. With the industrial revolution and the rise of large business organizations, this system of apprenticeship has faded away. But I suspect that it still captures the essence of how many, if not most, of the people actually learn the craft of leadership.

We interact in groups from a young age and we are constantly serving apprenticeships to the leaders of those groups—whether they are our parents, peers, teachers, coaches, or bosses. We complete our tasks and absorb ideas of leadership and how it is done from the leaders. We are generally not as focused as an apprentice would be. That is to say, we haven't taken on our tasks within the group with the intent of learning the craft of leadership, but nonetheless we learn something. And when it is our turn to lead we enact what we have learned. Probably without much skill, but we do what we can. If we are lucky we can have

conversations with the leaders in our lives about our own leadership and learn a bit more. If we are even luckier, those leaders will be masters and there will be a lot to learn. If we are unlucky, we may learn the craft of leadership from an abusive, alcoholic parent who has little craft skill and even less interest in developing our craft skills.

To improve upon this method of learning from observation and practice, in modern times, organizations—from the military to universities to large businesses—have taken to explicitly training people to be leaders, using all of the methods that I have been talking about in this chapter. But as we have moved to an explicit mode of teaching leadership, something has been lost—the sense of leadership as a practice, as a craft that needs to be learned in an embodied way and pursued for its own sake over our lifetime. Instead, implicit ideas of learning as the transfer of information where I have learned something once I have committed the appropriate facts to memory, such as knowing the names of all fifty state capitals, come to dominate our approach. Skills are seen as something that can be mastered, in the way that we master addition and subtraction, rather than being a practice that can never be perfected but can only be submitted to in a lifelong discipline. The apprentice wasn't looking for a set of facts and a few skills that he could draw upon when needed. The apprentice was committed to the idea of pursuing excellence in the craft that he was learning and knew that it was a lifelong commitment. How many of us today commit to the idea of pursuing excellence in the craft of leadership?

All of which is not to say that there isn't something to be gained from the modern practice of studying and learning leadership in more explicit ways. Ideas and practices of leadership are constantly changing and growing. The explicit study of leadership allows these ideas and practices to be shared and communicated far more rapidly than any system of guilds, apprentices, and masters ever could. We have tremendous insight into Mahatma Gandhi's[10] revolutionary practice of the leadership of nonviolent resistance, because he spent time theorizing what he was doing and countless scholars have spent careers inquiring into what he did. The challenge today is to approach leadership as both an embodied craft that requires a lifetime commitment to excellence in practice and as a topic of intellectual, explicit learning.

One of the difficulties with approaching leadership as a craft is the immateriality of leadership practice. Unlike playing a violin or making a sculpture, the practice of leadership isn't about working with a material thing. Instead, it is about working with people, about crafting relationships, making meaning, and motivating action. I want to

stress that this doesn't mean that there isn't the same sort of submission and obedience to the realities outside of oneself that Matthew Crawford identifies as a critical aspect of craft. It is just that those realities don't have a material existence that we can identify through our five senses. Instead, those realities exist in the social world of relationship, motivation, intention, and meaning. Just as the sculptor changes the shape of the clay within the constraints of the physical materiality of the clay, the leader changes relationships and meaning within the constraints of the co-constructed immateriality of those relationships and meanings.

Concluding Thoughts about Leadership Development

Coming back to the bigger picture of leadership development, the majority of leadership development programs approach it as a craft. At least their conceptual understanding of leadership is that it is a craft, even if they don't call it craft—especially those who refer to it as an art. It is a craft in the sense that it is a set of skills, which can be taught as processes for achieving particular ends. It is not about solving something in the sense that mathematics is about finding a single correct solution, but instead it is about getting somewhere, arriving at a desired destination.

However, the typical leadership development processes that are used to develop this craft do not follow traditional ways of developing craft skills and craft mastery. Instead, we teach academic courses that cover theories of leadership and weeklong intensive courses that allow students to reflect on rich experiences that may give some insight into their own leadership. And although these may be helpful (and even necessary) for learning the craft of leadership, they are not the sort of long-term, embodied processes that we see in learning craft skills such as woodworking or acting.

There are also some schools of leadership development that do seem to conceptualize leadership as an art. That is, they think of leadership as creating a departure experience for others—although generally not stated in those words. Words such as "transformation" are used. But I would suggest that these approaches also suffer from the same issue of not developing the craft of leadership necessary to enact an art of leadership in the way that we believe crafts are learned.

So the first step in developing the craft and then the art of leadership is to recognize that it is a craft and consider seriously what that means

for leadership development. We don't expect people to learn wood-working or acting by reading a book—although it may be helpful. We don't learn a craft by absorbing a bunch of intellectual information about the craft. We learn by doing, by observing, by reflecting upon what we're doing, and by having a master talk with us about what we're doing. We learn a craft by submitting to the discipline of that craft. We don't learn a craft by taking a weeklong class in beautiful surroundings. As a journeyman or even as a master, we may need such classes from time to time to continue the never ending pursuit of our discipline, but that is not how we learn it. In short, we need to recognize that most of what we think of as leadership development today are the supporting tasks of leadership development and not the primary process.

Following from this is a recognition that leadership is about creativity, and the heart of a creative process is the relatively simple skill of staying with your senses and imagining new ways of making sense of things. As Richard Sennett says:

> Craftwork embodies a great paradox in that a highly refined, complicated activity emerges from simple mental acts like specifying facts and then questioning them.[11]

This questioning is not the same as rational analytic problem solving. It is closer to design thinking and it must be at the heart of leadership development. Part of this core ability is an ability to question yourself and your own practice—in a productive way, not in a "crying in your beer" way.

This is not to say that rational analytic thinking and models based in good empirical research aren't useful to leadership—they are very useful. But leaders must learn to integrate and draw upon the rational analytical understanding with their creative process. Scientists do this every day as they both use and question existing models and theories at the same time. It is the essence of the research process—to draw upon the wealth of existing work in the field and to go farther into uncharted territories. This is the process that creative leaders engage in as well, and leadership development work should explicitly develop these skills.

A key aspect of engaging in the practice of specifying facts and questioning them is having sensory information to pay attention to. If we are to lead and follow in the complex social and material world in which we live, then we need to learn in that same world. We need to learn to pay attention to the sensory evidence from that world and

learn firsthand how our actions interact with the world. If staying with your senses is at the heart of a creative process, we need to learn in an environment that allows us to do that. When we reduce the sensory information—with simulations, cases, role plays—we fundamentally change the task of staying with our senses. Luckily, we all do live in a complex world and that world is full of leadership. Wherever there is coordinated action, wherever a group acts together, there is leadership. That leadership may be distributed and changing, it may be fleeting and hard to pin down and recognize as such, but that is the nature of a great deal of leadership.

The good news is that these instances of leadership that are all around us are opportunities to learn, to rehearse leadership, and to develop your own practice of leadership. The painter paints, and even if the paintings never see the light of day, the painter can develop her practice, her skill, and her discipline as a painter. The same is true for a leader. As you interact with others, whether they are peers, family, or colleagues, you have the opportunity to develop your own practice of leadership. To really develop a craft, a discipline, a practice, it is helpful to work with a master. There aren't leadership guilds to which we can apprentice. Instead we have mentors. The relationship between mentors and mentees is not quite the same as between apprentice and master, but I think it is the closest thing we can have. And we can have more than one relationship—something that wasn't true of masters of old.

CHAPTER TWELVE

Coda: Final Reflections

Leadership is a craft. It's as simple as that. In some cases, that craft may produce art—it may engage the imagination and take us someplace we have never been. Most of the time, it doesn't need to be art, but it is always a craft. I don't think this is new, but it is a different way to think about leadership.

Thinking about leadership as a creative process is a fundamentally different way to think about leadership. And I believe that it does matter how we think about leadership. It matters if we think of Ulysses S. Grant as a transformational leader, or Martin Luther King, Jr. as a charismatic leader, or Barack Obama as an authentic leader. It makes a difference if we think of a leader as being the one who is in charge (and thus conflate leadership and formal authority), or if we think of leadership as being a distributed activity that is done by many different people. It matters if we think of leadership as being on a continuum from participative to authoritarian, or if we think of leadership as being fundamentally about articulating and embodying the identity story of the group.[1]

It matters how we think about leadership because how we think about something has a huge influence on what we see and what we do. Humans tend to see what they are looking for, at least in the realm of complex social phenomena such as leadership. That is to say, if we think of leadership as something that people with formal authority do, then we will tend to see leadership in their actions and not in the actions of people without formal authority. Our ideas about the world also guide our actions, and if we think of leadership as being about strongly exercising power, then we will tend to strongly exercise power when we

want to lead. So if we would like to see leadership that is truly a creative process enacted in the world, we must first think of leadership that way. Hopefully, in this book I have opened the door to doing just that.

One of the advantages of thinking about leadership as a craft is that it gets us past all those silly questions about whether leaders are born or made—whether we can learn to be leaders. We know that we can all learn a craft. Some of us may have more natural talent for it than others, and in the long run some of us will be better at it than others, but we can all learn to draw,[2] to make a table, to grow vegetables—craft is fundamentally egalitarian.

When I was in fourth grade I started to learn the craft of playing the trombone. I didn't have a lot of natural talent, but I liked playing in a band. By the time I was a senior in high school, I had developed a reasonable amount of craft skill at playing the trombone and I was the third chair trombone in the high school jazz band. I was an adequate craftsman, but not an artist, which as it turns out is pretty much what a high school jazz band needs in a third trombone. Today's organizations need leadership at every level. Today's organizations need third trombone players and they don't have to be artists—they won't be asked to play solos,[3] but they will be asked to play their part with adequate craft skill. That's not to say that we don't need soloists—artist leaders—as well. We need both.

The great hope of approaching leadership as a craft is that through the dedication to your craft, through the long process of working on your craft skills, of paying attention to your own process, some will become masters and artists. And just as the world needs third trombone players, the world also needs soloists—the diva trumpet player who is willing to blow out his lip for an audience of fourth graders.[4] In short, leaders who will always give their all in their efforts to take people some place they have never been before. That is the art of leadership, and we are in desperate need of it.

I say desperate need because I have a growing sense that our current ways of organizing and managing ourselves are reaching their limits. When I say ways of organizing, that includes the idea of a culture driven by consumption, a democracy that equates representation with money, business based in self-interest and short-term monetary gain, and financial capitalism based in ideas of never ending growth. In the USA, these ways of organizing have produced unprecedented wealth, but also climate change, increased income disparity, and a crumbling infrastructure. Perhaps it is simply a result of growing older, but my overall sense is that, as a people, we are approaching or already in the

midst of a critical change that will be as significant as the Renaissance or the Industrial Revolution in its impact.

If we are in the midst of such change, then we need artist leaders to feel the complexity of our interconnected society and lead us through that complexity. Rational analytics that are based in assumptions that the past is a good indicator of the future won't get us there. Working within existing systems and paradigms won't get us there—the fix for a broken system doesn't come from within that system. It takes a craft master who is deeply committed to staying with the evidence of her senses and working collaboratively with others, all the while constantly working on and learning about her own practice to create the departure for all of us.

Growing up in the United States, I was taught that many of the other founding fathers wanted George Washington to be king rather than the first president of the new country. But Washington refused. I think that was the act of leadership art that created the departure that eventually led to democracy as a possible form of government in countries all over the world. I'd like to think that, as an artful leader, George Washington was paying attention to the evidence of his senses and had the self-awareness to recognize that even though he might be a great king, he might also give in to the temptations and potential tyrannies that come with being a king. Instead of making sense of the founding of the new country as a chance to replace the old king with himself as a new king, he saw it as a chance to replace the old way of governing with a new one that didn't have a king at the top. I don't think Washington had any idea that the form of government with an elected leader serving a defined term of office would catch on as it did. Nor do I think he would have dreamed of the consequences of such a form of government (both positive and negative). Indeed, if he did know where it would go, then it wouldn't have been a true departure, it wouldn't have been art.

These moments in history, such as George Washington refusing to be king, give me hope for the future. It is those moments that in retrospect turn out to have been a departure that led us to places we wouldn't have thought possible. Or perhaps, more to the point, history is full of moments when leaders acted artfully and led a group to do something that *everyone* knew was impossible. In his state of the union address in 1941, Franklin Delano Roosevelt challenged the country to produce a ridiculously large number of tanks and planes for the war. The experts knew it was impossible, but then the country went and did it. Of course, there was a lot more to the great industrial war effort than FDR simply challenging the nation, there was a craft of leadership

exercised at every level, that stayed with the evidence of their senses and made sense of things within their own domain in new ways—ways that hadn't occurred to the naysayers.

The need for creativity in leadership, whether that is a craft of leadership or an art of leadership, is tied to the complexity of our times and our world. It has become increasingly clear that we don't live in a world that can be described in terms of simple cause and effect relationships. More and more it seems that it can hardly even be described with the esoteric mathematics of fractional exponent functions that is the backbone of modern complexity theory. Luckily, over countless eons, we humans have developed a way to deal with complexity that does not require mathematical modeling. It is the heart of our creative process, the heart of our intuition and imagination and it works pretty well. It is that fundamental human ability to make sense of complexity in a useful and novel way that is at the heart of creative leadership, which is the core of the craft and art of leadership.

Because it is a fundamental human ability, we all have it. There are plenty of leaders in our world who are craft masters. We may not recognize them, but they exist, quietly practicing their own craft of leadership—concerned with method and technique that most of us might easily miss, constantly learning and advancing their own practice. These masters may not even know that they are masters, they're just doing what they do. We, who would become craft masters and perhaps even artist leaders, must seek them out, learn from them, apprentice at their feet, and eventually sit by their side.

There is an important way in which the craft of leadership is different from traditional crafts such as woodworking or quilt making. At the end of the day, the woodworker puts down her tools and stops working the wood. I'm not sure the leader ever puts down her tools and stops leading. Of course, the woodworker doesn't stop being a woodworker when she puts her tools down. The leader can't put her tools down, because she *is* her tools. Which raises the question, where does leadership stop and the rest of your life begin? Is all of your life leadership or is leadership just a lens for looking at your life in the way that your faith or any other practice you have is? Are we really talking about living your life as craft, living your life as art?

I think the short answer is, yes. The sort of paying attention to your own practice and inquiring into your own passion that I have been talking about can certainly apply to all of your life. The idea that we can continually learn and improve our own practice—whatever that practice might be—can apply to all of our life. Approaching your life as

a craft is not really a radical idea. It is not so very different from countless spiritual traditions that have suggested some sort of conscious engagement with your own practice, whether that engagement is couched as mindfulness or meditation-in-action or something else.

Perhaps, at its simplest, the craft of living your life is as simple as having a purpose, an intention for where you want to go—a destination, if you will—and working diligently to get there. It means constantly learning and focusing on the process with an awareness of the inherent paradox that you may never get to that destination, in fact you may not really even want to get there. But if you keep at it, if you work hard and pay attention to what you're doing with a spirit of reflection and inquiry, you may surprise yourself and others and end up someplace you never imagined—a departure, if you will—and that is the art of living.

NOTES

One Craft, Art, Creativity, and Leadership

1. Ellen Dissanayake (Dissanayake 2000) lays out the importance of the role of making things and making them special from the perspective of evolutionary biology in her fascinating book, *Art and Intimacy*.
2. In *Transforming Leadership: A New Pursuit of Leadership* (Burns 2003), 172.
3. The interconnectedness of these issues is laid out in the classic *Limits to Growth* (Meadows, Randers, and Meadows 2004).
4. These are what leadership scholar Ronald Heifetz (1994) calls *adaptive* challenges, in contrast to *technical* challenges that can be addressed by applying existing technical knowledge.
5. This distinction between craft and art comes from Daved Barry and Stefan Meisiek's (2010) research and has been very helpful in furthering my own thinking.
6. Sawyer's book *Explaining Creativity: The Science of Human Innovation* (Sawyer 2006) provides an excellent review of the academic work across disciplines, and his book *Group Genius: The Creative Power of Collaboration* (Sawyer 2007) provides a more popular, how-to approach to the subject.
7. *Kubla Khan* was first published in 1816. This is quoted from *The Poetical and Dramatic Works of S. T. Coleridge: With a Memoir* (Coleridge, Coleridge, and Coleridge 1854, 172).
8. A more complete argument as to why this story isn't true is made in *Creativity: Genius and Other Myths* (Weisberg 1986).
9. There continues to exist a great deal of writing and consulting around creativity that is focused on generating the creative idea—more ideas, better ideas, and so on, as if the creative process is only about the idea, the creative spark.
10. From *The Illusion of Leadership* (Ibbotson 2008), 83.
11. The seemingly commonsense term "sensemaking" comes from the work of Karl Weick (1995) and is based in the radical inversion of the idea that things happen for a reason. Instead, a sensemaking perspective assumes that we create a reason for why things happened after they happen. These reasons may not be accurate, but they do need to be plausible.

Two Focus on the Process

1. The naming of these stages is based on Keith Sawyer's (2006, 2007) work.
2. There are other descriptions of the creative process, such as the Creative Education Foundation's Creative Problem Solving Process (see Parnes 1992, for a fuller exploration of this work) that focuses on stages of divergent and convergent thinking.

3. In *Leading Minds* (Gardner 1995).
4. I have written about my playwriting process and how I make sense of it in a variety of academic articles (e.g., Taylor 2000, 2003b, 2003c).
5. The class was taught by Brian Bomeisler and is based on his mother Betty Edward's famous approach to drawing, which is captured in the classic *Drawing on the Right Side of the Brain* (Edwards 1979).
6. The *Drawing on the Right Side of the Brain* website has a gallery of these self-portraits done at the start of the class along with the self-portrait done by the same person at the end of the class (http://drawright.com/gallery.htm), where you can judge for yourself if mine is among the worst.
7. The method of drawing is explained in detail in Betty Edwards's (1979) classic *The New Drawing on the Right Side of the Brain*.
8. This is taken from the Banff Centre website at http://www.banffcentre.ca/departments/leadership/assessment_tools/competency_matrix/.
9. In *The Illusion of Leadership* (Ibbotson 2008, 120).
10. For example, see Mary Uhl-Bien's (2006) conception of relational leadership.
11. The term *sensegiving* comes from Gioia and Chittipeddi's (1991) classic article "Sensemaking and Sensegiving in Strategic Change Initiation."
12. Popularized largely by Lee Strasberg and based in Stanislavski's work (1936a, 1936b, 1961).
13. This tradition reached the peak of its modern expression in the work of Grotowski (1968).
14. Developed in a lifetime of work by Bill Torbert (e.g., Torbert and Associates 2004; Torbert 1991, 1999, 2000; Torbert and Taylor 2008).
15. From *Action Inquiry: The Secret of Timely and Transforming Leadership* (Torbert and Associates 2004, 26).

Three Creative Mind-Set

1. Strategizing is one of Grint's four arts of leadership (Grint 2001).
2. For more on this idea of humans as making sense of the world in a narrative way, consult the work of Jerome Bruner (1986, 1990).
3. This is captured in the classic book *Sensemaking in Organizations* (Weick 1995).
4. See Dreyfus and Dreyfus's (2005) theory of expertise for a fuller description of how this works with experts.
5. For example, Martin Buber suggests taking an "I-thou" approach to others.
6. This is deductive reasoning. Inductive reasoning is more typically used to generate theories from particular situations, and abductive reasoning (Peirce 1957) is more closely aligned with the artistic approach described later.
7. This argument comes from *The Reenchantment of the World* (Berman 1981).
8. In recent years a contrarian understanding of the relationship between cholesterol and heart disease has been voiced in a variety of books, such as *The Myth of Cholesterol: Dispelling the Fear and Creating Real Heart Health* (Dugliss and Fernandez 2005), *The Heart Revolution: The Extraordinary Discovery That Finally Laid the Cholesterol Myth to Rest* (McCully and McCully 1999), and *The Cholesterol Myths: Exposing the Fallacy That Saturated Fat and Cholesterol Cause Heart Disease* (Ravnskov 2000).
9. It is important to note that traditional Chinese medicine would see things completely differently, and even how Western medicine sees the world does change over time.
10. In their book, *Reframing Organizations: Artistry, Choice, and Leadership* (Bolman and Deal 2003).

11. In the case of this book, I am a scholar of leadership and creativity and an artist, and this framework is based in my experience in both roles. So, yes this is how I make sense of leadership and hopefully it is helpful in reaching your own understanding of leadership.
12. The best-selling book *Blink* (Gladwell 2007) covers this in depth.
13. I don't use nerdly as a pejorative term, nor with any great pride, but rather simply as a description of who I was and who I am—president of the Centerville High School Science and Math club, a graduate of M.I.T., faculty at W.P.I., in short: a nerd.
14. In his article "Leadership as Art: Leaders Coming to Their Senses" (Springborg 2010).
15. By which I mean providing a way to make sense of events (Gioia and Chittipeddi 1991).
16. *The Art of Seeing: An Interpretation of the Aesthetic* (Csikszentmihalyi and Robinson 1990) offers an excellent empirical description of how we engage with art.
17. In *If They Give You Lined Paper Write Sideways* (Quinn 2007, 136).
18. As quoted in an Op-Ed in the *New York Times* (Kristof 2009).
19. See for example *Action Science* (Argyris, Putnam, and Smith 1985), *Change the World* (Quinn 2000), or *Action Inquiry* (Torbert and Associates 2004).
20. At the European Institute for Advanced Studies in Management Workshop on Organizing Aesthetics, in Siena, Italy, in May, 2000.
21. This lovely little book by Keri Smith (2008) is a real delight, and although it looks like a children's book, it is perfectly suited for adults who want to develop their creative process.

Four Passion

1. By the eminent psychologist, Mihaly Csikszentmihalyi (e.g., Csikszentmihalyi 1996; and Csikszentmihalyi and Robinson 1990).
2. See *Creativity in Context: Update to the Social Psychology of Creativity* (Amabile 1996) for a fuller discussion.
3. Alfie Kohn explores this idea in depth in *Punished by Rewards* (1993) and *No Contest—the Case against Competition* (1986).
4. In *The Element: How Finding Your Passion Changes Everything* (Robinson 2009).
5. The highlight of my amateur pool playing career came while playing nine ball when I managed to sink the nine ball on the break three times in a row.
6. In addition to Cameron's (Cameron and Bryan 1992) original work, there is an adaptation for the workplace called *The Artist's Way at Work* (Bryan, Cameron, and Allen 1998).
7. He tells the story of a man who cannot find his passion in the third book of the Ishmael trilogy, *My Ishmael* (Quinn 1997), and makes a more intellectual case in *Beyond Civilization* (Quinn 1999).
8. The play has been performed at the Organizational Behavior Teaching Conference in Scranton, Pennsylvania, in June 2005; at the Organizational Theatre Exploratorium in Banff, Alberta, in September 2008; the Academy of Management Conference in Montreal in 2010; as well as in several of my classes.
9. I think you'll see that its roots as a play show through, as it has a lot of dialogue left from the play.
10. The hero's journey is described by Joseph Campbell (1949) in *The Hero with a Thousand Faces*.
11. The book *Immunity to Change* (Kegan and Lahey 2009) offers a great approach for identifying these areas and learning to work with them and open them up.
12. For example, see "Authentic Leadership Theory and Practice: Origins, Effects and Development"(Gardner, Avolio, and Walumba 2005) for academic work, or *Authentic*

Leadership: Rediscovering the Secrets to Creating Lasting Value (George 2003) for an example of practitioner work.

13. Both books (Bryan, Cameron, and Allen 1998; Cameron and Bryan 1992) are excellent.

14. My thanks to Piers Ibbotson (2008) for sharing these words with me. They are from *The Roots of Honour (Unto this Last)* (Ruskin 1860).

Five Collaboration

1. Business as an Agent of World Benefit—held at Case Western University in June 2009.

2. A group of wonderful friends who meet to give feedback on each others' writing. The members are Rich Dejordy, Erica Foldy, Pacey Foster, Danna Greenberg, Tammy MacLean, Peter Rivard, and Jenny Rudolph.

3. A great deal has been written about improvisation. One of the best books is the foundational work *Impro: Improvisation and the Theatre* (Johnstone 1979).

4. The short book *Social Construction: Entering the Dialogue* (Gergen and Gergen 2004) is a good introduction to social constructionist ideas.

5. This insight comes from a stream of thinking about *Managing as Designing* (Boland and Collopy 2004) and the idea of "decision mind" versus "design mind."

6. This claim was first made by the American pragmatist philosopher Charles S. Peirce.

7. This is one of the best-known models of creativity, but for me it doesn't match my own sense of my creative process. I don't feel as if I'm diverging and creating lots of ideas and then choosing between them when I write or draw.

8. IDEO believes in sharing their process, which has been written about in the books *The Art of Innovation: Lessons in Creativity from IDEO, America's Leading Design Firm* (Kelly 2000) and *The Ten Faces of Innovation: IDEO's Strategies for Beating the Devil's advocate & Driving Creativity throughout Your Organization* (Kelly 2005).

9. Admittedly, there are improv games that do stop and replay lines differently, but in terms of the basic structure, stopping and replaying is deadly.

10. In his classic *Impro* (Johnstone 1979). The chapter on status is the best description of the enactment of the micro-dynamics of power I've ever seen.

11. This perspective on leadership comes from Dennis Gioia and Kumar Chittipeddi's research (e.g., Gioia and Chittipeddi 1991).

12. Ibbotson 2008.

13. Frisbee is a registered trademark of the Wham-o corporation, and the game is often played with other flying discs, such as those made by Discraft.

14. The Pig Dogs did win the C division of the tournament one year, and I think, over the years, we won more games than we lost.

15. The complete rules of the game are available online from the Ultimate Players Association at www.upa.org.

16. Lao Tzu wrote the *Tao TeChing*.

17. See his 2001 article in the *Harvard Business Review* (Collins 2001) for details.

18. Chris Argyris argues that most management theory is unactionable, in his book *Flawed Advice and the Management Trap : How Managers Can Know When They're Getting Good Advice and When They're Not* (1999).

19. Barbara Karanian and I explore this idea in an article called "Working Connection" (Taylor and Karanian 2009).

20. For a lengthier description of status behaviors, see the chapter on status in *Impro* (Johnstone 1979).

Six Creative Domain

1. Plot Point 1 comes from Syd Field's (1982) terminology for the dramatic structure of movies.
2. Brad Jackson and Ken Parry's *A Very Short, Fairly Interesting and Reasonably Cheap Book about Studying Leadership* (2008) would be a good place to start if you would like a deeper discussion.
3. This comes from the book *Leading Minds* (Gardner 1995), a well-researched and provocative view of leadership based in a study of great leaders of the twentieth century.
4. For example, for a practitioner perspective, look at *Leadership is an Art* (DePree 1989) or from a more academic perspective, look at *The Three Faces of Leadership: Artist, Manager, Priest* (Hatch, Kostera, and Kozminski 2004).
5. On page 27 of his book *The Arts of Leadership* (Grint 2001).
6. This is from the brilliant and simply titled book *A Theory of Organizing* (Czarniawska 2008).
7. This idea comes from *Organizational Culture and Leadership* (Schein 1992).
8. In *Leading Minds* (Gardner 1995).
9. Salovaara's (2009) research uses a fascinating leadership simulation called the Blind Bottle exercise.
10. I consider the difficulties of a lack of stable sensemaking at length in an article called "Dissolving Anchors: Acid Management on Mars" (Taylor 2003a) in the journal *Tamara*.
11. As the early 80s band *Human Sexual Response* put it, "They love their work, their work is love," in their song, *What Does Sex Mean to Me?*
12. Gloria Steinham wrote in 1965, "I don't like to write, I like to have written" (Steinham 1983). I suspect that she wasn't the first writer to say this and she certainly won't be the last.
13. This tension is at the heart of William Torbert's (1991) book *The Power of Balance*.
14. Most notably, Peter Senge (1990; Senge et al. 1994) in his classic *Fifth Discipline* work.
15. See Arthur Bartow's (2006) *Training of the American Actor* for an excellent review of the major schools of acting in the United States.
16. They have developed an entire approach around the original idea (Kouzes and Posner 2002).
17. Donna Ladkin and I have articulated an approach to authentic leadership based in acting training (Ladkin and Taylor 2010).
18. There has been a small but growing field of research into organizational aesthetics (see Taylor and Hansen 2005, for more).
19. Kegan and Lahey (2009) offer an excellent approach to understanding the potential obstacles to getting better at something you would like to improve, in their book *Immunity to Change*.

Seven Craft and Art

1. One of my playwriting professor's at Emerson once admitted in class that he would much rather watch a good hockey game than a play because the drama was better.
2. Malcolm Gladwell (2008) elegantly makes this case in *Outliers*.
3. I explored this idea in more detail in an article called *The Aesthetics of Management Storytelling* (Taylor, Fisher, and Dufresne 2002).

4. Most notably the three-legged chairs designed by Frank Lloyd Wright for the cafeteria in the Johnson Wax building in Racine, Wisconsin, which have been judged too unstable and dangerous to actually sit in but also of historic importance, so they sit unused.
5. These are Keith Grint's (2001) four arts of leadership.
6. In May 2010 in Bled, Slovenia, at IEDC, Bled School of Management.
7. From *the WAR of ART* (Pressfield 2002), 108.
8. From *The Illusion of Leadership* (Ibbotson 2008), 84.
9. Keith Grint's (2001) analysis of MLK's rhetorical skills as an example of the art of persuasive communication is one of my favorites.
10. For a discussion of this idea of performative presence, take a look at the book *Leadership Presence* (Halpern and Lubar 2003). For more about the relationship between acting and leadership authenticity, see the article "Enacting the 'True Self': Towards a Theory of embodied Authentic Leadership" (Ladkin and Taylor 2010).
11. See the book *Trading Up* (Silverstein and Fiske 2003) for an in-depth discussion of the idea that consumers will spend more in particular areas for luxury brands (a classic differentiation strategy).
12. Lao Tzu wrote the *Tao Te Ching*.
13. Quoted from "The Art of Leadership and Its Fine Art Shadow" (Barry and Meisiek 2010), 341-342.
14. This line of analysis is largely conjecture since I don't have a lot of data other than the description from Barry and Meisiek, but hopefully the conjecture is not too far-fetched and serves to illustrate the point.
15. This is from the brilliant and simply titled book *A Theory of Organizing* (Czarniawska 2008).
16. If you are interested in a longer discussion of the role art can play in change processes, see "Theatrical Performance as Unfreezing: Ties That Bind at the Academy of Management" (Taylor 2008).
17. From *To the Desert and Back* (Mirvis, Ayas, and Roth 2003), 3–4.
18. Mark Rice is the founding Dean of the WPI School of Business (where I work).

Eight Leadership in the West Wing (With Yacan Gao and Giuseppe Contini)

1. Abraham Lincoln was known for asking his opponents to work in his administration (Goodwin 2006).
2. To use Gladwell's (2000) phrase.

Nine Your Own Process

1. There is a more rigorous explanation of this approach in a chapter called *Teaching Reflective Practice* (Taylor, Rudolph, and Foldy 2008) in *The Handbook of Action Research*.
2. The names have been changed to hide the identity of those involved.
3. This comes from Diana Smith's (Smith 2008) book *Divide or Conquer* and is based in the ladder of inference (Argyris, Putnam, and Smith 1985; Senge et al. 1994) concept.
4. This was developed by the consulting firm *Action Design* (www.actiondesign.com) and is described in more detail in a chapter of *The Handbook of Action Research* called *Collaborative Off-Line Reflection* (Rudolph, Taylor, and Foldy 2001).

5. This is Bill Torbert and Associates' (2004) four types of speech that we saw at the end of chapter 2.
6. The change immunity map was created by Robert Kegan and Lisa Lahey (2001). They provide an excellent description of how to use it in their book *Immunity to Change* (2009).

Ten Going Deeper

1. Note to reader from the story's author: The structure of this story was no accident. My first versions had better transitions and more explanation, but I found that by pruning the story I achieved a choppiness that captures the incongruency (juxtaposition? sudden transition?) of my life over the past five years.
2. These ideas come from research on the similarities between acting and leadership that was done by Donna Ladkin and me (Ladkin and Taylor 2010).

Eleven Developing the Craft and Art of Leadership

1. This is a slightly altered adaptation of the learning pathways model developed by Action Design (www.actiondesign.com).
2. Donella Meadows (1997) identifies the mind-set out of which the rules and structures arise as the highest leverage place to intervene in a system. These mind-sets often come from a disciplinary perspective that defines what sorts of things are problems and what sort of methods are appropriate for solving those problems.
3. This idea comes from Russ Floreske's paper "Laertes: The Principle Part of Delta Hamlet," which he wrote while we were both students at Centerville High School.
4. The Myers Briggs test describes your personality on four dimensions: (1) extroversion (E) versus introversion (I), (2) Sensing (S) versus Intuition (N), (3) Thinking (T) versus Feeling (F), and (4) Judging (J) versus Perceiving (P).
5. There's a much more detailed model of how this process works in Jenny Rudolph's (Rudolph, Morrison, and Carroll 2009) simulation, if you are interested in exploring this in depth.
6. If you've never been fortunate enough to learn in a studio environment, there's a great description of a master architect teaching the skills of design to a student architect in *The Reflective Practitioner* (Schön 1983).
7. I note that acting teachers often have a similar belief about acting styles, but they have no problem being very directive and making very specific suggestions about technique and skill.
8. From *Shop Class as Soulcraft* (Crawford 2009), 53.
9. For a great discussion of craft, check out Sennett's (2008) book, *The Craftsman*.
10. A personal favorite of mine is Robert Quinn's *Change the World* (2000).
11. In *The Craftsman* (Sennett 2008), 268.

Twelve Coda: Final Reflections

1. This fascinating idea of leadership comes from *Leading Minds: An Anatomy of Leadership* (Gardner 1995).

2. The *Drawing on the Right Side of the Brain* program is proof that everyone can learn to draw. Just go online at look at the gallery of before and after self-portraits (http://drawright.com /gallery.htm) and see for yourself.

3. I did play one solo, which was during a jam session we did at the end of a performance of *Ease on Down the Road*. I played the solo on the tambourine. I'm sure there's a lesson here, but it escapes me. Regardless, it was fun and is one of my fondest memories of high school jazz band.

4. Dave Coleman was our first trumpet and he did once blow out his lip at a concert at an elementary school. His mouth piece filled with blood and several of the fourth graders thought that was a lot cooler than the music we were playing.

REFERENCES

Amabile, Teresa M. 1996. *Creativity in Context: Update to the Social Psychology of Creativity.* Boulder, CO: Westview Press.

Argyris, Chris. 1999. *Flawed Advice and the Management Trap : How Managers Can Know When They're Getting Good Advice and When They're Not.* Oxford: Oxford University Press.

Argyris, Chris, Robert Putnam, and Diana Smith. 1985. *Action Science: Concepts, Methods, and Skills for Research and Intervention.* San Francisco: Jossey-Bass.

Barry, Daved, and Stefan Meisiek. 2010. "The Art of Leadership and Its Fine Art Shadow." *Leadership* 6 (3): 331–349.

Bartow, Arthur. 2006. *Training of the American Actor.* New York: Theatre Communications Group.

Berman, Morris. 1981. *The Reenchantment of the World.* Ithaca: Cornell University Press.

Boland, Richard J., and Fred Collopy, eds. 2004. *Managing as Designing.* Stanford, CA: Stanford University Press.

Bolman, Lee G., and Terrence E. Deal. 2003. *Reframing Organizations: Artistry, Choice, and Leadership.* San Francisco: Jossey-Bass.

Bruner, Jerome S. 1986. *Actual Minds, Possible Worlds.* Cambridge, MA: Harvard University Press.

———. 1990. *Acts of Meaning.* Cambridge, MA: Harvard University Press.

Bryan, Mark, Julia Cameron, and Catherine Allen. 1998. *The Artist's Way at Work: Riding the Dragon.* New York: Quill.

Burns, James MacGregor. 2003. *Transforming Leadership: A New Pursuit of Leadership.* New York: Atlantic Monthly Press.

Cameron, Julie, and Mark Bryan. 1992. *The Artist's Way: A Spiritual Path to Higher Creativity.* New York: Putnam Books.

Campbell, Joseph. 1949. *The Hero with a Thousand Faces.* New York: Princeton/ Bollingen.

Coleridge, Samuel Taylor, Derwent Coleridge, and Sara Coleridge Coleridge. 1854. *The Poetical and Dramatic Works of S. T. Coleridge: With a Memoir.* Boston: Little, Brown and Company.

Collins, Jim. 2001. "Level 5 Leadership: The Triumph of Humility and Firece Resolve." *Harvard Business Review* 79 (1): 66–76.

Crawford, Matthew B. 2009. *Shop Class as Soulcraft: An Inquiry into the Value of Work.* New York: Penguin.

Csikszentmihalyi, Mihaly. 1996. *Creativity: Flow and the Psychology of Discovery and Invention.* New York: Harper Perennial.

Csikszentmihalyi, Mihaly, and Rick Robinson. 1990. *The Art of Seeing: An Interpretation of the Aesthetic.* Malibu, CA: Getty.

Czarniawska, Barbara. 2008. *A Theory of Organizing.* Northhampton, MA: Edward Elgar.

DePree, Max. 1989. *Leadership is an Art.* New York: Dell.

Dissanayake, Ellen. 2000. *Art and Intimacy: How the Arts Began.* Seattle: University of Washington Press.

Dreyfus, Hubert L., and Stuart E. Dreyfus. 2005. "Expertise in Real World Contexts." *Organization Studies* 26 (5): 779–792.

Dugliss, Paul, and Sandra Fernandez. 2005. *The Myth of Cholesterol: Dispelling the Fear and Creating Real Heart Health.* Ann Arbor, MI: MCD Century Publications.

Edwards, Betty. 1979. *The New Drawing on the Right Side of the Brain: A Course in Enhancing Creativity and Artistic Confidence.* New Yorl: Tarcher.

Field, Syd. 1982. *Screenplay: The Foundations of Screenwriting.* New York: Dell.

Gardner, Howard. 1993. *Creating Minds: An Anatomy of Creativity.* New York: Basic Books.

———. 1995. *Leading Minds: An Anatomy of Leadership.* New York: Basic Books.

Gardner, William J., Bruce J. Avolio, and Fred O. Walumba, eds. 2005. "Authentic Leadership Theory and Practice: Origins, Effects and Development." In *Monographs in Leadership and Management,* edited by J. G. J. Hunt. Vol. 3. Amsterdam: Elsevier.

George, Bill. 2003. *Authentic Leadership: Rediscovering the Secrets to Creating Lasting Value.* San Francisco: Jossey-Bass.

Gergen, Kenneth J., and Mary Gergen. 2004. *Social Construction: Entering the Dialogue.* Chagrin Falls, OH: Taos Institute Publications.

Gioia, Dennis A., and Kumar Chittipeddi. 1991. "Sensemaking and Sensegiving in Strategic Change Initiation." *Strategic Management Journal* 12 (6): 433–448.

Gladwell, Malcom. 2000. *The Tipping Point: How Little Things Can Make a Big Difference.* New York: Little, Brown and Company.

———. 2007. *Blink: The Power of Thinking Without Thinking.* Boston: Back Bay Books.

———. 2008. *Outliers: The Story of Success.* New York: Little, Brown and Company.

Goodwin, Doris Kearns. 2006. *Team of Rivals: The Political Genius of Abraham Lincoln.* New York: Simon & Schuster.

Grint, Keith. 2001. *The Arts of Leadership.* Oxford: Oxford University Press.

Grotowski, Jerzy. 1968. *Towards a Poor Theatre.* New York: Simon and Shuster.

Halpern, Belle Linda, and Kathy Lubar. 2003. *Leadership Presence: Dramatic Techniques to Reach Out, Motivate, and Inspire.* New York: Gotham Books.

Hatch, Mary Jo, M. Kostera, and A. K. Kozminski. 2004. *The Three Faces of Leadership: Artist, Manager, Priest.* London: Blackwell.

Heifetz, Ronald A. 1994. *Leadership Without Easy Answers.* Cambridge, MA: Belknap/ Harvard.

Ibbotson, Piers. 2008. *The Illusion of Leadership: Directing Creativity in Business and the Arts.* New York: Palgrave Macmillan.

Jackson, Brad, and Ken Parry. 2008. *A Very Short, Fairly Interesting and Reasonabley Cheap Book about Studying Leadership.* Los Angeles: Sage.

Johnstone, Keith. 1979. *Impro: Improvisation and the Theatre.* London: Faber and Faber.

Kegan, Robert, and Lisa Laskow Lahey. 2001. *How the Way We Talk an Change the Way We Work.* San Francisco: Jossey-Bass.

———. 2009. *Immunity to Change: How to Overcome It and Unlock the Potential in Yourself and Your Organization.* Boston: Harvard Business Press.

Kelly, Tom. 2000. *The Art of Innovation: Lessons in Creativity from IDEO, America's Leading Design Firm.* New York: Doubleday.

———. 2005. *The Ten Faces of Innovation: Ideo's Strategies for Beating the Devil's Advocate & Driving Creativity Throughout Your Organization.* New York: Doubleday.

Kohn, Alfie. 1986. *No Contest—the Case against Competition.* New York: Houghton Mifflin.

————. 1993. *Punished by Rewards.* New York: Houghton Mifflin.

Kouzes, Jim, and Barry Posner. 2002. *The Leadership Challenge.* San Francisco: Jossey-Bass.

Kristof, Nicholas D. 2009. "Would You Slap Your Father? If So, You're a Liberal." *New York Times,* May 27, 2009.

Ladkin, Donna, and Steven S. Taylor. 2010. "Enacting the 'True Self': Towards a Theory of Embodied Authentic Leadership." *Leadership Quarterly* 21: 64–74.

McCully, Kilmer S., and Martha McCully. 1999. *The Heart Revolution: The Extraordinary Discovery That Finally Laid the Cholesterol Myth to Rest.* New York: Harper Collins.

Meadows, Donella H. 1997. "Places to Intervene in a System." *Whole Earth* 91 (Winter): 78–84.

Meadows, Donella, Jorgen Randers, and Dennis Meadows. 2004. *Limits to Growth: The 30-Year Update.* White River Junction, VT: Chelsea Green Publishing Company.

Mirvis, Philip, Karen Ayas, and George Roth. 2003. *To the Desert and Back: The Story of One of the Most Dramatic Business Transformations on Record.* San Francisco: Jossey-Bass.

Parnes, Sidney J., ed. 1992. *Source Book for Creative Problem Solving: A Fifty Year Digest of Proven Innovation Processes.* Buffalo, NY: Creative Education Foundation.

Peirce, Charles S. 1957. *Essays in the Philosophy of Science,* edited by V. Thomas. New York: The Liberal Arts Press.

Pressfield, Steven. 2002. *The WAR of ART: Break Through the Blocks and Win Your Inner Creative Battles.* New York: Grand Central Publishing.

Quinn, Daniel. 1997. *My Ishmael.* New York: Bantam.

————. 1999. *Beyond Civilization Humanity's Next Great Adventure.* New York: Three Rivers Press.

————. 2007. *If They Give You Lined Paper Write Sideways.* Hanover, NH: Steerforth Press.

Quinn, Robert E. 2000. *Change the World: How Extraordinary People Can Accomplish Extraordinary Results.* San Francisco: Jossey-Bass.

Ravnskov, Uffe. 2000. *The Cholesterol Myths: Exposing the Fallacy That Saturated Fat and Cholesterol Cause Heart Disease.* Washington, DC: New Trends Publishing.

Robinson, Ken. 2009. *The Element: How Finding Your Passion Changes Everything.* New York: Viking.

Rudolph, Jenny W., J. Bradley Morrison, and John S. Carroll. 2009. "The Dynamics of Action-Oriented Problem Solving: Linking Interpretation and Choice." *Academy of Management Review* 34 (4): 733–756.

Rudolph, Jenny W., Steven S. Taylor, and Erica Gabriella Foldy. 2001. "Collaborative Off-line Reflection: A Way to Develop Skill in Action Science and Action Inquiry." In *Handbook of Action Research: Participative Inquiry and Practice,* edited by P. Reason and H. Bradbury. London: Sage.

Ruskin, John. 1860. *The Roots Of Honour*

Salovaara, Perttu. 2009. "Narration of Change in the Context of Leadership Development Program." In *EURAM.* Liverpool, United Kingdom.

Sawyer, R. Keith. 2006. *Explaining Creativity: The Science of Human Innovation.* New York: Oxford University Press.

————. 2007. *Group Genius: The Creative Power of Collaboration.* New York: Basic Books.

Schein, Edgar H. 1992. *Organizational Culture and Leadership.* 2nd ed. San Francisco: Jossey-Bass.

Schön, Donald A. 1983. *The Reflective Practitioner: How Professionals Think in Action.* New York: Basic Books.

Senge, Peter M. 1990. *The Fifth Discipline: The Art and Practice of the Learning Organization.* New York: Currency Doubleday.

Senge, Peter M., Charlotte Roberts, Richard B. Ross, Bryan J. Smith, and Art Kleiner. 1994. *The Fifth Discipline Fieldbook: Strategies and Tools for Building a Learning Organization.* New York: Doubleday.

Sennett, Richard. 2008. *The Craftsman*. New Haven: Yale University Press.

Silverstein, Michael J., and Neil Fiske. 2003. *Trading up: The New American Luxury*. New York: Portfolio.

Smith, Diana McLain. 2008. *Divide or Conquer: How Great Teams Turn Conflict into Strength*. New York: Portfolio.

Smith, Keri. 2008. *How to be an Explorer of the World*. New York: Penguin.

Springborg, Claus. 2010. "Leadership as Art: Leaders Coming to Their Senses." *Leadership* 6 (3): 243–258.

Stanislavski, Constantin. 1936a. *An Actor Prepares*. Translated by E. R. Hapgood. New York: Routledge.

——. 1936b. *Building a Character*. Translated by E. R. Hapgood. New York: Routledge.

——. 1961. *Creating a Role*. Translated by E. R. Hapgood. New York: Routledge.

Steinham, Gloria. 1983. *Outrageous Acts and Everyday Rebellions*. New York: MacMillan.

Taylor, Steven S. 2000. "Aesthetic Knowledge in Academia: Capitalist Pigs at the Academy of Management." *Journal of Management Inquiry* 9 (3): 304–328.

——. 2003a. "Dissolving Anchors: Acid Management on Mars." *Tamara: Journal of Critical Postmodern Organization Science* 2 (4): 1–6.

——. 2003b. "Knowing in Your Gut and in Your Head: Doing Theater and My Underlying Epistemology of Communication." *Management Communication Quarterly* 17 (2): 272–279.

——. 2003c. "Ties That Bind." *Management Communication Quarterly* 17 (2): 280–300.

——. 2008. "Theatrical Performance as Unfreezing: Ties That Bind at the Academy of Management." *Journal of Management Inquiry* 17 (4): 398–406.

Taylor, Steven S., Dalmar Fisher, and Ronald L. Dufresne. 2002. "The Aesthetics of Management Storytelling: A Key to Organizational Learning." *Management Learning* 33 (3): 313–330.

Taylor, Steven S., and Hans Hansen. 2005. "Finding Form: Looking at the Field of Organizational Aesthetics." *Journal of Management Studies* 42 (6): 1211–1232.

Taylor, Steven S., and Barbara Karanian. 2009. "Working Connection: The Relational Art of Leadership." *Aesthesis: International Journal of Art and Aesthetics in Management and Organizational Life* 3.

Taylor, Steven S., Jenny W. Rudolph, and Erica Gabrielle Foldy. 2008. "Teaching Reflective Practice: Key Stages, Concepts and Practices." In *Handbook of Action Research*, edited by P. Reason and H. Bradbury. London: Sage.

Torbert, Bill, Susanne Cook-Greuter, Dalmar Fisher, Erica Foldy, Alain Gauthier, Jackie Keeley, David Rooke, Sara Ross, Catherine Royce, Steve Taylor, and Mariana Tran. 2004. *Action Inquiry: The Secret of Timely and Transforming Leadership*. San Francisco: Berrett-Koehler.

Torbert, William R. 1991. *The Power of Balance: Transforming Self, Society, and Scientific Inquiry*. Newbury Park, CA: Sage.

——. 1999. "The Distinctive Questions Developmental Action Inquiry Asks." *Management Learning* 30 (2): 189–206.

——. 2000. "The Practice of Action Inquiry." In *Handbook of Action Research*. London.

Torbert, William R., and Steven S. Taylor. 2008. "Action Inquiry: Interweaving Multiple Qualities of Attention for Timely Action." In *Handbook of Action Research*, edited by P. Reason and H. Bradbury. London: Sage.

Uhl-Bien, Mary. 2006. "Relational Leadership Theory: Exploring the Social Processes of Leadership and Organizing." *Leadership Quarterly* 17: 654–676.

Weick, Karl E. 1995. *Sensemaking in Organizations*. Thousand Oaks, CA: Sage.

Weisberg, Robert W. 1986. *Creativity: Genius and Other Myths*. W. H. Freeman & Co.

INDEX

Printed in the USA
CPSIA information can be obtained
at www.ICGtesting.com
LVHW011040280823
756501LV00005B/51